Carmen,

Live the Map!

PIECING TOGETHER
AMERICA

SERVING THE BEST FEATURES AND
CRAFTSMANSHIP OF EVERY MAJOR CITY

The Nation's Most Traveled and Bestselling Author

DANIEL SEDDIQUI

INTRODUCTION

I believe that wherever we are in life is where we're supposed to be. It appears, I was destined to be everywhere.

I feel most alive when there are places to go, people to meet, and new things to learn. There's something about having 'been there, done that' that never gets old. All my life, I've wanted the pinpoints on the map to become my reality, and strive to create authentic connections defined by relating. Afterall, relating comes from experience and an understanding of place, that's how we generate things in common. My curiosity of America turned into an obsession, not wanting to leave a place untouched or a people overlooked.

I have traveled to each of the 50 States at least 20 times, covering every mid-size and major city, and thousands of towns. I don't travel for the sake of visiting a place, but rather to be in a place. When I embarked on 50 jobs in 50 states, I wanted to be that coal miner burrowing into mines of West Virginia, returning home to rinse off the dust, or that morning show meteorologist preparing slides to forecast the weather for Cleveland, or that cowboy buckling his belt and tipping his hat for a rodeo audience in South Dakota.

As I came face to face with the country's most problem-plagued communities, I wanted to address the issues first-hand. I ran shoulder-to-shoulder in a 5k road race in a town struggling with its designation as having the highest obesity rate in the country, and strained my back hovering to pick green peppers along with migrant field workers. When I felt deep divides, I sought to mend them in small but significant ways by immersing myself in different cultures. I sang with the Mormon Tabernacle Choir, and shot archery with Cherokee Indians.

My journey truly started when I discovered maps at age six. I had a globe in my bedroom that my older brother and I would spin, and wherever our finger landed – unless of course, it was the ocean – was where we imagined living someday. My parents took notice of my interest and bought me an atlas, encyclopedias, international books, and even trading cards of countries. I never thought the many nights studying maps throughout my childhood would lead to forging a path where I experience every job, culture, and road for that matter, in America. It's been a blessing and a curse to live the map. On one hand, I've explored the variety of what travel offers, but on the other, it comes with great sacrifice: leaving comfort and certainty, always being the stranger in town, and carrying an unwavering curiosity that never allows me to be fully in the moment.

Destinations are never a direct line. Roads reflect our life's curves, yields, and undulations, and we're never alone – there's always someone on that same road going somewhere to fulfill responsibilities, maintain relationships, or escape the everyday. We are all headed someplace, but much of the path is unknown and that's what makes it an adventure. We can't predict our fate, so we must learn to embrace the road ahead. We'll get to our destination sooner or later, it's waiting for us, so there's no point in rushing to it.

After college, wide-eyed and full of hope, I never expected the rejection faced by so many graduates, or the desperation that followed. Turns out, it was a gift because in those low moments my childhood curiosity resurfaced. When I allowed that wonder to chart my future, I accepted the challenge as a part of my story. Doors started to open, relationships were created, and one experience led to another. Back in 2008, fearlessly contacting thousands of employers, asking for a volunteer role is what led me on a path I could never have envisioned. That was my finger on the spinning globe moment.

NEVER STOP LEARNING

Top: 50 Jobs in 50 States, Las Vegas 2008

Bottom: Piecing Together America, Las Vegas

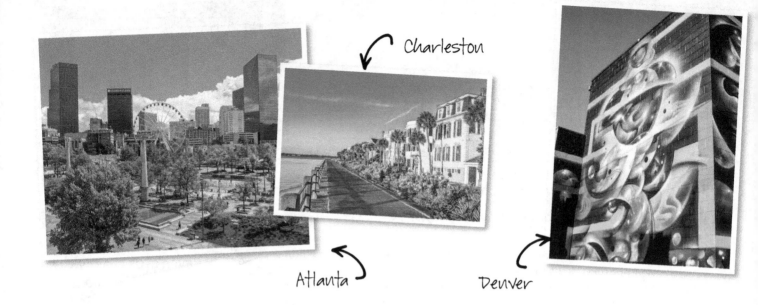
Charleston

Atlanta

Denver

In my mid-thirties, one of those unforeseeable detour signs appeared, throwing me off the road and leading me in a new direction. From all the places in the world to land, my heart called me to the midwest. I enrolled in graduate school and worked in the athletics department at the University of Minnesota. I thoroughly enjoyed my new life in the Twin Cities, exploring the lakes, attending sporting events, and biking neighborhoods. Still, it was a challenge not having a circle of friends, feeling alone. After months of settling into the city, I was walking through the skywalks and stumbled into an attached hotel lobby where I noticed hundreds of conference goers, a perfect setting for people watching. Overhearing a group's conversation, asking each other what to do during their free time, I wanted to jump in and offer some suggestions. I didn't but was disappointed to hear they just returned from a lackluster meal at a restaurant chain. You can have a bite to eat anywhere.

Suddenly, I had an idea. I wanted to showcase the most unique features of all the major cities in America. Spend a day in each place, find the best neighborhoods, parks, museums, historic sites, events and so on. I called it, A Day in Your City. There was something missing. Something more meaningful.

I sat on the idea for a while, as life was still happening. I met a woman, and after knowing her for only two months, proposed. It didn't take long to find the reason my heart called me to Minnesota. Then, the pandemic hit, and we felt stuck living in downtown Minneapolis, not being able to enjoy any of the luxuries of big city life. Everything was shut down. We decided to move to Bend, Oregon. It was another spinning of the globe moment.

We got married, bought a house, had a baby, and started new jobs. We accomplished some of life's major milestones within three months. As I was decorating my home office, the empty shelves and walls irked me. There was something missing. Something meaningful. As my idea of A Day in Your City started to percolate, I thought about having a piece from each major city that reflects the history, culture, and industry. I called it, A Piece of Your City. The concept stretched to another level by wanting to learn a new skill from a local and handcraft a memento together. This would be my way of making connections with points on the map.

Piecing Together America became my craft. I wanted to learn how to mold clay into a piggy bank at a pottery in Charlotte, tie rope into navy knots in Virginia Beach, press vinyl records in Cleveland, spray graffiti in New York City, pour latte art in Seattle, and weave sweetgrass baskets in Charleston. America prides itself in traditions, creating symbols of successes and failures. It's a nation of doers, those that innovate and those that make it come to fruition. Every piece of America has a story, leaving a legacy that inspires the next generation. On this expedition, I met with 70+ artists that wanted to leave their mark in this world by crafting something they cherish most and graciously being part of my project. Each artisan I worked with has a dream, makes sacrifices, and revealed the emotion that fuels their craft. When I painted alongside an elderly Acoma Indian woman her eyes filled with tears. "I'm Native and you're Anglo, and we're sharing a gift by a power greater than ourselves," she said. We were destined to be a part of each other's journey and our gift in America is the freedom to connect and create.

America is a work of art!

TABLE OF CONTENTS

Anchorage

CHAR BROILED
MEMPHIS

Chef's Note

Memphis will always have a role in forming America's identity and an iconic city that has an obligation to preserve its history, like exhibits in a museum. Voices have proven to be amplified here, from the evolving music sound of Elvis Presley, Johnny Cash and BB King to the assignation of Martin Luther King Jr. that empowered his message to the ends of the earth. Remnants of the past will always remain present because the light that Memphis has created is too significant to bury. The downtown trolley train's bell is ringing, the Mississippi River bridge's lights are flashing, and the voices of Memphis are still heard from one generation to the next.

Cook Time: 26 hours

7am	Shelby Farms Park
8am	Drive Poplar Ave.
10am	Sun Studio
11:30am	Stax Studio
2pm	The National Civil Rights Museum
5pm	Walk the Pedestrian Bridge to Mud Island
7pm	Beale Street

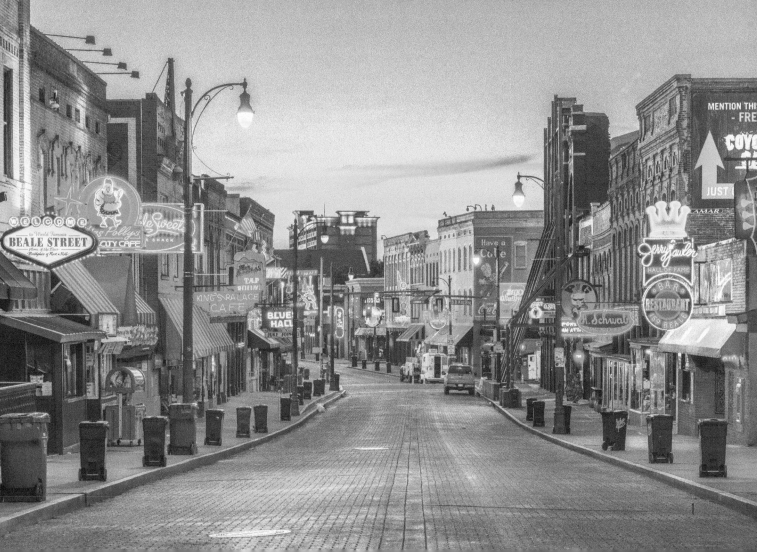

CHAR BROILED
MEMPHIS

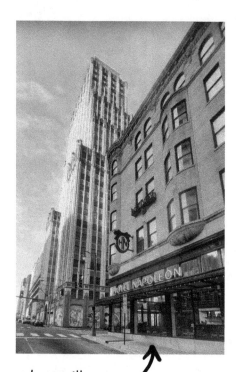

The Grill

Hotel Napoleon

179 Madison Ave.

Located in Downtown Memphis' historic Winchester building and listed on the National Register of Historic Places, this grande dame hotel dates back to 1902 and delivers luxurious, Old World elegance with a full roster of amenities. Built by Napoleon Hill, its classic architecture is a fixture of the neighborhood, which includes other famous landmarks like FedEx Forum and lively Beale Street. There's a lot within walking distance to make your stay even more entertaining. The staff is very accommodating, and the rooms are spacious with great lighting.

Pre-heating

Shelby Farms Park, 7am

6903 Great View Dr N

Explore the trails or circle the lake, inhale the nature of Tennessee, and enjoy one of the country's largest urban parks. There's something for everyone, even two upscale restaurants leveled with the water in a modern visitor's center and event center.

Tenderizing

Drive from Germantown to Downtown on Poplar Ave., 8am-9:30am

One street can give you a good sense of the many diverse Memphis neighborhoods. Begin in the affluent suburb Germantown that has luxurious massive homes and gated communities. Continue to the edge of the University of Memphis campus and Overton Park, which is home to the Memphis Zoo, Brooks Museum of Art and a popular city golf course. Head through the commercial district of Midtown and the charming Victorian Village. Before reaching downtown, you'll be fascinated by the Memphis prideful art murals in decrepit neighborhoods.

A Touch of Seasoning

Tour the Studios that changed music history
Sun Studio, 10am-11:15am

706 Union Ave.

Known worldwide as "The Birthplace of Rock'n'roll". It is the discovery location of musical legends and genres of the 50's from B.B. King and Elvis Presley to Johnny Cash and Jerry Lee Lewis; from Blues and Gospel to Country and Rock'n'roll.

Stand in the very same spot where Elvis approached the secretary's desk asking to audition and his first recording. Your tour guide will tell you the inside stories of B.B. King, Howlin' Wolf and Ike Turner before Elvis, Johnny Cash, Carl Perkins, Jerry Lee Lewis, & Roy Orbison who were all drawn to the new Sun Sound.

Stax Studio, 11:30am-1pm

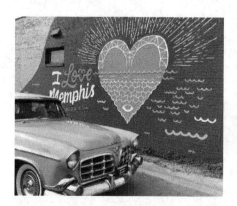

Local Inspiring Flavors

Breakfast
The Arcade Restaurant

540 S Main St.

The oldest diner in Memphis, built in 1919 has multiple rooms and plenty of seating. As you look around this old re-discovered part of Memphis, South Main Street, it still has the same look and feel that it did many years ago. The buildings have been refurbished, yet the old-time charm still exists.

Lunch
Central BBQ

147 E. Butler Ave.

It is no easy task to stand out from the crowd in a town as discerning about their barbecue as Memphis, but Central BBQ has managed to do just that, attracting throngs of hungry Memphians with a decadent offering of ribs, hot wings, and most importantly, pulled pork sandwiches (they also have famously delicious side dishes). You're likely to find a line outside Central BBQ, but it is sure to be worth the wait.

Dinner
Take a stroll down South Main Street in downtown for sidewalk dining as you watch the historic trolley pass.

926 E McLemore Ave.

I can't believe how many hits came out of this studio and the reason why Memphis is also known as Soulsville. There are many amazing exhibits and memorabilia from the biggest stars of soul, gospel, funk and blues. Self-guided tour through one of the best music museums in the country.

Marinating

The National Civil Rights Museum (Lorraine Hotel), 2pm-3:30pm

450 Mulberry St.

The most famous motel room in the world. Martin Luther King Jr. left a legacy for those fighting for justice and freedom. Be inspired by one man's purpose by learning the sacrifices he endured for a better today.

Walk the Pedestrian Bridge to Mud Island, 5pm-6:30pm

Big River Crossing

Enjoy an incredible evening stroll over to a small peninsula to capture the greatest views of downtown and the Mississippi River. Stay long enough for the light show running at the top and middle of every hour from sundown to the 10:30pm finale of the Hernando de Sota Bridge. Keep in mind, all the bridges over the Mississippi River light up.

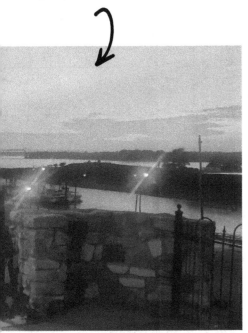

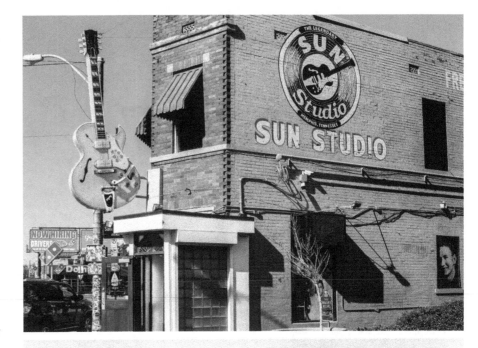

Let's get Cooking

A METAL MUSIC NOTE

Metal Museum
374 Metal Museum Dr.

Momento

Why I Choice this Craft

Memphis has a rich music history, specifically Blues & Soul. Walking down the iconic Beale St, you'll find brass music notes on the sidewalk, similar to the Hollywood Stars. Also notice the music notes on patio railings and other various places. I thought about making a music note of metal and connected with the Metal Museum. The only one of its kind in North America, The Metal Museum exhibits artist's metal work and offers public programs. The grounds are set for a wedding with a beautiful sculpture garden. Plus, the views are the best of the Mississippi River. I'm happy to say that this piece of Memphis is now used as a Christmas ornament and was given to each employee.

Beale Street, 7pm-10pm

Beale St.

After a day learning about the city's music history, hear it live. You'll have a new appreciation for the performing artists that are keeping the sounds of yesterday alive while implementing their own twist. This is one of the iconic streets of America, like the Strip of Vegas or the Broadway of Nashville.

A Tasty Choice

Throughout Memphis, the common theme is neon and LED lighting. I first noticed the classic neon signs lighting just about every business on Beale Street. Then, I noticed the fluorescent colors lighting up several bridges across the Mississippi, putting on a spectacular light show. When, I finally spotted hanging lights over parks in the city, I realized this was a special beautiful theme and maybe by accident.

DETROIT
PACZKI

Chef's Note

Detroit is resilient. Like Joe Louis, the attributed heavy-weight boxer and Detroit native, this city will not get knocked-out. Once one of the most powerful American cities to filing the nation's largest municipal bankruptcy, you'd think it would be down for the count, but when people have pride and the courage to reinvent, you'll get this thriving city we see today. Still branded by its auto industry, Detroit has attracted new industries and repurposed downtown into the hip and colorful Comeback City.

Cook Time: 24 hours

7am	Bike Dequindre
11am	M1 Concourse Performance Track
2pm	Henry Ford Museum
7pm	Detroit Tigers Game

The Skillet

Element at the Metropolitan
33 John R St

The 14pm-story Neo-Gothic office building built in 1925 had been abandoned for 40 years. During that time, scrappers had taken most parts of value and the city had even erected nets to catch debris from its collapsing facade. Instead of demolition, the Metropolitan Building has been brought back to life and did an exceptional job recreating many of its historical elements. It's steps away from top attractions like Ford Field, Comerica Park, Little Caesars Arena and thriving destinations in the Theatre District.

Pre-heating

Bike the Dequindre Cut and Eastern Market with Wheelhouse 7am-9:30am
1340 Atwater St

Detroit is an excellent city for cycling. There's lots of room on the road, great neighborhoods to explore, and 140+ miles of bike lanes.

Start from the Riverwalk Park, east on the Riverfront Path to the Dequindre Cut. This path formerly a railroad line, is below street level, so it's peaceful. Take it to Eastern Market at the Wilkins St. exit.

Eastern Market is the largest historic public market district in the United States, and the Eastern Market farmer's distribution center is the largest open-air flowerbed market in the United States and has more than 150 foods and specialty businesses. On Saturdays, about 45,000 people shop this city's historic market.

Local Inspiring Flavors

Breakfast
Walk downtown's Woodward Ave. to find plenty of hip coffee shops and restaurants. Enjoy the small green spaces in the area.

Lunch
American Coney Island
114 W Lafayette Blvd

Since 1917, this Detroit staple is one of the places that is iconic to dine at when in Detroit. High quality, specially-seasoned, natural skin casing hot dog from Dearborn Sausage and their own Keros family secret recipe Coney Island Chili Sauce developed decades ago. Add to that a topping of fine mustard and sweet chopped onions that is the final touch to the distinctive overall taste and flavor. Served in a warm steamed bun, it's no wonder the American Coney Island Hot Dog has been such a tantalizing treat that's still hard to beat after all these years!

Dinner
Buddy's Pizza
1565 Broadway St.

In 1946, a new style of pizza was born at Buddy's and it was different. Their one of a kind square pies are built by hand with the best ingredients. No shortcuts, just a stubborn belief in doing things right. They believe in creating good food that's meant to be gathered 'round – from family dinner, to date night, game night and everything in between. They've always had a way of turning strangers into friends and friends into family. They are The Original Detroit-Style Pizza.

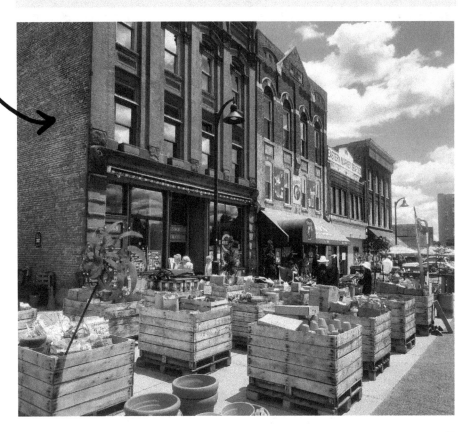

DETROIT
PACZKI

Kneading

**M1 Concourse Performance Track
11am-1pm**

1 Concourse Dr., Pontiac

M1 Concourse is an 87-acre playground for auto enthusiasts that includes the world's largest community of Private Garages and a state-of-the-art 1.5pm-mile Performance Track with its own private Motorsports Club. M1 is a place where enthusiasts can keep, show and exercise their vehicles in the company of other enthusiasts and enjoy unforgettable experiences in a social setting unavailable to people who keep their cars at home or in a traditional storage facility. Plans for the development include expanding the Private Garage community, a corporate event center, and more.

Trying this, gets your heart racing just as fast as coming around turns are 85 mph, but you can reach up to 125 in the next heartbeat. I had to stop early because it's only for certain people.

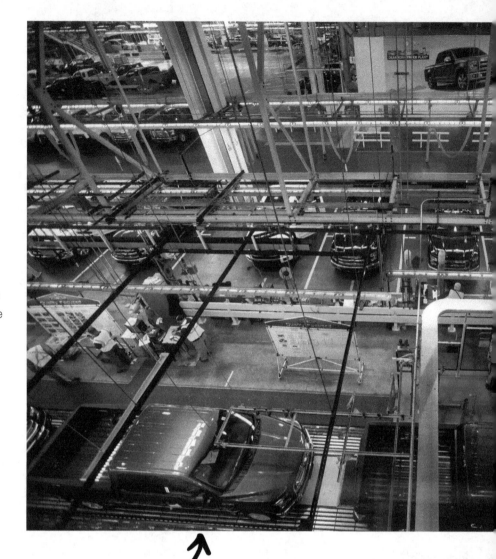

Rolling

Learn how Detroit is known as Motor City

The Henry Ford Museum of American Innovation 2pm-5pm
20900 Oakwood Blvd. Dearborn

You don't have to be a car enthusiast to appreciate the great American innovation of Henry Ford. On a campus of its own, Greenfield Village, explore a world-class indoor-outdoor museum and be inspired by one of our greatest innovators.

That's not all. Visit the Ford Rouge Factory, where you can watch vehicle manufacturing. I had never been so fascinated watching people work. From a catwalk, see the step-by-step process of the automotive assembly-line. Each worker has their station as the conveyor of vehicles comes around. The manufacturing floor is surprisingly immaculate.

Frying

Detroit Tigers Game 7pm-10pm
2100 Woodward Ave.

All of Detroit's Professional Teams (Red Wings, Tigers, Lions, Pistons) are within a block. That is something very special and a great way to get traffic into downtown.

Enjoy an evening game at Comerica Park, where the stadium seats sit low with the field. It's a beautiful atmosphere, even if you're not a Tigers fan.

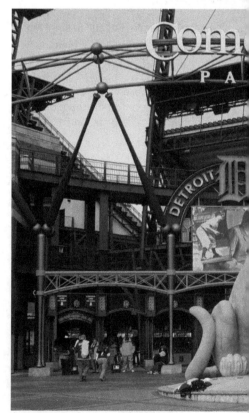

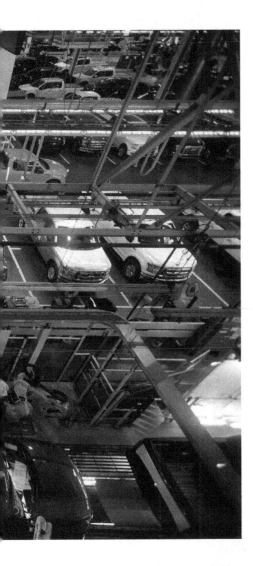

MODEL CARS

Pasteiner's, Automobilia on Woodward Ave.

33202 Woodward Ave.

Why I Choice this Craft

It's no surprise that Detroit has a rich automobile history, which naturally attracted die-hard car enthusiasts. Learning about the many car clubs in the metro area and their passion to build die-cast models of their favorite vehicles, I wanted to make one for myself. People spend thousands of dollars and hundreds of hours building their model, but I had enough time to build a plastic Ford GT on Woodward Ave.

Banking on the city's car culture, Woodward Ave hosts the Dream Cruise, North America's largest celebration of automotive culture, attracting nearly one-million visitors and thousands of classic and specialty vehicles to Metro Detroit. Starting in 1848, when the roadway was converted from logs to planks, young carriage drivers would race along Woodward Avenue. Woodward Avenue was developed as a major street in Detroit in the early 20th century, and was lined with mansions and major churches.

By 1958, the roadway was used by youth for unofficial street racing. The wide width, median, and sections lacking a large commercial presence attracted drivers eager for the competition. The numerous drive-ins along the road, each with its dedicated local teenaged clientele, were also popular. In the age of the muscle car, Woodward had numerous car dealerships and automobile accessory shops.

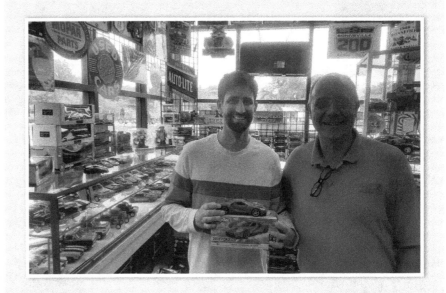

A Tasty Choice

Downtown has many alleys that have been repurposed from dark, dingy, and dilapidated to a commercial strip and public art destination. The Belt Alley, Green Alley, and Parker's Alley are perfect examples of Detroit's reinvention. Enjoy walk-up window food establishments and boutique shops

CHILE ROASTED
ALBUQUERQUE

Chef's Note

Don't be fooled by the dull beige-colored theme on the roadways, residential and commercial structures, or the natural rocky terrain because Albuquerque knows how to pop with contrasting colors stringing down hot air balloons, chile ristras, mineral decor, and blazing sunsets. It's easy to fall in love with ABQ's nature, traversing the highest peak of the Sandia Mountains on the world's longest tram or walking North Valley's cottonwood trails along the Rio Grande. It's just as easy to admire its revamped appeal of Route 66 and Historic Old Town. But as the city evolves, the roots are too deep to lose its cultured identity.

Cook Time: 27 hours

9am	Sandia Peak Tramway
11am	Balloon Museum
12:30pm	Drive the North Valley
2pm	Tingley Beach
3pm	Historic Old Town
7pm	Route 66
Day 2	
10am	Turquoise Museum

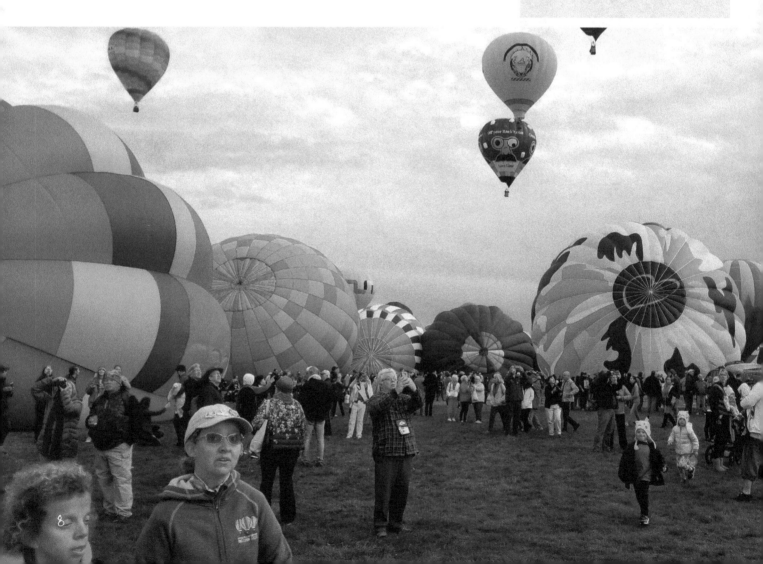

The Oven

Hotel Andaluz
125 2nd St NW

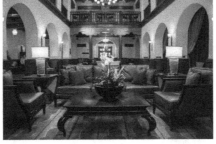

Andaluz – short for Andalucian – evokes the passion and pride of the region of Spain that has inspired the hotel's decor and architectural style. The four interlocking A's of the logo reflect an adaptation of classic Andalucian tile. Look for the logo in the traditional Andalucian arch that graces the hotel's public spaces. Hotel Andaluz has a rich history in downtown Albuquerque and only the fourth hotel ever built by Conrad Hilton. This is not just a hotel, but an experience prompting snapshots from the luxurious lobby to the elaborate rooms.

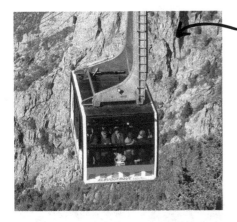

Pre-heating

The Sandia Peak Aerial Tramway
9am-10:30am
30 Tramway Road NE.

Rising from the hustle and bustle of Albuquerque, you ascend one of America's most stunning urban peaks. Reaching the 10,378-foot crest of the Sandia Mountains, an 11,000 square mile panoramic view awaits you. It's an elevation of the body, mind, and soul in a mere 15 minutes. At the top, enjoy hiking, skiing or a snack.

At the base, take a drive through some neighborhoods to view the most expensive properties in New Mexico. Beautifully designed adobe architecture and locally inspired landscaping.

Coating

Balloon Museum 11am-12pm
9201 Balloon Museum Dr NE

Through innovative exhibits, the balloon museum showcases the adventurous spirit, endeavors and achievements of individual balloonists, including several Albuquerque residents who continue to break records in the ballooning world. The balloon museum is named after two Albuquerque pilots who were pioneers in long-distance helium balloon flight. Ben Abruzzo and Maxie Anderson were part of the crews who first successfully crossed the Atlantic Ocean in a balloon in 1978 and the Pacific Ocean in 1981. If you choose to book a ride, this is one of America's bucket list items.

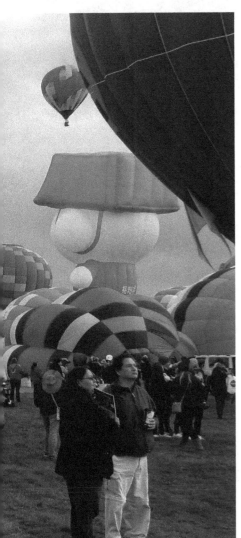

Local Inspiring Flavors

Breakfast
MÁS
125 2nd St NW

Located in the stylish Hotel Andaluz, MÁS is a full-service restaurant and tapas bar inspired by the bold flavors, rich history and exuberance of Spanish cooking. MÁS offers fresh reinventions of traditional Spanish cuisine with an emphasis on organic, fresh and locally-sourced foods and high quality ingredients.

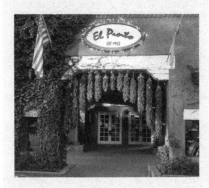

Lunch
El Pinto
10500 Fourth St. N.W.

The best opportunity to try traditional New Mexican food in Albuquerque, nestled in the cottonwoods of the North Valley, El Pinto is a family tradition. Voted the Best New Mexican Restaurant by the locals, you will be sure to enjoy a fabulous meal while you relax on one of many decorated rooms or patios on a property adorned by enormous ristras.

Dinner
66 Diner
1405 Central Ave NE

People come from across town and from all over the world to experience this historic ambiance and enjoy fabulous food and shakes, reminiscent of the prime of Route 66.

CHILE ROASTED
ALBUQUERQUE

Blistering and Blackening

Take a Drive in the North Valley
12:30pm-1pm
This lush green valley that runs along the Rio Grande and is known for great outdoors for the nature-lovers. Plus, there are wineries, farmers markets and peaceful spas open to any visitor. The ranch homes are specular, not exactly what you thought Albuquerque would be.

Tingley Beach 2pm-3pm
1800 Tingley Dr. S.W.

Near the Rio Grande River lies a city park unique for catch and release fishing for all ages. One of the ponds is a bird-feeders heaven, thousands of swarming duck and geese congregate.

Historic Old Town 3pm-5pm
The heart of Albuquerque since the city was founded in 1706. Today, Old Town is the city's cultural center, with numerous museums, colonial Spanish church and more than 100 shops, galleries and restaurants. A perfect way to stroll through quaint streets and centuries-old adobe houses where local artists sell traditional crafts, like fine art, jewelry, rugs, and pottery.

Explore Route 66 at Nob Hill 7pm-9pm
A trip to Albuquerque is unfulfilling without connecting with its significant history, and learning how Route 66 is still thriving. Nob Hill is a vibrant district with eclectic shops, swanky dining and chic nightspots. Its Route 66 architecture and neon signs, combined with predominantly locally owned shops, galleries and restaurants, make Nob Hill a hip and fashionable area. Also, this area is home to the University of New Mexico.

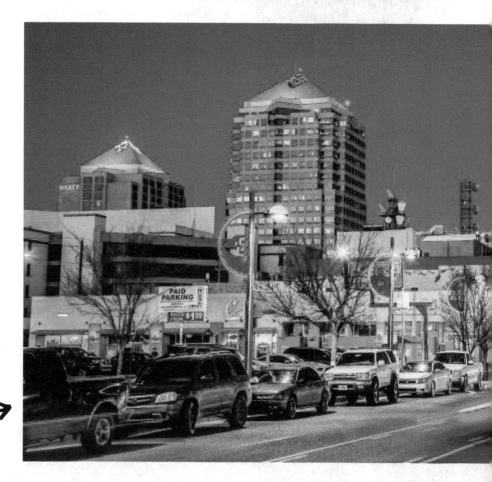

10

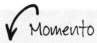
Let's get Cooking

PUEBLO NATIVE POTTERY ART WITH SHIRLEY CHINO

Why I Choice this Craft

Native American heritage is alive and well in New Mexico, home to 19 pueblos, 3 Apache tribes and Navajo Nation. One of the closest pueblos is of the Acoma people. Pottery has been central to pueblo life as a feature of ceremonial and utilitarian usage. For centuries, Pueblo pottery style is dominated by the olla-shaped vessel with a narrow base that gradually widens. The broadest section of the vessel is just before the taper towards the mouth begins. Unpainted Acoma Pueblo pottery is characteristically a light cream, almost white color. Some vessels are left unpainted, and the austerity of the pottery's natural color is breathtaking.

Most Acoma Pueblo pottery is painted, typically using red and orange (terracotta) outlined in black. Acoma artists are known for their use of fine line designs. Fine lines, symbolizing falling rain, are painted closely together. Line direction varies to create larger geometric patterns.

Another design common to Acoma Pueblo pottery is the parrot. Introduced by the Spanish, the parrot is special to the Acoma people; according to legend, the parrot led a group of Acoma women to a clean, cool watering hole. Shirley Chino showed me how to mold a hot air balloon shaped pottery and paint the sacred New Mexico symbol, meaning Circle of Life with vibrant yellow and red colors.

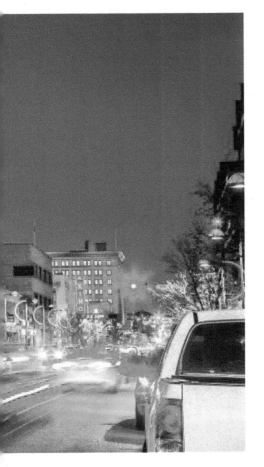

Pealing

Day 2

Turquoise Museum 10am-12pm
400 2nd St SW

Turquoise is not unique to New Mexico, but New Mexico is unique to turquoise. The Southwest Native Americans called turquoise "chalichihuiti," or sky stone, and considered it a sacred talisman for health, happiness and protection. Archeologists unearthed 56,000 pieces of turquoise in a single burial at Chaco Canyon. Mayan ruins as far away as Honduras contained jewelry with stones mined from the Cerrillos Hills along the New Mexico Turquoise Trail. This museum has the world's largest collection of turquoise and they're quite the pieces to observe.

A Tasty Choice

It's no secret that when it comes to sunsets, Albuquerque puts on one of the most brilliant, colorful, stop-you-dead-in-your-tracks shows. The scaping sky transforms into a vibrant watercolor painting, the city takes on a warm hue, and bright paint pots of color burst across the cloudline. While the sunsets are some of the most exceptional in the world, the thing that really sets our sunsets apart from those you'll see anywhere else might surprise you.

The Sandia Mountains. "Sandia" means watermelon in Spanish, and these mountains reinforce their perfectly-given namesake every evening at dusk. As the sun drops below the horizon, the string of awe-inspiring vistas illuminate into an unexpected and radiant pink/red hue. It's one of those things you truly have to see to believe.

SAN FRANCISCO
SOURDOUGH

Chef's Note

When the fog dissipates, the sunlight unveils a city of shinning bridges, sparkling towers, and reflective waters and there a plenty of peaks to observe the views. A year-long calendar wouldn't be enough to display the iconic images of the stacked pastel colored hillside homes and the rows of Victorians, the numbered wooden piers, or the 30+ distinct neighborhoods. San Francisco goes through history fast, attracting movers and shakers, creating industries that have come and gone, yet has established a culture of fearless pioneers from around the globe.

Cook Time: 28 hours

7:30am	Golden Gate Park
11am	Golden Gate Bridge
1pm	Lovers Lane
2:30pm	Lombard Street
3:30pm	Cable Car
5:30pm	Chinatown
7:30pm	Union Square
Day 2	
7:30am	The Embarcadero

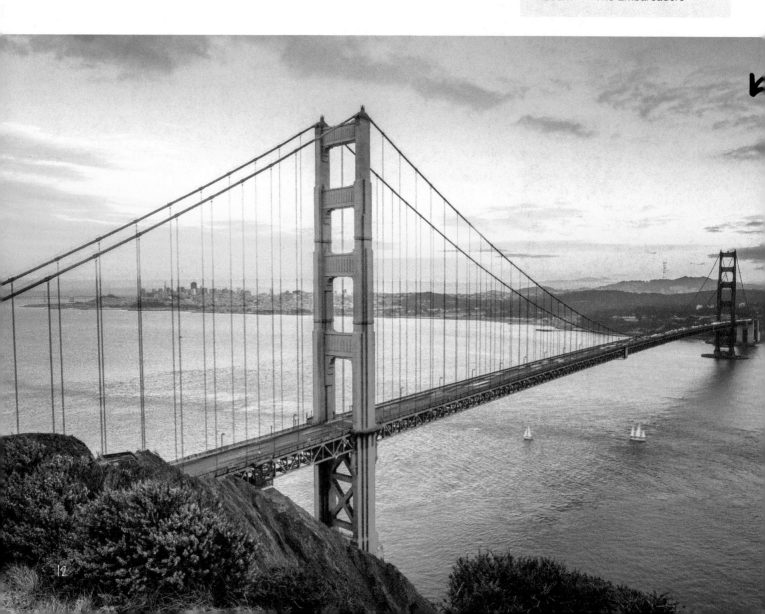

12

The Dutch Oven

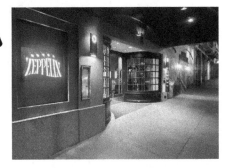

Hotel Zeppelin
545 Post St.

Rebelliously celebrating San Francisco's bold, bohemian past. Vibe with the city's progressive mindset. The hotel turns it into a living story that leaves you feeling reconnected and open to adventure. Count on a mind-altering experience and stylish delivery, inspired by the city's famed rule-breaking poets, authors, and musicians. As a guest, you are welcome to break the mold, too. Come and be transformed and don't forget about the massive game room on the lower level.

Mixing

The Panhandle and Golden Gate Park 7:30am-9:30am
Enjoy an active, yet pleasant path of Monterey cypress and Eucalyptus trees at the Panhandle into Golden Gate Park's Japanese tea garden, Stowe Lake and waterfalls, museums, a polo field, and even a cycling track. The thousand-acre park has something for everyone and is even connected to Ocean Beach, where you can watch surfers in frigid waters.

Stretching and Folding

The Golden Gate Bridge 11am-12:30pm
A trip to San Francisco is not complete without walking one of America's most iconic structures. Each year the Golden Gate Bridge attracts more than 10 million visitors to take in its tremendous 746pm-foot tall towers, sweeping main cables, signature International Orange color and Art Deco styling. It is a sensory experience featuring color, light and sound. Be prepared for gusty winds walking over the junction of the ocean and the bay.

Lovers Lane at the Presidio 1pm-1:30pm
There are many nature escapes in San Francisco, but this one is special. Walking in San Francisco is unavoidable, and many of the local's primary mode of transportation and this stroll through a half-mile lane of Eucalyptus trees is a breathtaking city experience.

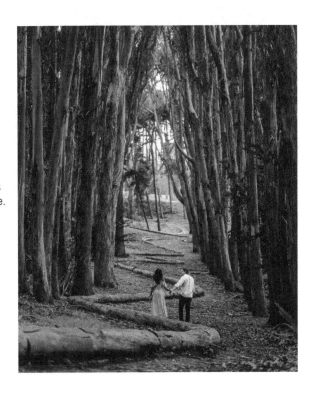

Local Inspiring Flavors

Breakfast
Pork Store Cafe
1451 Haight St.

Dine in the historic Haight and Ashbury neighborhood, known for the gathering of the 1967 'Summer of Love' colorful hippie culture. Choose your tasty American comfort food (including regional choices) in a tiny, no-frills space.

Lunch
Rose's Café
228 Union St.

A favorite in the Cow Hollow neighborhood, Rose's Café is a hangout for locals who bask in the sun at sidewalk tables, duck inside for a cappuccino, or stay for a leisurely lunch or dinner. Many customers are regulars who frequent our pretty bistro-café that offers table service and deliciously consistent food – Italian fare created using organic local produce, fresh seafood, humanely raised meats, and free-range poultry. Rose's artisan bakers bake a daily selection of pastries, desserts and breads. Blessed with quiet residential streets and ample entertainment opportunities, Cow Hollow sits atop the wish lists of a variety of San Franciscans, from new families to long-established members of the city's upper class.

Dinner
Explore Chinatown's many authentic Chinese restaurants and don't be surprised by ducks hanging in the windows.

SAN FRANCISCO
SOURDOUGH

Shaping

Drive Lombard Street 2:30pm-3pm

Known as the "Crookedest Street in the World," Lombard Street is one of San Francisco's most popular landmarks. Every year, millions of visitors walk or drive down its eight sharp hairpin turns. Surrounded by Russian Hill mansions and perfectly manicured landscaping and flowers, it is also one of the city's most scenic streets. Take a spectacular photo at the bottom looking up or enjoy the breathtaking view from the top looking out onto the San Francisco Bay, the Bay Bridge and Coit Tower.

Cable Car and Cable Car Museum 3:30pm-5pm
1201 Mason Street

Start at the museum to understand about the history and operation of the cable car. From the first run in 1873 to the present, learn about the inventor, technologies, builders, rapid expansion, near loss and the ongoing efforts to save and rebuild the cable cars of San Francisco.

As a Bay Area native, we call the cable car, trolley train and is a fun experience to jump on and off the train, as it descends the steepest roads with stunning views.

Scoring

Chinatown 5:30pm-7pm

North America's first and largest Chinatown, is located next to North Beach and the Financial District. With its pagoda-style architecture, ornate lamp posts, exotic menus and other distinctive elements, a stop here can feel more like a trip abroad than a neighborhood stroll.

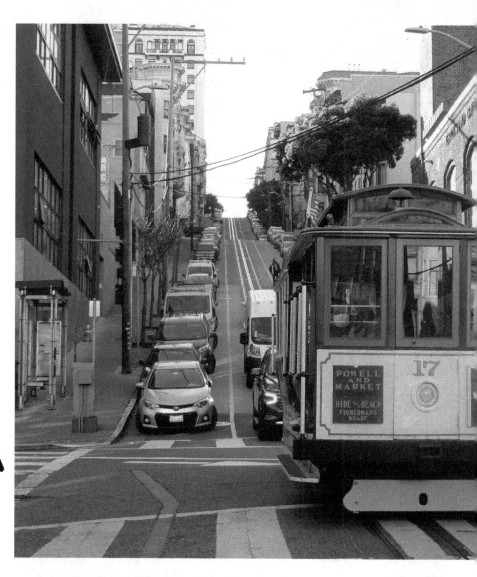

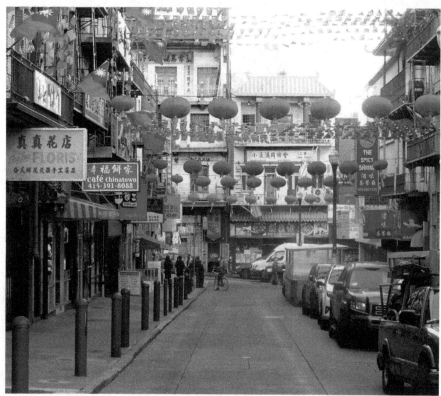

14

Let's get Cooking

FORTUNE COOKIE

Golden Gate Fortune Cookie Factory
56 Ross Alley

Why I Choice this Craft
Since the mid-1800's, San Francisco has the oldest and largest Chinatown in America, and has established a rich traditional Chinese heritage for the American-born. The neighborhoods throughout Chinatown, may feel like you're in a foreign country, which has become one of the most cherished districts in the country. Although, the fortune cookie was invented by Japanese Americans, Chinese Americans popularized the dessert throughout the country in every Chinese restaurant. One worker at the Golden Gate Factory, makes 10,000 cookies per day, while a local San Francisco college professor creates the fortune sayings inside. I'll never forget one of my fortunes that read, "you will live with no boundaries."

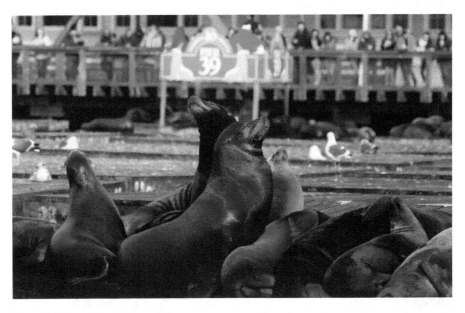

Union Square 7:30pm-8:30pm
Enjoy the night lighting of elegant shops in a city filled with great shopping. Union Square is the neighborhood with the most abundant retail therapy, not to mention fine hotels, great meals and green spaces to sit outside and enjoy San Francisco's temperate climate.

Virtually every name brand in fashion is on or near the 2.6pm-acre square, a landmark park in the heart of the downtown shopping and hotel district.

Day 2
Baking

SCOOTER THE EMBARCADERO 7am-9am
The Embarcadero is the boulevard that runs all along the waterfront of San Francisco, from the Bay Bridge, past the Ferry Building, and down to Pier 39 and Fisherman's Wharf.

Ferry Building- The city's main ferry terminal has morphed into a gourmet hotspot. Inside the building is a collection of gastronomically-interesting booths and eating places to tempt visitors with special condiments, desserts, wines, and numerous other delicacies.

Pier 39- This is the city's waterfront shopping and entertainment pier. Pier 39 marks the end of the Embarcadero and the beginning of Fisherman's Wharf.

A Tasty Choice

Parking in the city can be a nightmare, yet an unforgettable scavenger hunt. That's excluding to mention, driving the hilliest streets is challenging itself. They're so steep that you can't see the ground when driving through an intersection. There seems to never be any open spots, and when there is, the signs are not favorable. Finding space is so scare, parking at a 90-degree angle is required on the hills, so when you get out of your car, the door swings open. For parallel parking uphill, you must not forget to turn your wheels away from the curb. When parking downhill, turn the wheels towards the curb.

NEW YORK
-STYLE LEMON ICE

Chef's Note

There are two types of people; those who love to live in New York City and those that would hate it, but we can all agree it's a great place to visit. It has the highest standard for urban life; great transportation, food establishments on every corner, world-class cultural and educational centers, several professional sports teams, massive green space and beautiful views. There's no place like New York City, full of energy, tirelessly exploring the incredible diversity. This city has so much influence, underground culture becomes mainstream.

Cook Time: 24 hours

7am	Tennis lesson
11am	Hip Hop Lesson
2pm	Draw a comic
4pm	Graffiti Art
6:30pm	Cooking lesson

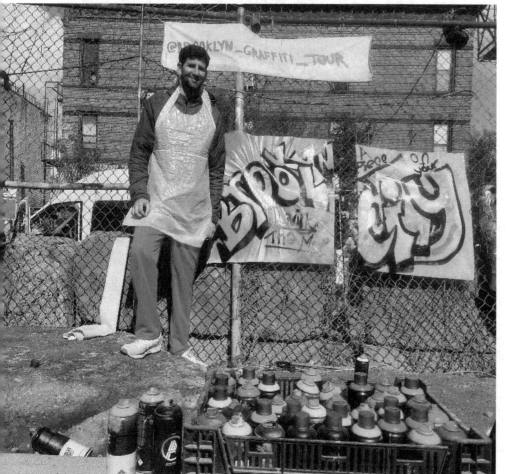

The Blender

Hilton Garden Inn Staten Island
1100 South Ave, Staten Island

Off I-278, less than nine miles from the Staten Island Ferry terminal and Newark Airport. The William T Davis Wildlife Refuge is one of the many nearby parks, far removed from the city life, almost like a suburb.

Boiling

QUEENS

Billie Jean King Tennis Center
7am-9am

Flushing Meadow - Corona Park,
Flushing

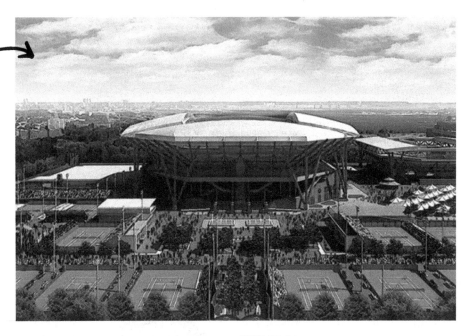

One of the world's largest public tennis
facilities, is home to the US Open and its
centerpiece arena, Arthur Ashe Stadium.
It is active throughout the year hosting
players, programs, and events on the
grounds and at its Indoor Training Center.

Take a tennis lesson and play on the
courts legends play; Pete Sampras,
Serena Williams, Steffi Graf, and Roger
Federer to name a few.

Simmering

BRONX

The Bronx House Dance Studio
11am-12pm

990 Pelham Pkwy S, Bronx

As a community center, they offer
dynamic educational, health, recreational
and cultural programs that are enriching
and meaningful.

Take a hip-hop dance class, where this
genre of music started right on these
streets and became a worldwide cultural
phenomenon.

My instructor, Thanh Woods states "hip
hop is a language, it's in the way you
move and the way you act."

Stirring

MANHATTAN

The New Yorker Magazine 2pm-3pm

1 World Trade Center

There are so many industries to explore
in this borough, whether it's finance
and banking, fashion, real estate and
of course media and publishing.

I stopped by The New Yorker, the
pinnacle for cartoonists to share their
satire on current events and politics.

Cartoonist, Adam Thompson, states "the
creative ideas can't be forced. You have
to wait, kind of like fishing. Just keep
your brain in a receptive state."

*"The interminable nightmare we're all living
through ate my homework."*

Freezing

BROOKLYN

Brooklyn Unplugged Tour and
Graffiti Art 4pm-5pm

100 Bogart St, Brooklyn

Wherever you walk in this borough,
notice graffiti on every inch of wall,
doors, trains, even cars and trucks. New
York City is the hub of graffiti art and a
form of expression and community. Try
your hands on spray painting your own
canvas.

I met with artist, Caty Wooly shares
"much of the art is not tagging as you
would think, but organized and permitted
by each neighborhood and attracts
artists from around the world."

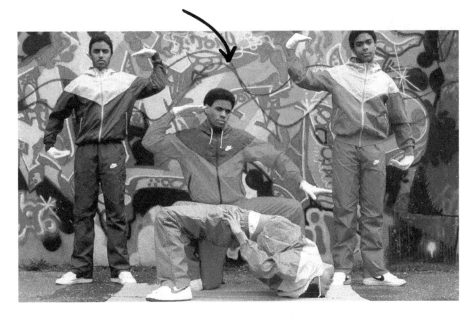

NEW YORK
-STYLE LEMON ICE

Shaving

STATEN ISLAND

Casa Belvedere 6:30pm-8pm

79 Howard Ave., Staten Island

The Italian Cultural Foundation at Casa Belvedere celebrates everything Italian via a myriad of exceptional public program offerings: language and cooking classes; art and photo exhibits; film and fig festivals; opera luncheons and casino nights; Italian car shows and fashion shows; live concerts and theatrical performances; guest chef experiences and wine tastings; Bocce to bingo (tombola) ... it all happens at Casa Belvedere!

Built by the Roebling-Stirn family in 1908, this Italianate-style, neo-Renaissance building is one of the few remaining of its kind in New York City. This multi-million-dollar rehabilitation project began in 2010 and is ongoing.

Casa Belvedere (house with a beautiful view) has established itself as a vibrant and buzzing community cultural center and an anchor in the community.

I had a chance to make pesto pomodoro with Chef James Paone. "We have the highest concentration of Italians in America, and we want to pass on our heritage through this center"

A Tasty Choice

Although one of the most diverse cities in the world, most people have personalities alike. Loud, expressive, open, prideful, opinionated are just some to describe New Yorkers. It might seem hard to get into a conversation, since the pace is quick and busy, but once you're in one, it's just as hard to get out. New Yorkers love visitors, even more so outside of Manhattan. They might not crack a smile, but their big and unique personalities will give you one.

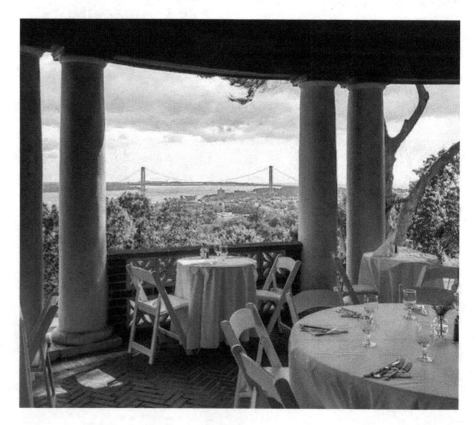

FRIED
LOUISVILLE

Chef's Note

Louisville is a prime example of how a city's long-standing traditions can turn into internationally recognized brands. The Kentucky Derby, the Louisville Slugger, Kentucky Fried Chicken, and the Bourbon Trail; these brands will always be associated with Louisville throughout our lifetime and beyond, the notoriety many cities strive towards. Louisville isn't settling, as the city continues building new traditions, uniquely blending the Midwest and the Southern culture into a charming destination.

Cook Time: 24 hours

7am	Cherokee Park
10am	Bourbon Tour
12pm	Muhammad Ali Center
3pm	Drive S. 3rd St.
6pm	Big Four Bridge and the Waterfront Park

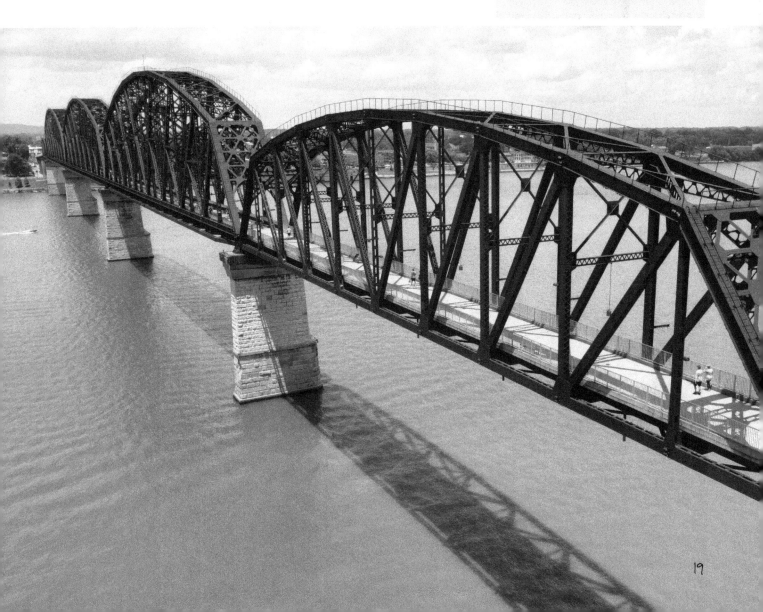

FRIED
LOUISVILLE

The Deep Fryer
Hyatt Regency
320 W Jefferson St.

Stay in the heart of downtown Louisville, next to 4th Street Live, and within walking distance to all the top Louisville attractions. The lobby is massive, elevators run high, and the quality of service is fantastic. Expect a busy hotel, since there are many floors and rooms, but it's a great way to spark up a conversation with other visitors. Request a room with the view of the Ohio River.

Coating
Cherokee Park 7am-8:30am
745 Cochran Hill Rd.

Start your day off right, exploring one of the many great parks in Louisville. Try the Scenic Loop at Cherokee Park, a 2.3 mile trek around with lanes for cars and pedestrians. This park is one of the original parks that Frederick Law Olmsted designed, which includes a lush meadow over the rolling hills surrounded by the Beargrass Creek Valley forest. This park has sunny grass fields and shady dense forests.

Marinating
Old Forester Bourbon Tour 10am-11:30am
119 West Main St.

In 1870, George Garvin Brown signed and sealed Old Forester with a promise: a guarantee of the finest quality and utmost consistency. Five generations and 150 years later, they've returned to Whiskey Row. On your tour, see fermentation, distillation, barrel making, maturation & bottling. Tasting rotation changes and includes (4) expressions.

Muhammad Ali Center 12pm-2pm
144 N. Sixth St.

A cultural attraction and international education center that is inspired by the ideals of its founder Muhammad Ali. The Ali Center's innovative and immersive visitor experience, public and educational programming, and global initiatives carry on Muhammad's legacy and inspires exploration of the greatness within ourselves. Two-and-a-half levels of award-winning exhibits introduce Ali's epic life through six core values: respect, confidence, conviction, dedication, giving, and spirituality. The Ali Center includes an amazing five-screen orientation theater film, historic Civil Rights era media footage, an interactive timeline of Ali's life, video of Ali fights, hands-on boxing fun, two art galleries, children's Hope and Dream wall, retail store, cafe and more.

Local Inspiring Flavors

Breakfast
Morning Fork Louisville
1722 Franklin Ave.

Get a chance to explore the Butchertown and NuLu Districts, by eating at Morning Fork. They've whipped up some really exciting dishes, both traditional, tried-and-true classics and unique, one-of-a-kind creations, that are sure to please everyone. They've worked tirelessly to create a menu they're sure you will love!

Lunch
Logan Street Market
1001 Logan St.

20+ Local Chefs, Artisans, & Merchants. In-house restaurants for dining, specialty crafts and wares. A fun atmosphere, whether you choose to be inside or outside.

Dinner
Guy Fieri's Smokehouse
434 S.4th St.

Award-winning chef, restaurateur, author and TV personality, Guy Fieri brings his dining concept, Guy Fieri's Smokehouse, to Fourth Street Live!.

Inducted into the American Royal BBQ Hall of Fame in 2012, Guy Fieri's passion for BBQ is heavily influenced in this flagship location. The restaurant features 6,700 square feet of dining space, an enclosed patio, a large smoker custom-made by Ole Hickory and two bars.

"I am the greatest, I said that even before I knew I was." Muhammad Ali

Whisking

Drive S. 3rd Street 3pm-5pm

Explore many of the main features and neighborhoods of Louisville on one street. From downtown, take 3rd Street to the University of Louisville and then to Churchill Downs, where they run the Kentucky Derby. On the way back via S. 2nd Street, make sure to stop and see the most elegant neighborhood in the country, St. James's Ct. You won't be disappointed. Beautiful water features within a promenade and lamp posts with gas lighting in a neighborhood filled with historic mansions.

Coating

The Big Four Bridge and the Waterfront Park 6pm-8pm

Walk 1/2 mile across the Ohio River connecting Waterfront Park to Jeffersonville, Indiana. A treasured destination in Louisville, the bridge is the perfect spot to watch the sunset.

Constructed in 1895 as a railroad bridge, the Big Four Bridge first provided rail access for freight and passengers traveling between Louisville and Southern Indiana. The bridge operated until 1969 when it was decommissioned, the ramps removed several years later. This is a must, since the views are stunning and a chance to walk between states over the iconic Ohio River.

The waterfront park is wide, perfect for festivals and concerts. It's also very long, as you can choose to walk along the Ohio River for miles.

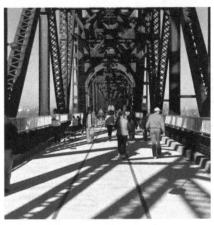

Let's get Cooking

LOUISVILLE SLUGGER BAT

The Louisville Slugger Factory & Museum

800 W. Main St.

Why I Choice this Craft

Whether you're a fan of baseball or not, the Louisville Slugger is an American symbol. Get ready to smell the wood, see the wood chips fly, and learn about the making of baseball bats since 1884, when 17pm-year-old Bud Hillerich crafted the company's first bat for a local superstar hitter. The rest is history. The sport's biggest stars had custom made bats throughout their careers, totaling 3,000 types of bats.

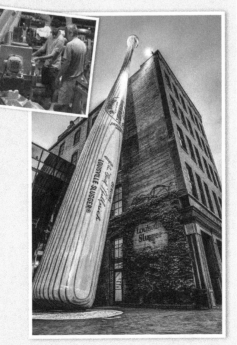

A Tasty Choice

The Louisville Slugger's brilliant advertising has influenced several other companies in the city to feature their product outside their business. An enormous bat sits against the brick walls, outside the entrance of the Louisville Slugger, letting potential customers know what they produce. Now, you can find other enlarged products parked against the entrances of other companies.

ATLANTA & WAFFLES

Chef's Note

Take notes because Atlanta doesn't need a large body of water to prove it's a world class city. It's all done right; starting with the charisma of people, to the charm of the neighborhoods, love for its nature, exhilarating nightlife, trendy shops, reflections of history, and revolutionizing health and sciences. The city wasn't large enough to contain such wonders, having to expand its creation into sprawling suburbs. Atlanta has a surprise around every corner and up every hill, eagerly inspiring exploration of every nook and cranny.

Cook Time: 24 hours

	
8am	Freedom Park
10am	MLK Legacy Sites
12:30pm	Centennial Park
4pm	Buckhead and Lennox Square
7pm	Fox Theatre

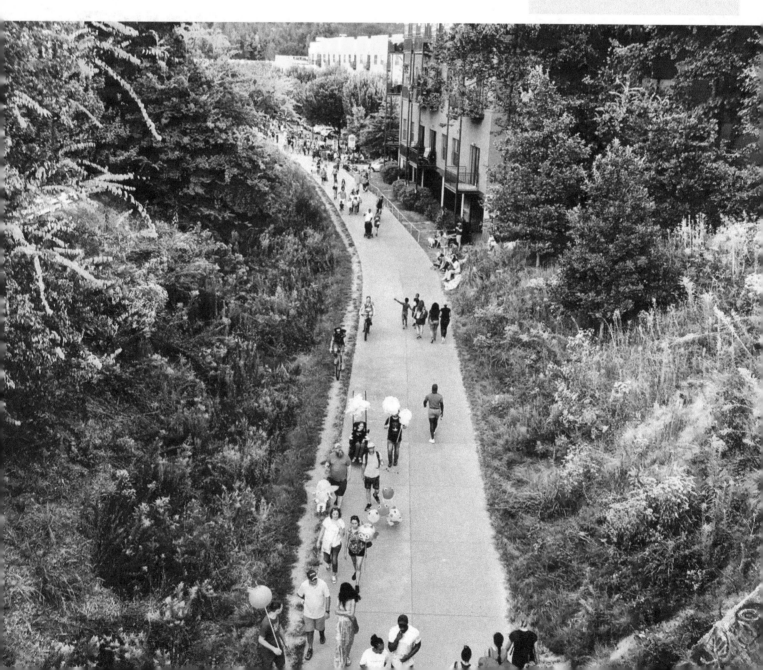

The Waffle Iron

Element Atlanta Midtown
640-2 Peachtree Street

Element Atlanta Midtown is designed for today's healthy, active traveler who wants to maintain a balanced lifestyle while on the road. Element invites guests to settle into a nature-inspired design that is clean, modern, and bright. Guestrooms feature spacious and airy studios and one-bedroom suites which are outfitted with fully equipped kitchens, spa-inspired bathrooms, and signature Heavenly® Beds. You're in the center of it all with views of the city that light up your room. Rise up to our signature Rise complimentary breakfast and enjoy Element's eco-conscious practices and programs designed to fit an active lifestyle and ensure a smarter, better way to stay. The service by the staff, makes you feel treated like a family member.

Pre-heating

Freedom Park 8am-9:30am

Atlanta's most connected park, linking together seven of the city's most historic and desirable neighborhoods—Candler Park, Little Five Points, Inman Park, Old Fourth Ward, Poncey-Highland, Virginia Highlands, Druid Hills, and Lake Claire. Located at the intersection of Moreland Ave and North Ave in Atlanta, Georgia, Freedom Park's 200+ acres boast eight miles of gently curving paths for walking, jogging, and bicycling.

Freedom Park is aptly book-ended by National Parks sites dedicated to Jimmy Carter and Martin Luther King Jr., two American treasures and national leaders, both awarded the Nobel Prize for Peace. The park overlays the first completed section of the Atlanta BeltLine, connecting community business and neighborhood assets with ease.

The vision for the Conservancy is to continue to develop the park into an innovative green space celebrated for its inspiring origin and beauty—for all of Atlanta and the world to enjoy.

Local Inspiring Flavors

Lunch
The Varsity
61 North Avenue

The Varsity in downtown Atlanta is the original, world famous location. This enormous restaurant sits on 2 city blocks and can accommodate 800 diners inside. Opened in 1928, this store quickly gained the reputation of being "the world's largest drive in". At The Varsity Atlanta they are dedicated to living up to our slogan "The FUN place to eat!" In Georgia, The Varsity is a family tradition, no trip to Atlanta is complete without a hot dog, some rings and an FO!

Dinner
South City Kitchen
1144 Crescent Ave. NE

South City Kitchen Midtown serves Southern classics with a sophisticated spin from an iconic bungalow in the heart of Midtown Atlanta. Since opening more than two decades ago and changing the landscape of Southern cuisine and the Atlanta restaurant scene, they've been serving signature dishes like fried chicken and shrimp & grits alongside innovative, inspired regional cuisine.

Their nationally-recognized food and wine list and service come together seamlessly for weekday lunch, weekend brunch, nightly dinner and group dining events.

Whether you're in Atlanta on business, enjoying a romantic night out on the town or meeting up with friends before a show, dine with them and enjoy the best contemporary southern food in Atlanta.

ATLANTA
& WAFFLES

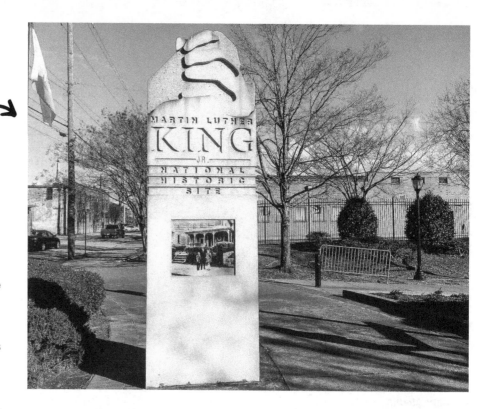

Whisking

Martin Luther King Legacy Sites
10am-11:30am

"I have a dream!" started right here in Atlanta, the birthplace of Martin Luther King Jr. The man that has forever changed human civility, as every person subconsciously hears his voice of fighting for equality.

Within a few blocks, see the home where MLK first lived, Ebenezer Church where he was a co-pastor, and his tombstone along with his wife's. This National Park is a great site to draw inspiration from his profound statements.

Beating

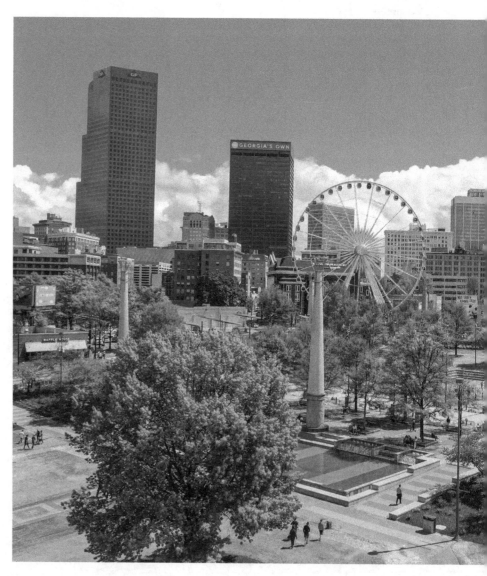

Centennial Park 12:30pm-3:30pm

No trip to downtown Atlanta is complete without a visit to Centennial Olympic Park, a 22pm-acre green space that serves as Georgia's legacy of the 1996 Summer Olympic Games. The park is home to:

The World of Coca-Cola -Spend the day interacting with multiple exhibits, learning about the storied history of the iconic beverage brand, and sampling beverages from around the world. See the vault the holds the secret ingredient.

Georgia Aquarium - Inside you'll discover more than 10 million gallons of water, home to more animals than at any other aquarium.

The National Center for Civil and Human Rights- A museum and human rights organization that inspires people to tap their own power to change the world around them. The Center's iconic exhibitions feature the papers and artifacts of Dr. Martin Luther King, Jr.; the history of the US civil rights movement; and stories from the struggle for human rights around the world today.

Coating

**Explore Buckhead and Lennox Square
4pm-6pm**

Atlanta's Buckhead and its elegant
residential streets are tree-lined and
full of some of the most remarkable
architecture and landscapes in all the
south, including its most prized home
the Swan House, located at the Atlanta
History Center.

Visitors will find the trendiest of fashions
and a variety of popular brands at Lenox
Square, Phipps Plaza and Buckhead
Village District. Buckhead dining ranges
from casual eats to gourmet fare from
Atlanta's culinary icons and best new
chefs. And as the sun sets, Buckhead's
hotel bars and rooftop lounges mix the
right ingredients for a memorable night
out on the town.

Let's get Cooking

MARTIN LUTHER KING JR. 3D METAL SCULPTURE
Carl Moore Custom Metal Work

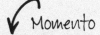
Momento

Why I Choice this Craft
Inspired to duplicate Xavier Medina-
Campeny's striking Atlanta sculpture,
I contacted Carl Moore, a local metal
artist. No person has had more of
an impact on a city, quite like Martin
Luther King. It was clear to make
a piece reflecting his character.
Four hours of cutting, bending, and
polishing metal, I made a heavy piece
of Atlanta's history.

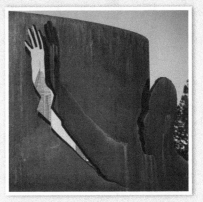

Frying

Watch a Show at Fox Theatre 7pm-9pm

660 Peachtree St. NE

The historic Fox Theatre is one of Atlanta's premiere venues for live entertainment.
The Fox's 4,665 seat theatre hosts more than 150 performances a year ranging from
Broadway to rock to comedy to movies. Billboard Magazine ranked the Fox Theatre
in Atlanta as "The #1 non-residency venue worldwide for the decade (5,000 seats or
less)."

A Tasty Choice

In Atlanta, the "City in a Forest," trees play the roles of landmarks, friends, celebrities,
teachers and time capsules.

Many are survivors – of war, tornadoes, fires and living room additions. Sprawl is a
frenemy, clearing wide swaths in some parts of town and in others, sparing pockets of
forest that would be more densely developed in other cities.

PHILADELPHIA
CHEESESTEAK

Chef's Note

Philadelphia is the 'Jerusalem' of America, highlighting sacred sites to our nation's history. Known as being the Birthplace of America, where the Declaration of Independence and the Constitution were signed, the stitching of the American flag and home of the first U.S. Mint, it's no wonder squares, parkways, and campuses throughout downtown, are designated to commemorate the pivotal events that shaped our nation. Considering the rich history, it's hard to find a more prideful city behind its food, sports, and personalities.

Cook Time: 24 hours

	
7:00am	Go for a drive
8:00am	Fairmount Park
11:00am	The Betsy Ross House
12:30pm	Independence Hall
2:00pm	Ben Franklin Blvd.

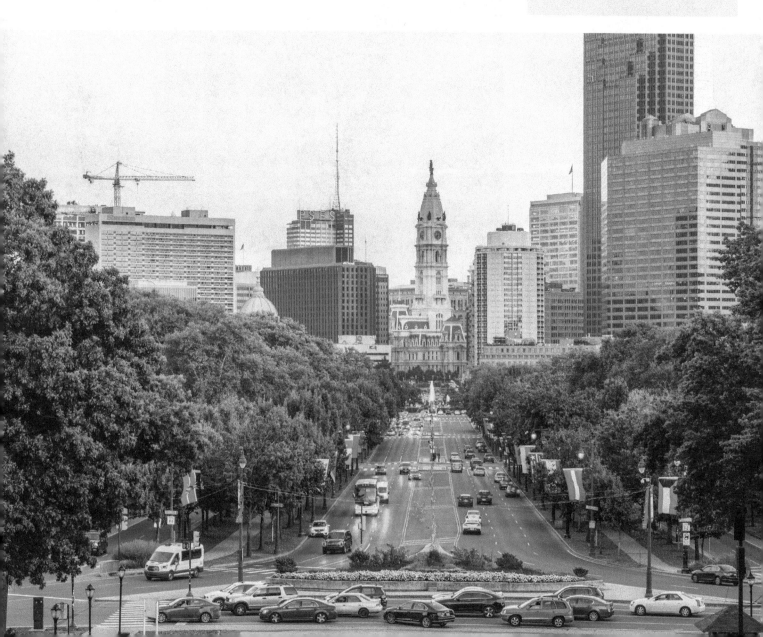

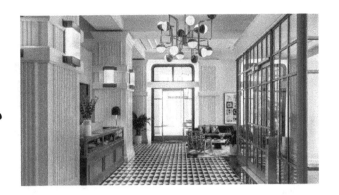

The Griddle

Canopy by Hilton City Center

1180 Ludlow Street

Once the historic Stephen Girard Building, their 19th-century hotel sits in Philadelphia's Midtown Village neighborhood. They're circled by dining, two blocks from Reading Terminal Market, and a half-mile from Independence Hall. Grab a complimentary Canopy Bike to explore the area, and enjoy our 24pm-hour fitness center and a welcome gift. You'll love the lobby and the restaurant ambience.

Slicing and Dicing

Drive from the Northside of Philadelphia down W. Roosevelt Blvd. 7:00am-7:45am
Get a glimpse of rowhomes from different eras as you descend part of America's first highway. I'm fascinated by the entrances and exits of the Blvd, where you can still drive parallel with the Blvd. but at slower speeds. It's a bit confusing for first timers. You'll find the area is more representative of residential Philadelphia than the City Center.

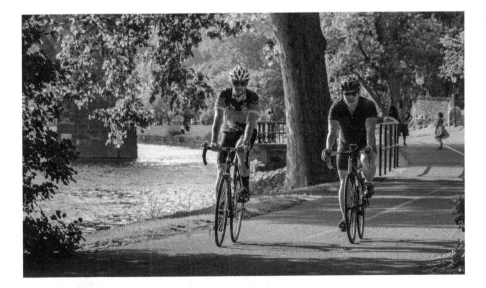

Sautéing

Fairmount Park 8:00am-10am
With more than 2,000 acres of rolling hills, gentle trails, relaxing waterfront and shaded woodlands, Fairmount Park keeps a wealth of natural landscapes in East and West sections of the park, divided by the Schuylkill River.

Kelly Drive is a popular stretch to enjoy navigating through gardens, sports fields, museums, and a natural rock tunnel. Fairmount has so much energy and excitement, it should be illegal.

Local Inspiring Flavors

Breakfast
Reading Terminal Market
51 N 12th Street

One of America's largest and oldest public markets, housed since 1893 in a National Historic Landmark building, the Market offers an incredible selection of locally grown & exotic produce, locally sourced meats and poultry, plus the finest seafood, cheeses, baked goods, and confections. You'll find everything you need to create a memorable meal, from cookbooks, to table linens, to kitchenware, to fresh cut flowers, and more. Plus, the widest variety of restaurants under one roof.

Lunch
Pat's or Geno's
Genos: 1219 S 9th St
Pats: 1237 E Passyunk Ave.

Rivalries come easy when you're across the street from one another and both claim to make the best Philly Cheesesteaks. Grab one of America's notable sandwiches and enjoy an authentic setting.

Dinner
Take a stroll through the walkable and charming streets of City Center West. Plenty of food establishments and other storefronts to explore.

PHILADELPHIA
CHEESESTEAK

Caramelizing

Tour the Sites that influenced America's history –
The Betsy Ross House 11am-12pm
239 Arch St

Meet Betsy Ross, where she'll explain how she was selected to make the American flag, at the time an act of treason. Walk around her modest home and learn about the active neighborhood streets of Philadelphia in the late 1700's.

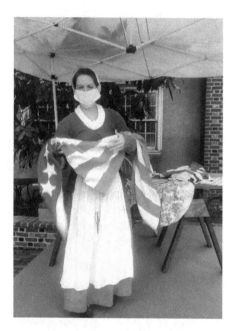

Independence Hall 12:30pm-1:30pm
520 Chestnut Street

Everyone is lining up to see the Liberty Bell and walk the civic building where the Declaration of Independence and Constitution were written and adopted.

Ben Franklin Parkway 2pm-4pm
One of the most fascinating boulevards in America. Start from City Hall, a massive architectural wonder with a roundabout like a European city center. Continue down to grand fountains and museum lovers' paradise. Catch flags from every country until you reach the iconic Rocky Steps at the Museum of Art.

Let's get Cooking

Momento

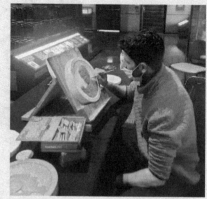

ENGRAVING U.S. CURRENCY
U.S. Mint
151 N Independence Mall E

Why I Choice this Craft
Philadelphia is home to the first and largest U.S. Mint and considering the history of the city, I wanted to make one of the million coins per thirty minutes. I had always wondered how the art was enacted on the currency, the artist's craft and the process of printing. I met with engraver Renata Gordon who walked me through her clay work, using fine utensils that take up to 3 weeks to create a mold. I left with a precious medal with the image of the U.S. Mint.

A Tasty Choice

Philadelphia's city landscape and architecture is incredibly diverse. Old and new co-exist to give this city so much character it blows my mind. You'll find some of the most tight and narrow historic brick streets, where only pedestrians can traverse to a sprawling modern downtown with wide streets and enough room for massive fountains. The number one feature are the 'squares' throughout the city streets, mostly consisted of brick paths leading to a center fountain, lush green space, and plenty of seating. It's a charming square block escape.

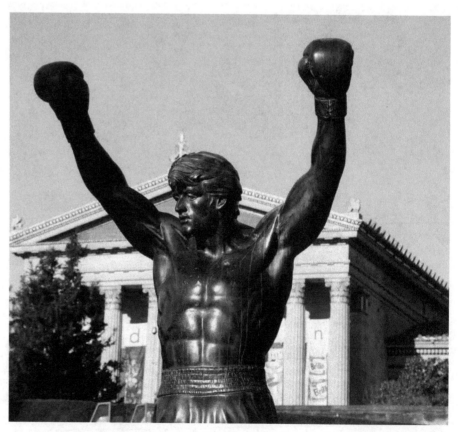

CHARLESTON
& GRITS

Chef's Note

America is fortunate to have a city like Charleston. It's a city that gives a feeling. The elegance of the pastel antebellum homes, the charm of the evening lighting, the sway from the breeze of the Palmetto trees, the manicured ivy stairways, the rumble of the cobblestone streets, and the inviting smiles from the locals all attribute to a class of its own. There is no mistaking the impression that the city wants to leave; inviting. Dress well.

Cook Time: 24 hours	
7am	The French Quarter
10am	City Market
2pm	Boone Hall Plantation
5pm	Sullivan's Island

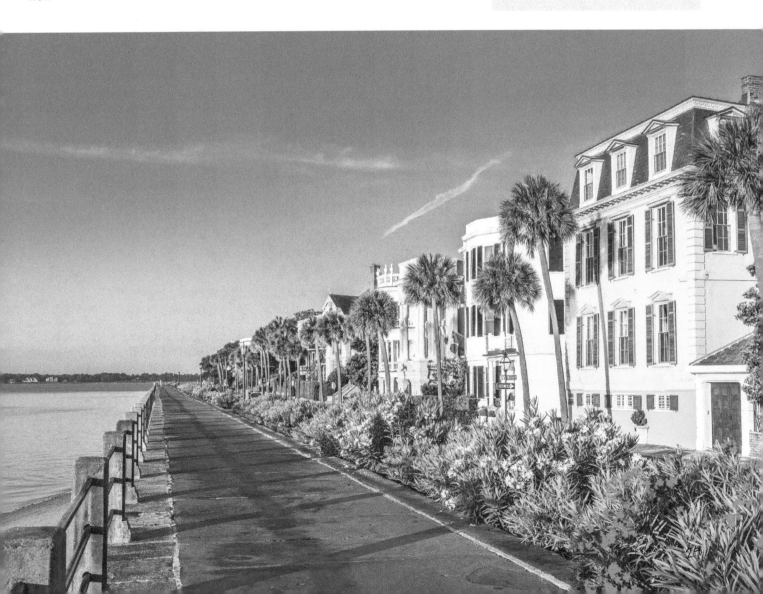

CHARLESTON
& GRITS

The Skillet

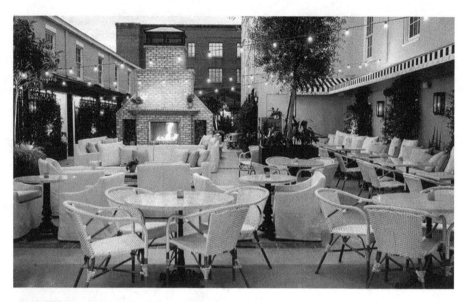

Hotel Emeline
181 Church Street

For the soulful sojourner, for the inquisitive local. For those who seek the new over the known, while wandering through the past. From their perch in historic downtown Charleston, welcome to Emeline. Wake to the sound of hooves on cobblestones and ringing church bells. Emeline will be a gracious host. Custom linens, local flair, modern necessities. And of course, a team that embodies the epitome of Southern hospitality.

Boiling

Run/Walk the French Quarter 7am-9am
Start from Washington Park, head North on Meeting St. to Marion Park. Circle back down the commercial street, King St. and head South to The Battery. This area is a landmark defensive seawall and promenade in Charleston, South Carolina, famous for its stately antebellum homes. Named for a civil-war coastal defense artillery battery at the site, it stretches along the lower shores of the Charleston peninsula, bordered by the Ashley and Cooper Rivers, which meet here to form Charleston harbor.

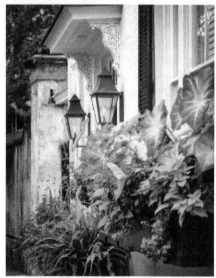

Whisking

City Market 10am-11:30am
The Historic Charleston City Market is one of the most visited places in Charleston. You may hear people refer to it as the "slave market" but no slaves were ever bought or sold here. This was actually the market where slaves bought things like meat, vegetables and seafood for the plantation. Today visitors and residents flock to the market to buy souvenirs, crafts, woven baskets, jewelry, clothing, sweets, and artwork to name a few. Take a stroll through the market to experience Charleston's true Southern charm or stop by one of the numerous restaurants to experience a truly culinary experience.

Local Inspiring Flavors

Lunch
Page's Okra Grill
302 Coleman Blvd., Mt. Pleasant, SC

Combines simple Southern cuisine with the casual elements of traditional coastal seafood. We look to use fresh, seasonal, local ingredients in our made-from-scratch dishes wherever we can. While our kitchen partners with local farms and seafood suppliers, our bar program follows suit and focuses on local spirits and craft breweries. Come join us for breakfast, lunch and/or dinner and let our professional and courteous staff show you true Southern hospitality.

Dinner
Frannie & The Fox
181 Church Street

For the adventure seeking, campfire loving, culinary enthusiast in us all, Frannie & The Fox presents a wood burning concept of shareable dishes. Whether you find yourself a guest of Emeline or a local to the Charleston area, we hope you find a warm and engaging environment that suits you any time of day.

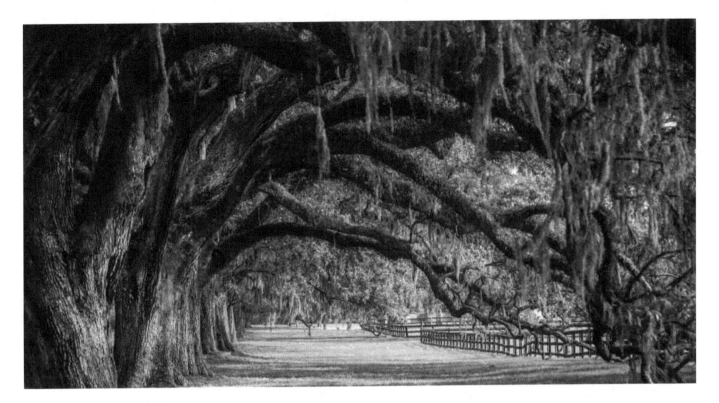

Browning

Boone Hall Plantation & Gardens
2pm-4pm

235 Long Point Rd., Mt. Pleasant, S.C.

Founded in 1681 when Englishman Major John Boone came to Charleston and established a lucrative plantation and gracious home on the banks of Wampacheone Creek. The family and descendants of Major Boone were influential in the history of South Carolina, the colonies and the nation. In 1743, the son of Major John Boone planted live oak trees, arranging them in two evenly spaced rows. This spectacular approach to his home symbolizes southern heritage and will take root in your memory for many years to come. It would take two centuries for the massive, moss-draped branches to meet overhead, forming today's natural corridor.

Stirring

Take a Walk on Sullivan's Island
5pm-7pm

Nestled at the mouth of the Charleston Harbor and neighbor to the Isle of Palms, Sullivan's Island is an inviting mix of wide beaches and watersports, history and folklore, local restaurants and shops, peace and perfect.

Let's get Cooking

SWEETGRASS BASKET
Ophelia's Sweetgrass Baskets
City Market

Why I Choice this Craft
With more than 50 resident Gullah artisans, the Charleston City Market is the very epicenter of sweetgrass basketry, one of the nation's oldest and most beautiful handicrafts of African origin.

For more than 300 years, people in Charleston have been weaving baskets using locally-harvested bulrush, a strong yet supple marshgrass that thrives in the sandy soil of Lowcountry. Originally used as winnowing fans to separate the

Momento

rice seed from its chaff, sweetgrass baskets are regarded among the nation's most prized cultural souvenirs.

A Tasty Choice
Charleston's flickering gas lanterns beside each exterior doorway, creates the appeal of timeless romance. It's a calming element that makes any evening stroll in Charleston one to remember. The history of the streets speaks through its flames.

MINNEAPOLIS
WALLEYE OVER
ST. PAUL WILD RICE

Chef's Note

They're not exactly identical twins, but there's no mistake, St. Paul and Minneapolis are siblings. Just listen to their bicker. Minneapolis: I have the Vikings, Twins, and Timberwolves. St. Paul: Don't forget, Minnesota is the hockey state, so what matters is the Wild. I have them. Plus, I have the nation's best State Fair and the Winter Carnival. Minneapolis: Let's not go there. I have the Chain of Lakes and the first bridge to cross the Mississippi River. I have the Basilica and the University of Minnesota. St. Paul: First off, I have their campus too, and home to many private universities. Second, I have the Cathedral. I didn't want to throw this card, but I am the Capitol City. Minneapolis: I was going to say, Target, US Bank and General Mills. One thing the Twin Cities can agree on, there's a special connection, offering both a winter and summer version of themselves. Minneapolis on the westside and St. Paul on the eastside of the river have so much going on, giving people a fear of missing out, wanting to be in all places at one time.

Cook Time: 30 hours

7:30am	Cathedral of St. Paul
9:30am	Mississippi River Blvd.
11am	Stone Arch Bridge
1:30pm	Bike the Ground Rounds/ Chain of Lakes
4:30pm	Uptown Minneapolis
9pm	First Ave.
Day 2	
9am	The Skywalks

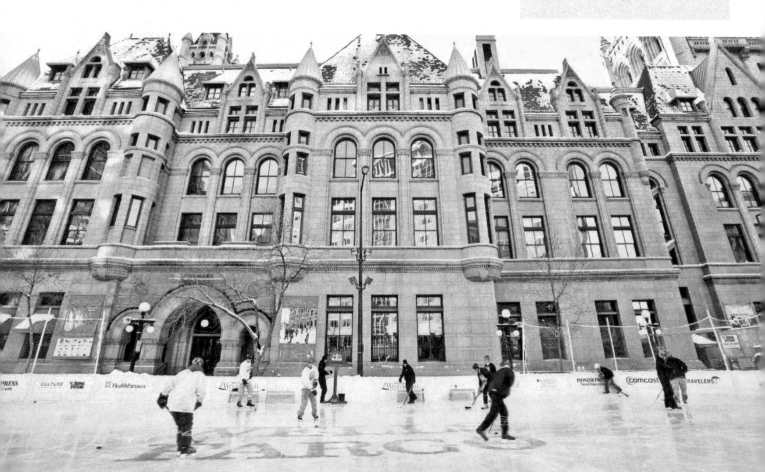

The Instant Pot

SpringHill Suites, St. Paul Downtown
472 Jackson St, St Paul

In a city of brewpubs and venerable avenues, notable museums and Gilded Age mansions, this hotel welcomes you to the historic Lower town area. Their new, custom-built hotel of 185 suites and upscale amenities, including heated, connected self-parking; a full-service bar with heated patio and fireplace; a massive lobby space, a state-of-the-art, zero-entry "Cool Pool" with splash features; and a premium fitness room with Matrix professional-quality equipment. Spacious suites offer 400 to 500 square-feet and impressive access to the Saint Paul RiverCentre and TRIA Rink St. Paul, as well as the Minnesota State Capitol, Xcel Energy Center, and CHS Field.

The Frying Pan

AC Hotel, Minneapolis Downtown
401 Hennepin Ave, Minneapolis

Located in the Hennepin Theatre District, guests enjoy the great proximity to all that downtown Minneapolis has to offer. From check-in to check-out, they've carefully curated each element of their hotel to provide a sophisticated retreat that's rich in style and substance. Their contemporary rooms feature upscale amenities. You'll also enjoy a European breakfast from the AC Kitchen, tapas and evening drinks at the chic AC Lounge, or walk to one of Minneapolis's fine dining restaurants nearby. Conveniently located, the hotel is just blocks from Target Field, Target Center, US Bank Stadium and Nicollet Mall.

Local Inspiring Flavors

Breakfast

Summit Hill is a highly concentrated down to earth neighborhood district. This neighborhood is famous for its regal Summit Avenue, a boulevard boasting the best preserved collection of Victorian mansions in the country and Grand Ave. is filled with boutique shops and restaurants. There are plenty of walkable spots to choose a meal to start the day.

Lunch

Aster Cafe

125 SE Main St. Minneapolis

Located under the trees on the prettiest street in Minneapolis. Overlooking the mighty Mississippi river and the skyline of the city, the Aster is a candle-lit restaurant-bar with a sweet European patio. Live music, great brunches, craft beers and cocktails, and a thoughtful wine. Their menu is fresh (no deep fryers!) and inventive.

Dinner

Lurcat Bar and Café

1624 Harmon Place, Minneapolis

Viewing the beautiful Loring Park, Lurcat is a hip, urban venue that boasts serious food and voguish design. A perfect blend of classic old world style with a Noveau twist. The expansive bar and lounge is ideal for casual cocktails and a la carte bites, while the romantic dining room creates the perfect ambiance for an exceptional foodie experience featuring sophisticated comfort food. Be impressed by the ambiance and decorative lighting.

MINNEAPOLIS
WALLEYE OVER
ST. PAUL WILD RICE

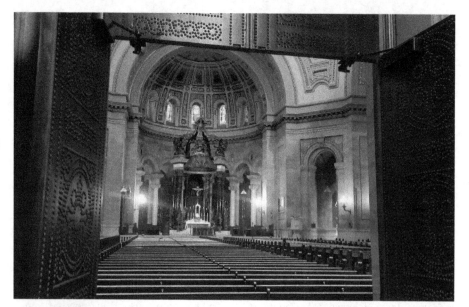

Beating

Cathedral of Saint Paul 7:30am-8:30am
239 Selby Ave. St. Paul

The Cathedral dominates the Saint Paul skyline and is situated on the highest point in downtown Saint Paul, Minnesota. It's almost identical to the majestic Capitol Building, making for an old European feel to the city. For the wider community, as well as for parishioners, the Cathedral provides opportunities to enhance their appreciation for the arts. The parish hosts a regular organ concert series showcasing the Cathedral's two Skinner organs. The Minnesota Orchestra and Vocal Essence are some of the groups that present concerts at the Cathedral each year.

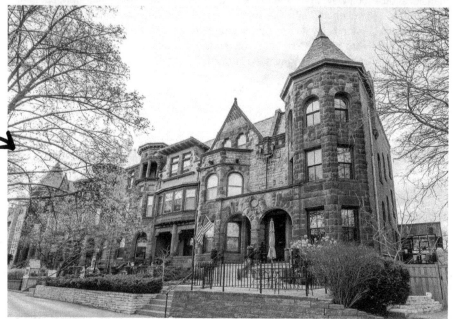

Drive Mississippi River Blvd.
9:30am-10:30am
One of the most beautiful neighborhood drives in the country, providing a grand view of the Mississippi River. This windy road lined by impressive historic mansions with extensive front lawns, also has a separate biking path, making for a tranquil experience. The road connects both cities with options to take one of many bridges across.

Combining

Stone Arch Bridge 11am-1pm
100 Portland Ave. Minneapolis

One of the most iconic landmarks in Minneapolis, is this former railroad bridge that crosses the Mississippi River and connects you to some of the most beautiful parts of the city. Walk across the Stone Arch Bridge to get breathtaking views of the downtown skyline, the waterfalls of the Mississippi River and the natural beauty that you typically don't find within a city. Theoretically, you're walking from the East Coast to the West.

On the east side, you'll find St. Anthony Main, a pocket of Northeast Minneapolis and the oldest part of the city. Walk down the cobblestone road and find plenty of patio drinkers, movie-goers and people-watchers. Take a stroll down to Water Power Park and find a gorgeous view of the River and St. Anthony Falls with a striking backdrop of the skyline. If you're feeling more adventurous, head over to Father Hennepin Bluff Park and walk out onto the footpaths and bridges to get a close-up of the Mississippi and Stone Arch Bridge. Also, you're just a few steps from Nicollet Island, which is actually an inhabited island on the river.

Bike the Grand Rounds/Chain of Lakes
1:30pm-4pm

America has no better urban biking trail system than the Grand Rounds, encompassing natural features, including lakes, creeks, woodlands, riverbanks, and wetlands, as well as constructed features, like canals, lagoons, greenways and parks, playgrounds, parkways, trails, golf courses, athletic fields, picnic grounds, gardens, and bridges.

This 51pm-mile loop might be a bit much, but the Chain of Lakes (10+ miles) is all you need in life. The Chain includes; Cedar Lake, Lake of the Isles, Lake Calhoun, and Lake Harriet. If you want to extend the ride, head to Lake Nokomis byway of the Minnehaha Creek Trail. The perimeter or shoreline of each lake offers something completely different, from the most affluent neighborhoods in the state, beaches, museums, rose gardens, performing stage, ice skating, and tons of people watching. These are active trails and one of the best natural features of any city to enjoy.

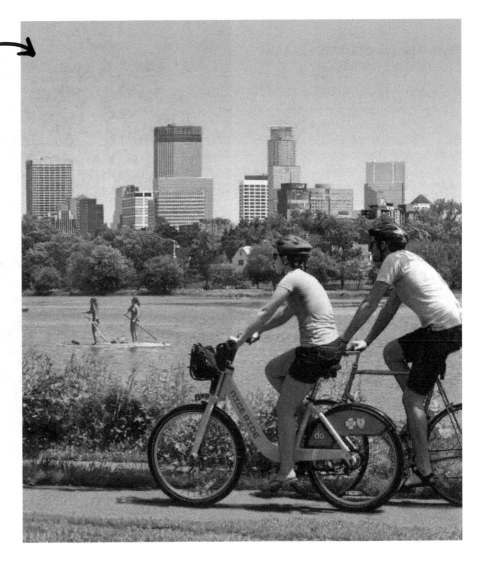

Dipping

Explore Uptown Minneapolis 4:30pm-6:30pm

Uptown is quite possibly one of the most urban areas in the entire great state of Minnesota. By definition, it functions almost as its own mini-city, and is certainly one of the liveliest communities in the Twin Cities metropolitan area. Along Lyndale Ave. and Hennepin Ave., you'll find this walkable district at its best.

Lake Harriet, Lake of the Isles, and Cedar Lake are only a few blocks away, making Uptown's tree-lined streets both welcoming and walkable— where the blues meet the greens. The mixture of housing, from studio apartments to lakeside mansions, offers much in the way of diversity, and one can take their pick from an array of bookstores, one-of-a-kind specialty shops, theaters, and locally owned restaurants and corner cafés.

In addition to shopping, dining, and entertainment, Uptown is an urban oasis reflecting the attitudes, landscapes, and spirit of a multi-disciplined and layered community. The Uptown area captures attention year-round simply because it's Uptown—intriguing and inviting, established and new, bohemian and fabulous. It is an eclectic mix that attracts businesses, residents, and visitors alike.

MINNEAPOLIS
WALLEYE OVER
ST. PAUL WILD RICE

Dance at the Iconic First Ave. 9pm-11pm
701 N. First Ave. Minneapolis

Celebrated as one of the longest-running, independently owned and operated venues in the United States. Their commitment to independence is led by the belief that unique, locally-owned live music rooms are imperative to the health of the community and economy. First Avenue is dedicated to promoting artistic expression in diverse voices old and new, to provide a community by offering artists a stage and a mic, and fans a place to gather.

As the musical epicenter of the Twin Cities, First proudly fosters relationships with artists and musicians at all stages in their careers, whether it's playing their first show at the 7th St Entry, selling out multiple nights at First Avenue, or playing one of our other independently owned venues like Turf Club, Fine Line, The Fitzgerald Theater, and the co-operated Palace Theatre.

First Avenue has served as the launching pad for countless artists and bands like Hüsker Dü, the Replacements, Semisonic, Hippo Campus, Soul Asylum, Lizzo, Prince, and many more.

Day 2
Flipping

The Skywalks 8am-10am
Get a sense of the morning pedestrian rush hour inside the skywalks. Did you know that you can walk the entire downtown inside, covering 9.5 miles and connecting 80 city blocks? Like an endless shopping mall, these well-maintained building connectors are mostly covered with carpet and marble and there's plenty of places to eat, shop, workout, be entertained and do business along the way. The skywalks are perfect for keeping its residence warm in the winter and cool during the summer and to beat traffic down below. They're all made of glass, so you can see what kind of traffic and weather you're avoiding outside.

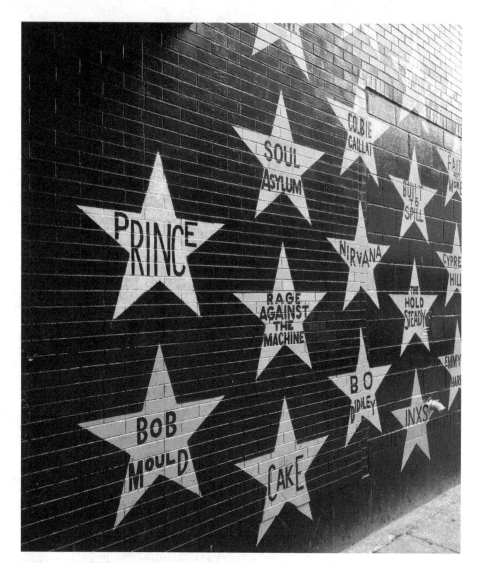

Let's get Cooking

WOOD CARVED BUTTER KNIFE
American Swedish Institute
2600 Park Ave. Minneapolis

Why I Choice this Craft

The Swedish butter knife, also called 'smörkniv' in Swedish, is an essential kitchen item in homes throughout Sweden. Typically, it is a wooden butter knife with a paddle-like shape that makes it comfortable to hold and perfect for spreading cold butter on bread or on Swedish crackers called 'knäckerbröd'. Minnesota has the largest population of Scandinavians in America, and their traditions are still practiced today. The butter knife is so widely loved in Sweden, it's sold in stores across the region, even in airports and used as welcome and parting gifts. I learned green woodcarving, meaning freshly cut from a living tree. Five traditional grips were introduced; scissor, forehand, pulling cut, thumb pull cut, and thumb push.

Momento in Minneapolis

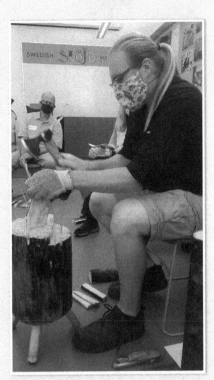

Momento in St. Paul

Let's get Cooking

SEED ART
Minnesota State Fair
1265 Snelling Ave N, St Paul

Why I Choice this Craft

What began in 1854 as a territorial fair to highlight agriculture and encourage farming in the region became the Minnesota State Fair in 1859, a year after Minnesota was granted statehood. Today, often referred to as the "Great Minnesota Get-Together," the annual Minnesota State Fair is one of the most popular tourist destinations in the region. The seed art and butter sculpting competitions are fan-favorites, impressing guests with these delicate and time-consuming arts. I worked with agriculture teacher, Ron Kelsey on an image of a Holstein cow, using flax seeds, sunflower seeds, chia and sesame seeds.

A Tasty Choice

Minneapolis: Viewing the skyline of the city, notice the tinted green/blue theme, whether the rooftop of historic brick builds or the new 40+ story glass buildings. Occasionally, the city will light up its bridges across the Mississippi with green, making for a beautiful display.

St. Paul: The Mississippi River bluffs create impressive steep cliffs, where affluent neighborhoods have been built since the mid-1800s. You wouldn't imagine, that a state known for its lakes has such beautiful sharp views from both sides of the river.

AUSTIN BRISKET

Chef's Note

This city didn't just happen, it was carefully planned by minds of compromising priorities. The active footpaths, sprightly sidewalks, vibrating venues, and serene blue space are all traits made to order in this American gem. Austin is an exception to the rule flawlessly complementing work and play, drawing envy from all corners of the country. Might as well bring a laptop to the trails because Austin figured out how to make work into a playground.

Cook Time: 25 hours

7:30am	Lady Bird Lake
10am	South Congress Avenue
2pm	Texas State Capitol
4pm	Mount Bonnell
7pm	Bat Tour
9pm	6th Street

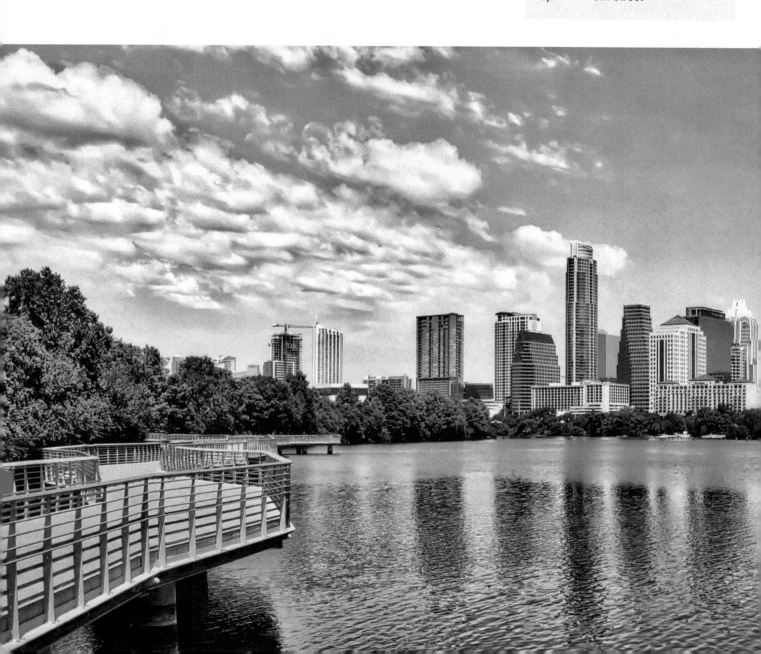

The Slow Cooker

The Driskill
604 Brazos St.

On the corner of 6th Street and Brazos Street, in the heart of downtown Austin, stands a historic landmark of Texas hospitality: The Driskill. For more than century, this iconic hotel has hosted restful nights, inspired gatherings, momentous occasions and then some. With 189 well-appointed guestrooms, three top-notch food and beverage outlets, storied spaces and matchless service, The Driskill is ready to welcome you to be a part of Texas history. Every part of this property will be remembered as class and elegance, from the hallways to the balconies.

Pre-heating

Ladybird Lake, Ann and Roy Butler Trail 7:30am-9:30am
In the heart of Austin, a lush, urban path that meanders along the water's edge and passes by skyscrapers, neighborhoods, under bridges, ball fields and cultural attractions. With the completion of the Boardwalk portion of the Trail in June 2014, the 1.3 mile gap along the south shore has been closed, and the Trail now serves our city in an additional way – as an alternative transportation route for our growing urban core.

With more than 2.6 million visits a year, the 10-mile trail is Austin's most recognized and popular recreational area. The Ann and Roy Butler Hike-and-Bike Trail is named for a former Austin mayor and his wife.

The trail is more than a great pathway—it is a place where Austin thrives. For many citizens and visitors, it represents the best Austin has to offer: outdoor recreation; a scenic, natural environment; and a diverse, vibrant mix of people.

Rubbing

South Congress Avenue 10am-12pm
Spend your morning with a leisurely stroll in the vibrant neighborhood of South Congress Avenue, just south of Lady Bird Lake, it's a must-stroll for visitors and a popular hang out for locals. SoCo oozes homespun character and boasts the story of Austin's yesteryear in its boutiques, eateries, galleries, murals and music venues. Plus, catch a great shot of the Capitol Building straight down the hill.

Local Inspiring Flavors

Breakfast
1886 CAFÉ & BAKERY
604 Brazos St.

Stocked with recipes from the hotel's past and their own family histories, the ladies of the Heritage Society operated a venue that to this day is known as "Austin's socializing parlor." Paying homage to the city and Heritage Society's roles, the 1886 Café & Bakery opened on July 4, 2002.

The quaint Victorian-style café serves up delicious traditional Texas comfort foods that combine time-honored original recipes with contemporary preparation. Dine on dishes such as Helen Corbitt's Cheese Soup, our famous Hangover Burger, or a bona fide Texas classic, Hot Fried Chicken.

Lunch
Terry Black's BBQ
1003 Barton Springs Rd.

Austin's premiere destination for legendary Texas barbecue, that includes all the favorite menu items, from brisket to cornbread and banana pudding. The line is so long, that bartenders offer drinks along the way.

Dinner
Emmer & Rye
SkyHouse, 51 Rainey St Unit 110

Opened in 2015,designed around the farmer's haul, featuring a menu that changes daily with a focus on seasonal and local cuisine. Heirloom grains are milled fresh for house made pastas, breads, and desserts, whole animal butchery is done on site, and an extensive in-house fermentation program captures flavors at their peak and preserves them for the off season.

Emmer & Rye is a carbon neutral restaurant. We work with Zero FoodPrint to help offset our carbon emissions.

AUSTIN
BRISKET

Texas State Capitol Building 2pm-3:30pm
1201 San Jacinto St.

The massive three-story Sunset Red Texas Granite structure is the largest capitol building in the United States, standing 14 feet higher than the U.S. Capitol building. Keep an eye out for elegant and ornate details, from the giant brass door hinges (so beautiful that people have tried to steal them over the decades!), to the detailed handrails. Look closely at the brass chandeliers in the House of Representatives Chamber to find that the light bulbs spell out T-E-X-A-S.

Mixing

Mount Bonnell 4pm-5:30pm
3800 Mount Bonnell Road

Actually located in Covert Park, Mount Bonnell is one of the highest points in Austin at 781 feet! The peak is named for George Bonnell, who served as Commissioner of Indian Affairs for the Texas Republic. While this view is pretty high up in the sky, don't be intimidated! The overlook of downtown and the 360 Bridge is actually more of a tourist destination than a workout, and is a great hot-spot for picture-taking and those on an adventurous date. When you reach the top of the 102pm-stair climb, you can rest at the view deck and pavilion to observe the Colorado River and lined with mansions.

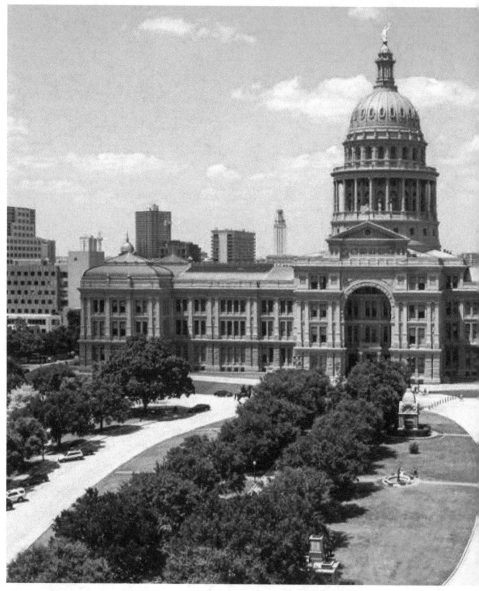

Slow Cooking

Capital Cruise Bat Tour 7pm-8:30pm
208 Barton Springs Road

Congress Avenue Bridge is the home of the largest urban bat colony in the world. Austin's bridge bats are Mexican free-tailed bats. They migrate each spring from central Mexico and return to Mexico in early Fall. Our cruises provide the best possible viewing, right from the water for one of the most incredible wildlife spectacles in the world! It's quite a spectacle, where people congregate on the bridge, paths along the water and dozens of boats and kayakers wait for the bats to appear, like a fireworks display.

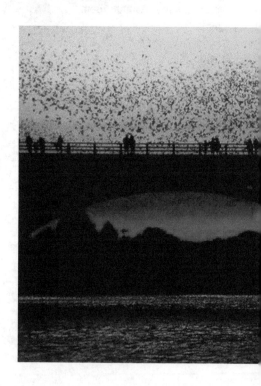

Let's get Cooking

MUSICAL SONG
Song Confessional
1101 Music Ln

Why I Choice this Craft

Austin City Limits Live at The Moody Theater (ACL Live) is a state-of-the-art, 2,750-person capacity live music venue that hosts approximately 100 concerts a year. It serves as the permanent home for the taping of the acclaimed KLRU-TV produced PBS series, Austin City Limits, the longest running music series in American television history. This series helped name Austin as the Live Music Capital of the World.

I provided my story inside of a booth, which songwriter Luke Watkins turned into lyrics and sourced it to a local band to produce a one-of-a-kind song.

Momento

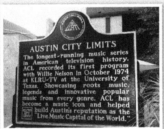

There's a boy
He is 6 years old
He is studying the lines
from El Paso to Kansas
From us to them.

There's a man
He's got twenty years on that kid
Sleeping in a van
Finding the line from where he's going
to where's he's been

Sometimes we lose the thread
But if you live into the map you
remember again

There's a boy
But he's hardly a child
He's studied with the best but it didn't
matter much
He's directionless

There's a man
In a fancy hotel
Thinking about the kid and how
grateful he is for the shit that he was
in once

Sometimes we lose the thread
But if you live into the map you
remember again

Basting

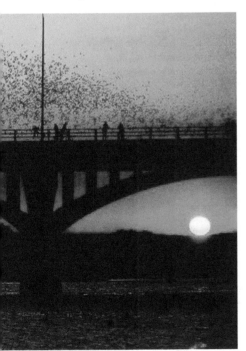

6th Street 9am-12pm
One of the most insane lively streets in the country that is distinctly Austin. Roughly three miles of colorful and bustling array of bars, restaurants and entertainment venues, it's a sure bet for experiencing local characters and the vibrancy of the city. Large televisions from the restaurants capture sports fans, outdoor patios capture the casual crowds and the upbeat music captures the rest.

The feel of 6th Street changes block to block, from classy to grungy to the sophisticated to the college partier. Check out the live music venues as you stroll the district.

A Tasty Choice

Ever hear of anyone complain about Austin? Me neither. Whether you're a visitor or a resident, Austin makes people happy. It's the nature within the city. It's the delicious food. It's the energy of the streets. It's the prestigious University of Texas. It's the wave of the future.

41

BOSTON
BAKED BEANS

Cook Time: 24 hours

7am	Commonwealth Ave and Emerald Necklace
10am	Fenway Park
12pm	College Campus Tour
3pm	Freedom Trail

Chef's Note

Boston is the living breathing encyclopedia of America; an education hub exploring subjects of science, history, sports, politics, fine arts, and medicine. It's no wonder dozens of colleges/universities have made Boston their home. History runs deep here, dating back to the nation's earliest days and beyond, where nearly every building has become a historical icon. Although the city preserved much of its past, Boston is a first-class city leading the modernized world.

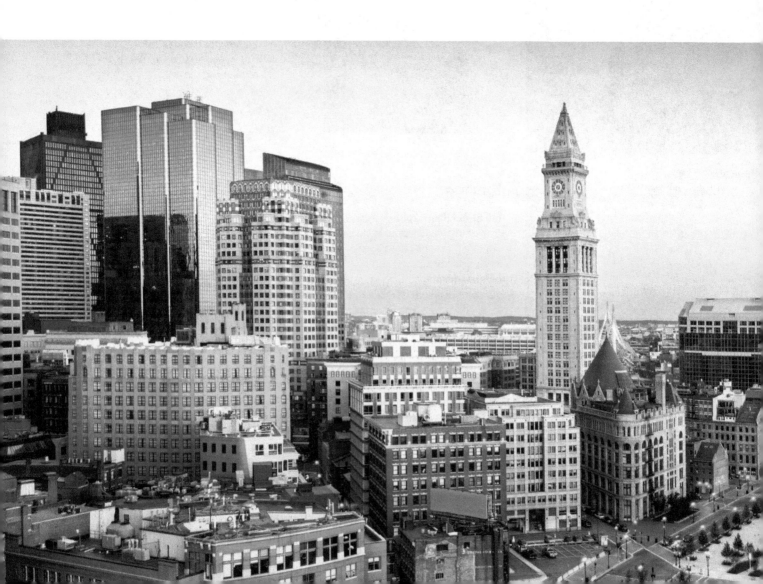

Dutch Oven

Boston Harbor Hotel

70 Rowes Wharf

As the waters of Boston Harbor give way to the city skyline, the iconic 60-foot stone archway of the Boston Harbor Hotel offers an entrée to the city unlike any other. Boston's only waterfront Forbes Five-Star and AAA Five-Diamond hotel is the essence of "classically current" luxury, welcoming guests arriving by land or sea to historic Rowes Wharf. The lobby interiors sweep you into an inviting home away from home, from the sophisticated yet comfortable furnishings and maritime color palettes to the marble flooring and unique flower arrangements it has the classic Cape Cod feel.

All 232 guest rooms and suites offer striking views of the Boston cityscape or the waterfront and harbor. Also, there tea time in the restaurant, reflecting the city's rich cultural past.

Local Inspiring Flavors

Breakfast

The Paramount

44 Charles Street

Since 1937 the Paramount restaurant has been a long-standing Boston favorite, evoking the history and character of Beacon Hill. This is a comfortable bistro serving three meals a day to both local and visitor, the kind of spot where you can begin the day with a Spanish omelet and end the night with a sirloin steak.

Lunch

Faneuil Hall Marketplace

Located in downtown Boston, steps away from the waterfront, Faneuil Hall is alive today as it was in 1742 when our nation's fathers proclaimed it "The Cradle of Liberty."

Over 70 retailers and 40 office tenants occupy the 200,000 square feet of retail and 160,000 square feet of space on Boston's iconic mixed use festival marketplace.

Customers enjoy unique, locally loved, and nationally recognized shops while indulging in the worldwide cuisine at our restaurants, pubs, and in the world-famous Quincy Market Colonnade.

The cobblestone promenades are filled with the music and jaw-dropping routines of world-renowned street performers and musicians.

Dinner

Ristorante Limoncello

190 North St,

Your home away from home in the heart of Boston's historic North End, known as the Italian District. Located on the Freedom Trail just a few doors down from the Paul Revere House in North Square, the food is great and the ambiance is even better.

BOSTON
BAKED BEANS

Pre-heating

Run/Bike Commonwealth Ave Mall and the Emerald Necklace 7am-9am

An extraordinary route to explore the wonders of Boston's nature, navigating through college campuses, riverways, and historic affluent neighborhoods. Start at the oldest park in America, Boston Commons and head down a tree-lined path on Commonwealth Ave. Mall. The trails are popular, and you'll feel the active lifestyle of the locals and understand why this is one of the fittest cities in the country.

Soaking

Fenway Park Tour 10am-11am

Nestled slightly outside of downtown Boston sits baseball's oldest and one of it's most iconic ballparks, Fenway Park. It's where generations of fans have went to see the Red Sox play for over a century. Although it's old with its history dating to 1912 this iconic ballpark retains many of the same characteristics as it did when it opened. There are no nose-bleed seats here, the stands are gradually compared to modern-day stadiums.

One of the most prideful and achieved franchises in all of sports. The tour gives an in-depth history of the build and the franchise.

College Campus Tour 12pm-1:30pm

Harvard, MIT, Tufts, Boston College and Suffolk are just a few of the 44 colleges/universities that call Boston home. Jump on a tour of one of these prestigious campuses, even pop into a lecture hall and be inspired by the next generation of doers and thinkers.

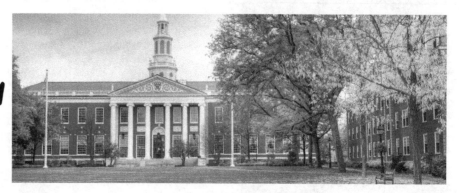

Baking

Walk the Freedom Trail 3pm-6pm

Walk Into History and experience more than 250 years of history on Boston's iconic Freedom Trail— the 2.5pm-mile red line leading to 16 nationally significant historic sites, each one an authentic treasure. Preserved and dedicated by the citizens of Boston in 1951, the Freedom Trail is a unique collection of museums, churches, meeting houses, burying grounds, parks, a ship, and historic markers that tell the story of the American Revolution and beyond. Today the Freedom Trail is a world-renowned, signature tourist experience attracting over 4 million people annually to visit Boston's precious 17th-, 18th- , and 19th-century sites.

Follow the footsteps of America's founding fathers on the Freedom Trail with live reenactments and costume interpreters.

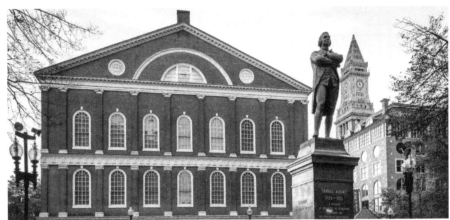

Let's get Cooking

TEA CHEST
Boston Tea Party & Ships
306 Congress St.

Why I Choice this Craft

On the winter night of Thursday, December 16, 1773 the "tea crisis" in Boston came to a head. Members of the Sons of Liberty disguised as Mohawk Indians were armed with an assortment of axes. They quietly boarded three ships carrying cargoes of British East India Company tea moored at Griffin's Wharf. In a span of three hours, 340 chests of British East India Company Tea were smashed and dumped into Boston Harbor. Over 92,000 pounds of tea were destroyed and thrown into the harbor. The implication and impact of the Boston Tea Party were enormous; the event directly led to the sparking of the American Revolution on April 19, 1775.

I had the opportunity to make a replica tea chest and try the five original teas; Colonial Bohea, Congou Tea, Young Hyson Tea, Lapsang Souchong Tea, and Singlo Tea.

← Momento

A Tasty Choice

Boston's city streets, highways, bridges and now the tunnel system are incredibly unique. The city wasn't originally built for this many people and this much development as we see today. Roadways are tight, the lanes are narrow and to make things more challenging, the drivers are fast and furious. Exits and entrances of roads are short, so defensive driving doesn't work here. The new tunnel system underneath downtown, called the Big Dig has alleviated much of the congestion, but drivers are more aggressive and if a lane is blocked, expect major delays.

TAMPA BAY
CON LECHE

Chef's Note

The cock-a-doodle-do of the roosters, the vroom of the water taxis, the squeals of the manatees, and the clinking of the historic streetcar, are all sounds that make Tampa Bay exotic and refreshing. The elegant development along the Hillsborough River and Bay and the preservation of historic districts, makes for a balanced blend to reflect on the city's past moving quickly into the future. The city is confident and modest, doing its thing. Tampa Bay doesn't need the flash to attract, yet people are coming in drives.

Cook Time: 23 hours

9am	Streetcar and Water Taxi
11:30am	Riverwalk
2pm	Watch the Manatees
5pm	Ybor City

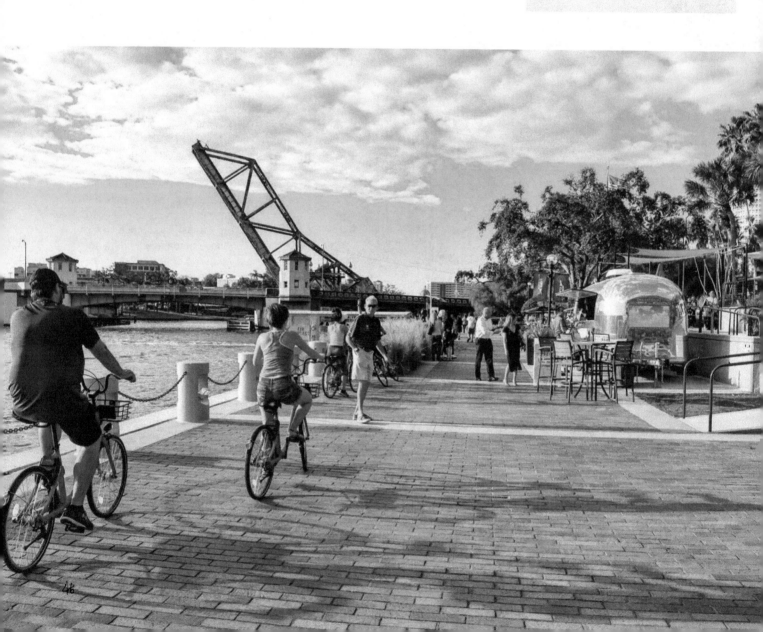

The Espresso Maker

Hotel Haya

1412 E. 17th Ave.

Revitalized casitas and brick façade storefronts along 7th Avenue are shining examples of Ybor City's rebirth. It all comes together at Hotel Haya. Through careful renovation and reimagining, the

iconic past of Ybor and thoughtful new construction join together in a boutique hotel blending reverence for history and optimism for the future. The lobby is elegant and spacious, with local iconic features, like a cigar case and a rooster figure. The beds are like sleeping on a cloud.

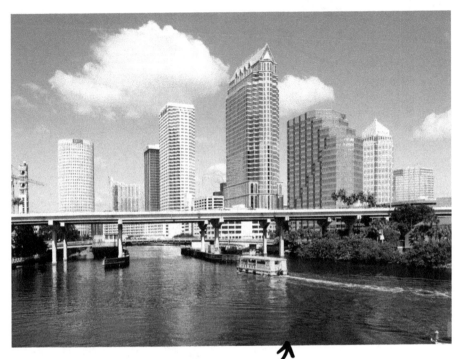

Brewing

Streetcar to the Water Taxi 9am-11:30am

Tampa Bay's TECO Historic Streetcar Line links downtown, the Channel District and the Ybor City National Landmark District with nine distinctive electric streetcars that run along a dedicated rail line. The cars are a mix of refurbished antiques and skillfully crafted replicas. Tickets are free and available at each station. Streetcars are free to ride all day. If you're lucky, you'll catch a mini concert during your trip.

Pirate Water Taxi offers daily tours of Tampa with 14 stops located along our route near attractions, museums, restaurants & parks! Simply buy tickets at our home dock (Stop #7 – Convention Center), online or after boarding the taxi at any of the stops located throughout Downtown Tampa. Once purchased, you will receive a Pirate Water Taxi wristband which allows you to hop on and off the taxi at any stop for unlimited rides – all day!

Transferring

Riverwalk 11:30am-12:30pm

If you didn't get enough views from the water, why not walk along it? The 2.4pm-mile sparking path captures many of the downtown attractions. It's a great way to wrap around the city, getting different views of the river and bay.

Local Inspiring Flavors

Breakfast
Café Quiquiriqui

1402 E 7th Ave.

Sip a Cuban coffee, café con leche or a refreshing local bottled juice. Snack on empanadas and alfajores, cubanos and tostadas. Cool off after a day in the Florida sun with a seasonal gelato. Settle in and work remotely from their cozy corner café. And, yes, they've got cigars.

Lunch
Sparkman Wharf

615 Channelside Dr.

Tampa Bay's latest outdoor and entertainment destination, Sparkman Wharf. Located in the Channel District along the Garrison Channel, enjoy a new type of dining experience housed in refurbished shipyard crates. This outdoor experience offers a lush one-acre park to enjoy friends, family, and even your furry friend. This is the perfect place to take in the great waterfront views, craft beer, live music, and exceptional dining.

Dinner
Columbia Restaurant

2025 E. Seventh Avenue

Florida's oldest restaurant fills an entire block in the heart by Ybor City, Tampa Bay's historic Latin Quarter. Since 1905, the Gonzmart family has operated the restaurant, expanding it over the years from a bar and sandwich shop to more than 1,700 seats. Six nights a week, the restaurant features Flamenco dancing. This is one of those establishments that has become an American icon.

47

TAMPA BAY
CON LECHE

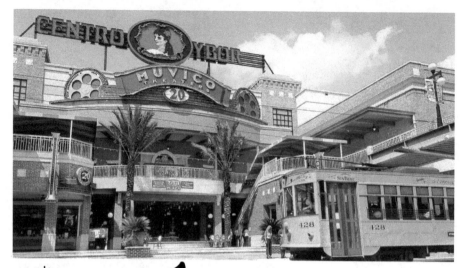

Stirring

Watch The Manatees 2pm-3:30pm
Apollo Beach

Big Bend Power Station in Apollo Beach has delivered reliable electricity to the community since 1970. Manatees gather in large numbers in the power station's discharge canal, where saltwater – taken from Tampa Bay to cool the units' flows, clean and warm, back to the bay. When Tampa Bay reaches 68 degrees or colder, the mammals seek out warm water refuges such as springs and power plants. Big Bend's discharge canal is a state and federally designated manatee sanctuary that provides critical protection from the cold for these unique, gentle animals.

Tasting

Ybor City 5pm-9pm

Stroll La Sétima, the heart of Ybor City, Tampa Bay's Latin Quarter and home to 130-plus years of history. From its founding in 1885, Ybor City flourished as a global center for cigar manufacturing and became a magnet for immigrants from Cuba, Spain, Germany, Italy and Eastern Europe. Visitors can still find skilled artisans rolling cigars the same way they have the beginning. There are many cigar shops, and establishments you can smoke inside and out.

A Tasty Choice

Wild chickens roam the streets of Ybor City, that are direct descendants of the chickens that lived in the backyards of the neighborhood's earliest residents over 100 years ago. Ybor City's chickens crossing the streets have become a welcome sight for those who live, work and visit the area. There are many places to catch glimpses, and sometimes even good areas to find where they are by simply using your eyes and ears. If you live in Ybor City, you can't dislike the chickens, because like it or not they have been there longer than you.

Let's get Cooking

CIGARS

J.C. Newman's Cigar Factory
2701 N 16th St

Momento

Why I Choice this Craft
A part of Tampa's Cigar City for almost 67 years. J.C. Newman's factory, known as "El Reloj," rolls their cigars by hand and by handoperated cigar machines. J.C. Newman is now a world-renowned company with factories in Nicaragua and the Dominican Republic. Cuban Cigars are more prominent here than in Cuba. I had a chance to roll the tobacco product at the last factory to exist in the city. What a process! The entire cigar is made of leaves, used with three different layers of tobacco. Rolling it by hand is the premium product and the traditional method. It's not easy work, so no wonder cigars are a delicacy.

ORLANDO JUICE

Chef's Note

Once the center of the citrus world, it's no surprise that Orlando has grown into the Theme Park Capital of the World, being home to Disney World, Universal Studios and Sea World to name a few. The sunny skies, year-around moderate climate, and proximity to the shores, made Orlando the exotic family destination it is today.

Cook Time: 18 hours

10am Gatorland

2pm Lake Eola

5pm International Drive

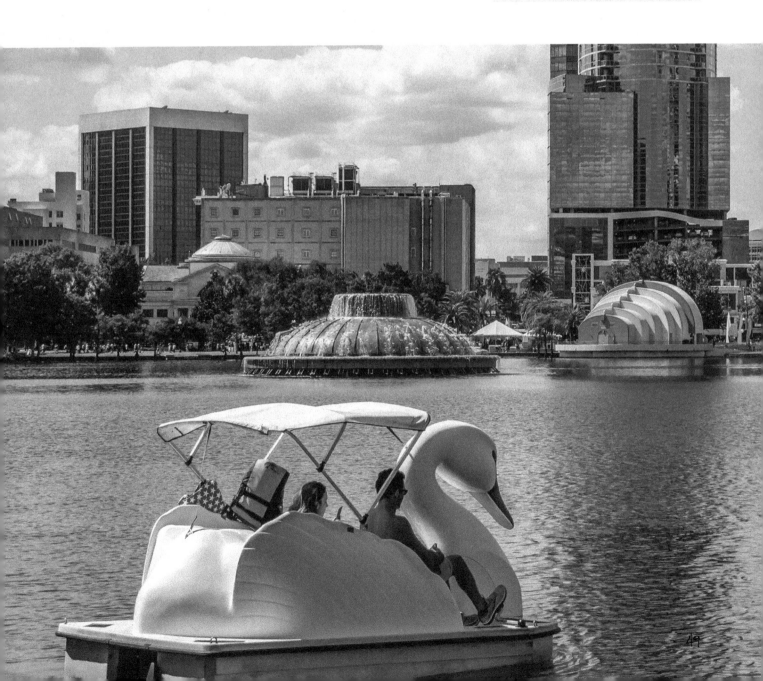

49

ORLANDO
JUICE

The Orchard

Club Wyndham Bonnet Creek

9560 Via Encinas

Located near Disney World's attractions, this multi-building complex with lush landscaping and incredible outdoor pool areas, features friendly staff, spacious condo-style suites and an atmosphere of family fun. Stroll along the lakefront sidewalk and enjoy an immense range of resort amenities and family activities

Picking

Gatorland 10am-12pm

Claimed to be Central Florida's first major attraction, originating as a roadside mud pit of alligators to the now 110pm-acre theme park and wildlife reserve.

Walk wood bridges over swamps or catch the observation decks, where you can see thousands of alligators lurking the waters. Even get a chance to feed the alligators up close.

In addition, see the world's first amusement park ride, The Iron Horse Express, a miniature train ride created by Owen Godwin.

Local Inspiring Flavors

Breakfast
Tesoro Cove Family Fare

Bonnet Creek

Start your day right with a hearty breakfast at the restaurant's buffet, featuring hot entrées, fresh fruit, and more.

Lunch
Briarpatch

252 Park Avenue, North Winter Park

One of Winter Park's most iconic restaurants, the Briarpatch has welcomed locals and visitors alike since 1980. It serves contemporary American cuisine in a warm and inviting atmosphere.

Using only the freshest local ingredients, the team is committed to showcasing seasonal Florida flavors.

Dinner
Cruise down International Dr. and find the most diverse, bizarre options of dining and atmosphere.

Peeling

Feista In The Park, Lake Eola 2pm-4pm

Located in the heart of downtown Orlando, some of the most talented artists and crafters around from Central Florida and around the country will line the streets around the park, plus savor the flavors from a variety of food vendors and enjoy live entertainment for the whole family! It's an impressive display of art around Lake Eola, nearly a mile long.

Momento

Squeezing

International Drive 5pm-7pm

I'd bet this is the longest commercial stretch in America, filled with restaurants, attractions, resorts, recreation, and shopping. It's an absolute must to see because there's something for everyone.

A Tasty Choice

You wouldn't believe how many lakes there are in Orlando, well over one hundred. Since the city is known for its attractions, Orlando implanted springs in the center of many of its lakes to create that theme park appeal. That mist from the gushing springs can be a great coolant during the summer months.

Let's get Cooking

CARTOON CARICATURES WITH RAFAEL DIEZ
Crealde School of Art

Why I Choice this Craft

One of the most common exhibits in theme parks are the live caricature illustrators, that seemingly draw a crowd each time a guest chooses to take a seat and put into the spotlight. The exaggerated work that plays on unique features of someone, is a form of humor that some people find amusing and sometimes offensive. I started to look at people's heads as shapes and tried finding the unique characteristics to embellish.

BUFFALO WINGS

Chef's Note

An All-American city is recognized by its civic engagement to address critical issues and create stronger connections among residents, businesses, and government leaders. Buffalo achieved that standard centuries ago through its vision, courage, and commitment. At one-time, America's top-10 largest city, being the world's leading grain port and national flour-milling hub thanks to the engineering marvel of the Erie Canal, Buffalo attracted people from around the world that wanted prosperity. This city has literally paved the way for what's possible and created much of our culture and industry we see today. Given its proven track record, abundance of natural resources, eagerness and willpower of its people, Buffalo is currently in its renaissance.

Cook Time: 24 hours

8:30am	Observation Deck
10am	Allentown
12pm	Canalside
2pm	Silo City
4:30pm	Niagara Falls

The Baking Sheet

The Roycroft Inn
40 South Grove St. East Aurora

In 1905 the Roycroft Inn was opened to accommodate visitors and artisans looking to experience this emerging community and style. The Inn became a center of activity for this community. In 1986, The Roycroft Inn, as part of the Roycroft Campus, received National Historic Landmark status. Over a nine year period, with support from the Margaret L. Wendt Foundation, The Inn was meticulously underwent an $8 million dollar restoration to return it to its original splendor. It was re-opened for guests in 1995.

Today, The Roycroft Inn continues to welcome visitors and be the center of the many community activities. It offers its guests a beautiful destination for an overnight stay, a special dining experience or both.

From the moment you enter the Campus and arrive at the Inn, you are immersed in the beauty and unique style of the Roycroft artisans. As you step through the grand doors "time still seems to stand still", at least for a minute. In the Salon you are surrounded by the beautifully restored murals created by Alexis Jean Fournier, an original Roycroft artist. Sit in an original Roycroft Morris chair, read a book by a handcrafted lamp or just wander through the series of exquisitely restored rooms and breathe in the history of this Historic Inn.

Pre-heating

City Hall Observation Deck 8:30am-9:30am
65 Niagara Square

Downtown Buffalo is like a museum without a roof. While many cities' early 20th-century masterworks have been lost to time, Buffalo's have been lovingly maintained and restored. I noticed the sides of many buildings still kept the painted logos and advertisements of businesses. The city is filled with architectural significance, and is nowhere near cookie-cutter, as many of the designs don't look like what you've seen before. The City Hall's observation deck will provide the best view of Buffalo.

Local Inspiring Flavors

Breakfast
Betty's
370 Virginia St.

Opening in 2004, Betty's quickly won the hearts and loyalty of Buffalonians with its cheerful, sunny dining room, its friendly and funky staff, and its moderately priced eclectic cuisine. Betty's food is simple, fresh, and creative, drawing on American and international influences, resulting in food that is wholesome, interesting, and unpretentious.

Betty's aspires to use food as a vehicle for bringing people together in ways that result in good feelings, good will, and a heightened sense of community in Buffalo.

Lunch
Anchor Bar, The Original Buffalo Wing
1047 Main St.

On a Friday night in 1964, Dominic Bellissimo was tending bar at the now famous Anchor Bar Restaurant in Buffalo. Late that evening, a group of Dominic's friends arrived at the bar with ravenous appetites. Dominic asked his mother, Teressa, to prepare something for his friends to eat.

They looked like chicken wings, a part of the chicken that usually went into the stock pot for soup.

Teressa had deep fried the wings and flavored them with a secret sauce. The wings were an instant hit and it didn't take long for people to flock to the bar to experience this new taste sensation. From that evening on, Buffalo Wings became a regular part of the menu at the Anchor Bar.

The phenomenon created in 1964 by Teressa Bellissimo has spread across the globe. Although many have tried to duplicate Buffalo Wings, the closely guarded secret recipe is what makes Frank & Teressa's the proclaimed "Best Wings in the World."

Dinner
Roycroft Inn Restaurant
40 South Grove St. East Aurora

Buffalo and Central New York are known for historic Inns, built during the Gilded age that were one-time private mansions, now wedding venues, restaurants, and hotels. The Roycroft Inn is a special New York tradition for formal dining and immersing into the lives of historic prominence.

BUFFALO WINGS

Allentown 10am-11:30am

With cool vibes dating back to the 60s, this quaint historic neighborhood is a perfectly quirky spot with a local vibe. Filled with bars featuring live music, trendy restaurants, local art galleries, antique shops, bookstores and boutiques, Allentown offers an off-the-beaten path look at Buffalo's indie culture. Enjoy a vast array of Victorian, Italianate and Queen Anne style homes in one of the first and largest historic districts in the country.

Goldening

Canalside 12pm-1:30pm
44 Prime St.

It was once the dark side of town where truckers went to refuel, grain scoopers grabbed a beer (where the term 'dive bar' was founded) and street racers burned rubber on an empty stretch of highway. Fences kept the curious away from the water and industrial debris littered empty lots. Today, the fences have come down, those lots have become parks and a bike path links the inner and outer harbors. While the occasional lake freighter still makes its way to Buffalo's harbor, the waterfront is now home to kayakers, paddle boarders, boaters, bikers and hikers – the site of a radical transformation from desolate to destination. Yes, this as the western terminus of the Erie Canal. Today, Buffalo's waterfront is best experienced in three distinct locations: Canalside, which is located at the foot of Main Street in downtown; the Buffalo River, which twists and turns from downtown through the Old First Ward and Valley neighborhoods; and the Outer Harbor, the massive parcel of green space, bike paths and marinas on the Lake Erie shore. Many of the city's largest outdoor events take place at Canalside. I happened to be there during the airshow, which brought thousands of people, observing from land and water. It was one of the most thrilling displays I've seen in America.

Whisking

Silo City Tour 2pm-4pm
85 Silo City Row

On this two-hour tour, Buffalo River History Tours transports you to Silo City via the Buffalo River. As you walk through Silo City, see and hear what made Buffalo the largest grain port in the world for 100 years. The campus is eerie (fitting for being near Lake Erie), yet remarkable reflecting on how much activity once swept these grounds. The trip inside Silo City takes you inside these majestic towers as you learn about the Perot Family Malting Plant and see the original coal-fired kilns. They go beneath the silos to see how the grain was transferred. You have an option to go all the way to the top, grasping the everyday traffic on narrow stairwells during its time of operation.

This area has been named one of the best industrial photography locations in the Western Hemisphere. Cameras are highly encouraged on this combination boat and walking tour of Silo City.

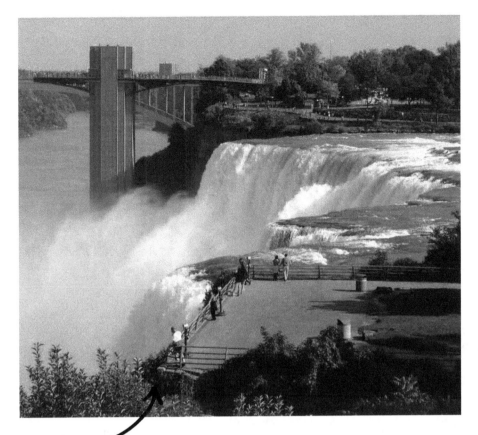

Drizzling

Niagara Falls and the Peace Bridge 4:30pm-7pm

Known for its jaw-dropping scenic beauty, thundering roars and shimmering rainbows, Niagara Falls has been captivating millions of visitors each year. The raw power of 4pm-6 million cubic feet of water rushing over the edges every minute of the day, is a true natural wonder that can be experienced by land, or water. If you brought your passport, take the Peace Bridge to Canada, up Queen Elizabeth Way to get to the Falls.

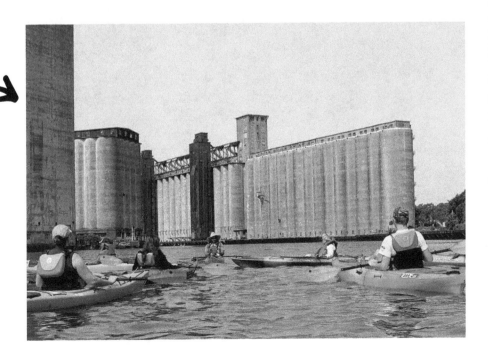

Momento

Let's get Cooking

BOOK PRINTING AND BINDING
The Roycroft Campus
31 S. Grove St. East Aurora

Why I Choice this Craft

Elbert Hubbard, a true Renaissance Man is the epitome of the American Dream. He believed if you work hard, you're going to succeed. Mr. Hubbard was a young soap salesman that developed the idea of couponing, inventing premium subscriptions and buy one get one. He became a multi-millionaire but wasn't satisfied being a soap salesman. He was inspired by William Morris' printing press in England and decided to start a printing press at the Roycroft Campus, meaning royal craft, became a site for local artisans. Mr. Hubbard earned a contract to create a filler for a magazine, and one of his works, A Message to Maria went viral and printed 30M copies at his campus, becoming the largest printing press in America. At the campus, you can learn about the original form of printing and binding books.

A Tasty Choice

The smell of cereal is in the air, thanks to Buffalo being one of North America's great milling capitals. Baked fresh along the Buffalo River every day, the winds from Lake Erie carry warm, slightly sweet, toasty oat aroma of Cheerios to nostrils citywide. This is seriously the best smelling city, taking long inhales to savor every bit of it.

CHICAGO DEEP DISH

Chef's Note

Chicago surpassed the standard of what a city should be. It's like the best traits of a city were selected from a lottery to make up this fascinating urban heaven. The best skyline from either side of the city, check. A massive lake that appears like the ocean, check. The finest local dishes, check. The most diverse ethnic neighborhoods, check. A transportation system that gets to every destination, check. World class museums and theaters, check. The largest urban park system, check. A vibrant nightlife, check. Shopping that extends miles, check. Chicago is unforgettable and displays features that undeniably become all-time favorites.

Cook Time: 30 hours

8am	Michigan Ave.
10am	Architectural Cruise
12:30pm	North Beach
2:30pm	Lincoln Park
4pm	Ethnic Neighborhoods
11pm	River North Nightlife

Day 2

9am	The Northshore

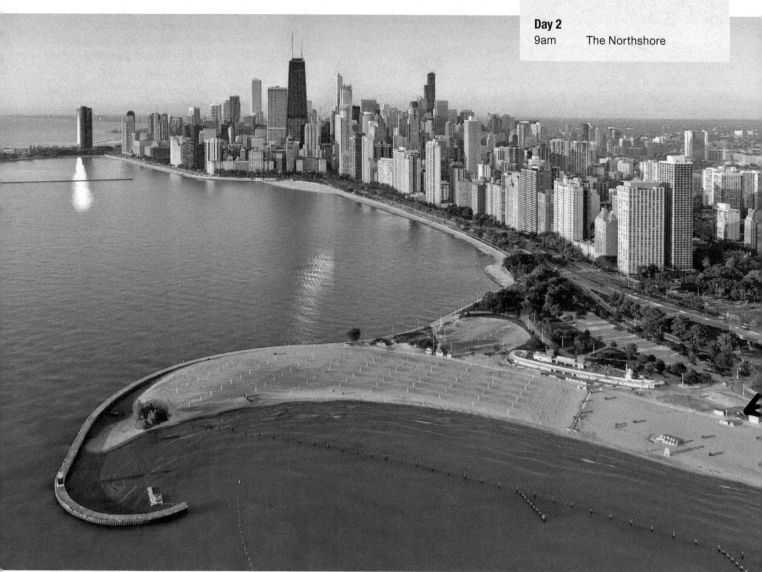

The Cake Pan

The Godfrey Hotel

127 W. Huron

Godfrey means peace and welcome; welcome to The Godfrey Hotel Chicago. Offering unforgettable style from the Cubist-influenced façade to the chic accommodations, each detail of this striking Chicago luxury boutique lifestyle hotel has been designed with the guest's experience in mind.

Pre-Heat

Walk Michigan Ave. 8am-10am

Also known as The Magnificent Mile, is one of the most famous shopping areas in the world — home to a dizzying array of popular stores, restaurants, attractions, and architecture all on one iconic street. It's one of the most beautiful urban streets in the world.

Chicago Architectural River Cruise 10am-11:30am

112 E. Wacker

Explore Chicago's iconic architecture aboard Chicago's First Lady. The only Chicago River cruise partnered with the Chicago Architecture Center (CAC), Chicago's First Lady Cruises offers visitors the city's most engaging architectural tour experience.

Highly trained and enthusiastic volunteer CAC docents (guides) provide visitors with a compelling and detailed narrative of Chicago's numerous architectural styles and the stories of the legendary figures who designed and built our city.

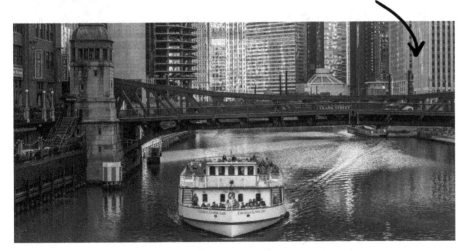

Kneading

Play at North Beach and Lake Michigan 12:30pm-2pm

As one of Chicago's most popular beaches, the beach features a unique and popular beach house that contains 22,000 square feet of space that features something for everyone and is permanently docked along this popular beach. This sleek, ocean liner-inspired building, decked out in a crisp blue and white, boasts one of the best views in the city. The beach house has upper decks and portholes for looking at the magnificent horizon or the multitudes of bikers, runners, walkers, and rollerbladers streaming down the lakefront trail. If you love volleyball, there are plenty of nets permanently placed on the beach.

Local Inspiring Flavors

Breakfast
Nutella Café

189 Michigan Ave.

Nutella® helps make even the most ordinary mornings feel special. Simply spread Nutella® on top of a croissant, waffle, crepe, pancake or piece of toast, and watch how the magic of Nutella® transforms a simple morning into something extraordinary.

Lunch
Portillo's Hot Dogs

100 W Ontario St.

They're known for their famous Chicago-style hot dogs, Italian beef sandwiches, chopped salad, cheese fries, homemade chocolate cake, and chocolate cake shake. Their Italian beef is slow-roasted for four hours, thinly sliced, and served on freshly baked French bread. Then, it's dipped in hot gravy made with their homemade blend of seasonings that they've been perfecting for 50 years.

Dinner
Giordano's Pizza

730 N Rush St.

Mama Giordano was famous around town for her exquisite cooking. Of all her renowned dishes, her most beloved meal was her "Italian Easter Pie". This pizza pie became a sacred tradition in the Giordano family and a legend in the town of Torino. Years later, Italian immigrants Efren and Joseph Boglio moved to Chicago to start their own pizza business. In 1974, on Chicago's historic south side, Efren and Joseph opened the first Giordano's in the world. Over the next 40 years and counting, millions of happy and loyal fans as well as hundreds of critics call Giordano's the city's "best" stuffed pizza!

CHICAGO
DEEP DISH

Lincoln Park and the Zoo 2:30pm-4pm

This picturesque neighborhood is a
nature lover's dream — manicured
gardens, a hidden lily pond, a historic
indoor botanical garden, and tons of
lakefront green space with sweeping city
views. It also happens to be home to one
of the country's oldest free zoos and an
acclaimed dining scene that includes
one of the best restaurants on the planet.
The neighborhood streets are the most
ideal places to go for an urban stroll, as
you pass by beautiful townhomes and
condos.

Spreading

Explore Ethnic Neighborhoods 4pm-8pm

One of the unique characteristics
of Chicago are neighborhoods that
are designated for ethnic influence,
whether its Ukrainian Village, Chinatown,
Greektown, Andersonville (Swedish),
Little India on Devon St. (Indian and
Pakistani), Lincoln Square (German),
Little Village (Mexican) and Little Italy to
name a few.

Take the 'L' train to these destinations
for the full experience. These
neighborhoods are scattered miles
throughout the city, so select a few.

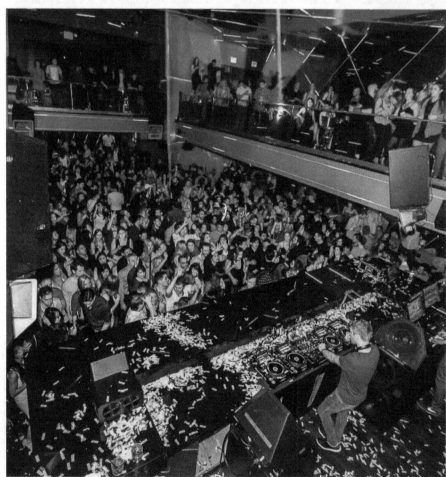

Layering

Nightlife at River North District
11pm-1am

Chicago is one of the rare cities in America that goes late into the night and early morning. You'll be surprised that people start lining up for the night clubs at 1:30pm-2am, a European nightlife influence. Find many dance floors and bars within walking distance in downtown.

Baking

Day 2
Take a Drive to the Northshore
9am-11am

The most beautiful and affluent suburbs in America are found north of Chicago. Drive up Lake Shore Drive from downtown until you reach Sheridan Road in Evanston. Continue up Sheridan, enjoy the quaint neighborhoods, business districts of each suburb until you reach Highland Park. Loop back down on Green Bay Road for a different scenery. There are plenty of places to stop along the way.

Let's get Cooking

3D ARCHITECTURAL MODEL SKYSCRAPER
Chicago Architectural Center

Why I Choice this Craft
Chicago became a center for architectural experimentation and innovation, home to the world's first skyscraper and many buildings that were at one time the tallest in the world. Chicago became home to a community of prominent architects. William Le Baron Jenney, Louis Sullivan, Frank Lloyd Wright, and Ludwig Mies became famous for developing innovative methods for erecting taller, more efficient, and more functional buildings. In the process, they contributed to the definition of modern architecture through a number of different styles. Among the many architectural styles found there, Chicago is home to its namesake Chicago School, as well as the International and Prairie School styles.

Momento

A Tasty Choice

The trains of Chicago are used by millions of passengers per day. It's an essential part of life, as they're seen and heard from anywhere. The 'L' train, short for elevated, is a classic Chicago feature that will always keep its historic look and feel. The platforms high-above the city streets navigate between apartment and office buildings, giving a unique peak into the local's lives. The Metro train is another service that sprawls to each Chicago suburb, so a car is not necessary in one of America's largest metro areas.

SAN DIEGO
SANGRIA

Chef's Note

If a city is a resort, feature San Diego in the catalog, advertised by a pristine coastal line crashing emerald-green waves against the dramatic rocky cliffs, verdant manicured roadways, Spanish Renaissance architectural styles, and a colorful nightlife. San Diego's air temperature and laid-back vibe is like sitting on a recliner inside a living room.

Cook Time: 22 hours

7am	Balboa Park
10am	Old Town
12pm	Little Italy
3pm	Mount Soledad
4:30pm	Coast Walk Trail
6:30pm	Gaslamp District

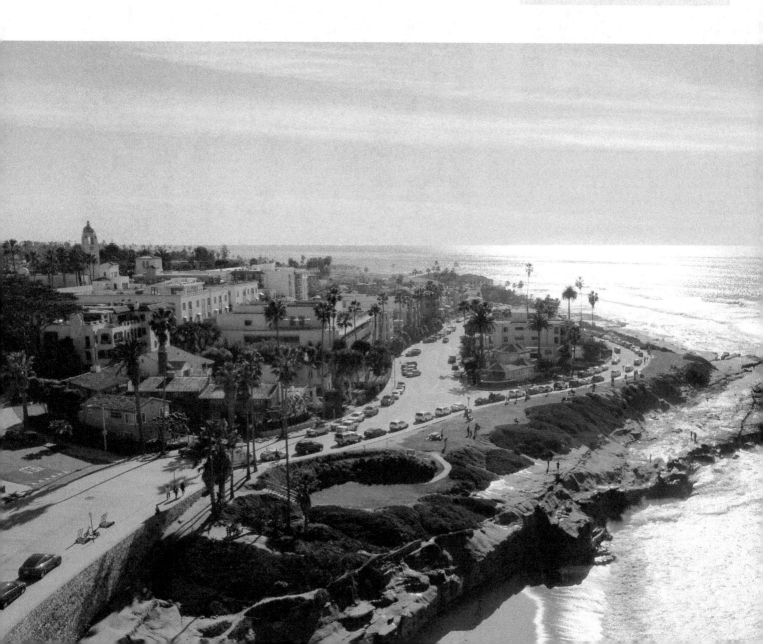

The Pitcher

The Sofia Hotel
150 W Broadway

An unforgettable experience for any guest lies in the hands of the host. Sofia's graciousness, charm, and attention to detail are everywhere from the fine linens and soothing toiletries, to the ambient bedside light, offering tired guests an opportunity to read or work from the comfort of their bed. Convenient to the active Gaslamp and Little Italy streets.

Local Inspiring Flavors

Breakfast
Breakfast Bitch

3825 Fifth Ave.

California coastal cities can be occasionally too hip, it becomes edgy. The party's at Breakfast Bitch where their staff is there to make sure you have fun and enjoy your experience. All meals are created to order with love and positive vibes only!

Lunch
Little Italy Food Hall

550 W Date St Suite B

Situated in the heart of San Diego's bustling Little Italy neighborhood, located at the Piazza della Famiglia,

the food hall features seven food stations and a full bar providing you with a glimpse into San Diego's diverse dining scene. Little Italy is a place of strong cultural heritage, founded by immigrant families who built a strong community with faith, hard work and social interaction. Their goal with the Food Hall is to pay homage to those families by creating a place of gathering and celebration.

Dinner
The Gaslamp District has an abundance of restaurants within several concentrated blocks.

Combining

Balboa Park 7am-9am
Ever changing. Always amazing. Where culture, science, and nature collide, Balboa Park is home to more than 16 museums, multiple performing arts venues, lovely gardens, trails, and many other creative and recreational attractions, including the San Diego Zoo. With a variety of cultural institutions among its 1,200 beautiful and lushly planted acres, there is something for everyone. This is one of the country's greatest parks and close to downtown.

Old Town 10am-11:30am
Go back in time and witness the living legacy of California's birthplace in Old Town San Diego State Historic Park. Its many preserved historic buildings and museums commemorate the early days of the town of San Diego from the period 1820 to 1870, allowing you to visit California's history firsthand.

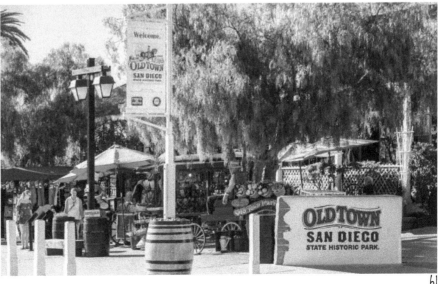

SAN DIEGO
SANGRIA

Sweetening

Little Italy 12pm-2:30pm

Once home to San Diego's flourishing tuna fishing industry and generations of Italian families who made their living on the sea, Little Italy is now a lively neighborhood with cozy patio cafés, international restaurants, craft brew stops, urban wineries, art galleries, sophisticated shops, boutique hotels, and the festive Piazza della Famiglia. The central gathering point in Little Italy is a European-style piazza known at Piazza della Famiglia. The 10,000-square-foot plaza connects India and Columbia streets and features a dramatic tiled fountain. Enjoy an afternoon stroll across the cobblestone street while relaxing before dinner. The piazza, in the "heart" of Little Italy, is dedicated to the past, present, and future families of the Little Italy neighborhood.

Stirring

Drive Mount Soledad 3pm-4pm

Known as one of the most prominent landmarks in San Diego. Atop this 822pm-foot hill sits the Mount Soledad cross and veterans monument. Known primarily for its veteran's memorial, it offers 360 degree panoramic views of San Diego and the Pacific Ocean. It offers one of the best views in San Diego County. On a clear day you can see from Scripps pier to downtown San Diego.

Look a little harder and you'll see the bridge to Coronado Island and beyond that, the mountains of Mexico. It's a great place to watch the sunrise or sunset as well as the perfect place to be enthralled by San Diego's city lights at night. This is an unforgettable drive through windy affluent communities.

Let's get Cooking

SURFBOARD
Bessell Surfboards
515 Westbourne St, La Jolla

Why I Choice this Craft

San Diego has 70 miles of open ocean coastline and as many distinct surf spots. Most of the shoreline consists of long beach breaks with primarily southwest exposure, and Point Loma and La Jolla are rocky points with a variety of reef breaks that work on north, west or south swells depending on their orientation. There are also patches of reef between Del Mar and Encinitas, man-made jetties at the Oceanside and Mission Bay harbor entrances, and the famous river-mouth set up of Trestles at San Diego's northernmost limits.

Even when surfers aren't out surfing, they're usually thinking about surf. This obsession has influenced the entire San Diego beach culture and even residents who don't surf embrace its important role in shaping their local identity. I met with local surfboard legend, Tim Bessell to learn about the process of shaping boards. Polyurethane foam can be cut to size, ranging from 5 ½ to 12 ft, depending on level of performance. It's sanded and coated with fiberglass.

Momento

Coast Walk Trail 4:30pm-5:30pm
1555 Coast Walk, La Jolla

La Jolla is full of hidden gems and beautiful coastal views, but there are few as gorgeous as the historic La Jolla Coast Walk Trail. First conceived in the early 1900s, the hiking trail has undergone several changes through the decades; today, it's one of the most popular hiking trails.

From the hike, you can spot several nearby attractions; including La Jolla Cove, La Jolla Shores beach, and on a super clear day, even downtown San Diego. The best way to see the beaches of La Jolla is to walk the shoreline of this upscale village. Part of this shoreline walk is officially called the La Jolla Coast Walk Trail, but few people walk the entire shore. It's a fun sandy trek that the entire family will enjoy. Look for wildlife along the route including colorful birds, friendly sea lions, and little critters in tide pools.

Chilling

Gaslamp District 6:30pm-9pm

The heart and soul of downtown San Diego filled with activities for any occasion, the Gaslamp is the perfect spot for a romantic date night, birthday celebration, bachelor/bachelorette party, bar hopping, or even simply dining out with the family. With a plethora of restaurants to pick from, from quick bites to fine dining, there are endless ways to satisfy your taste no matter what you are looking for.

After your meal, you can choose from a wide variety of entertainment options, including bars, clubs, cigar lounges, comedy shows, live music performances, and even rooftop escapes to avoid the crowded and busy streets. This is a one stop shop where everything is within a five minute walking distance and will surely make your night unforgettable.

A Tasty Choice

Spanish Revival houses are characterized by red tile roofs, stucco walls, decorative details, towers within the house, multi-pane windows and outdoor spaces. The Spanish architecture was deliberately selected to be in contrast to previous expositions in the eastern United States and in Europe. The display was so successful that Spanish Colonial Revival architecture became perhaps the dominant architectural style of San Diego in the 1920s.

CINCINNATI
CHILI

Chef's Note

Cincinnati is the textbook definition of revitalization. The old brick is deceptive, keeping its historic framework of the late 1800's, yet much of the city's interior is now modern and luxurious. Integrating its build around as many as thirteen hills, there's a surprise around every corner and up every slope. One of the pioneering industrial Midwest cities, the rust is starting to shine, the flowers along the Ohio River are blooming, as Cincinnati glitters with a view and vibe unmistakably its own. Here, east meets west, north meets south, old meets new and reinvention reigns. It's a city mounted with statues to commemorate its past, but they'll leave plenty of space for their next big thing.

Cook Time: 24 hours

	
7am	Riverfront Trail
10am	Proctor & Gamble Tour
11:30am	Underground Railroad Tour
2:30pm	American Sign Museum
4:30pm	American Corn hole Association
5:30pm	Go for a drive

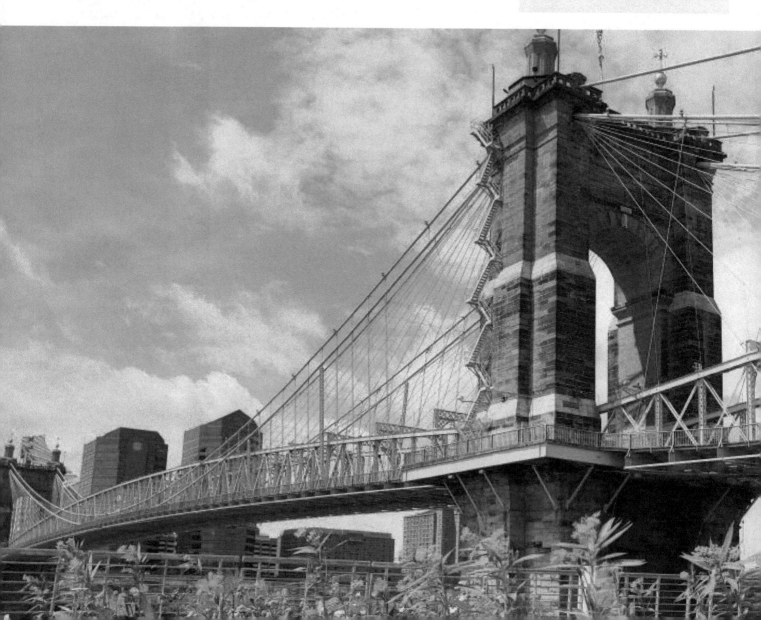

The Crockpot

The Lytle Park Hotel
311 Pike St.

Once an enclave for Cincinnati's elite, the historic Lytle Park is rising to prominence once again and along with it "The Lytle Park Hotel," born within a historic 1909 building, and intimately connected to the neighborhood's park. For Cincinnatians and out-of-town guests alike, this AAA Four Diamond hotel honors its refined roots while providing a refreshing hospitality experience animated by an irresistibly vibrant and captivating spirit. Guests will delight in the hotel's inventive juxtaposition of classic, historic and creative, seen in its decor, accommodations, cuisine and entertainment. It has a fine dining restaurant and rooftop lounge with the best views of the city.

Local Inspiring Flavors

Breakfast
Findlay Market
1801 Race St.

Ohio's oldest continuously operated public market and one of Cincinnati's most cherished institutions, welcoming more than one million visitors each year. Located just blocks from downtown in Over-the-Rhine, a dense historic neighborhood rich in 19th century architecture, Findlay Market remains the bustling center of farm fresh, locally sourced, artisanal and specialty foods. Home to more than 50 full-time merchants selling meat, fish, poultry, produce, flowers, cheese, deli, ethnic foods and more. On weekends, the Market also hosts a thriving Farmers Market, a vibrant Outdoor Market, numerous street performers and several special events.

Lunch
Camp Washington Chili
3005 Colerain Ave.

Stop by one of Cincinnati's beloved chili parlors! Open 24 hours a day, six days a week, Camp Washington Chili has been a staple on Cincinnati's West side since 1940. Here you will find the classic Cincinnati-style chili served on top of spaghetti and covered in mounds of cheddar cheese. The menu also includes burgers, sandwiches, and salads.

Dinner
Little Miami Brewing Company
208 Mill Street, Milford

State-of-the art, Small Batch, 7-barrel brewery and casual taproom serving our craft beer and Brick Oven artisan pizza in an open and airy brick warehouse along the Little Miami River and Bike Trail at the edge of old Milford which makes for an awesome destination location!

CINCINNATI
CHILI

Chopping

Biking the Ohio Riverfront Trail on a Cincy Red Bike 7am-8:30am

One of the best riverfront paths in the country, roll through the city like the Ohio River. Pass by historic bridges, public gardens and parks, and professional sports stadiums. It's an immaculate path and spans the entire front side of downtown for great views of Cincinnati and Covington, Kentucky.

Browning

Proctor & Gamble Tour 10am-11am

Learn how a company built on soap and candles became one of America's largest brand names. Discover the principles of innovation, research & development, and marketing to release successful everyday household items; Tide, Crest, Pampers, and Febreze. There's even a *Wall of Failures*, sometimes caused by being ahead of its time.

Draining

National Underground Railroad Freedom Center 11:30am-1pm

50 E Freedom Way

Located on the banks of the Ohio River – also known as the "River Jordan" – the National Underground Railroad Freedom Center shares stories of freedom's heroes, from the era of the Underground Railroad to contemporary times, highlighting today's ongoing enslaved issues and concerns. This museum challenges and inspires everyone to take courageous steps of inclusion and freedom. One of the best dedicated museums with intricate exhibits in America.

American Sign Museum 2:30pm-4pm

1330 Monmouth Ave.

This is the country's premier institution for preserving historic signs and promoting the sign industry's contributions to commerce, culture and the American landscape. From early, pre-electric signs adorned in gold-leaf, to the earliest electric signs, to beautiful art-deco neon, to the modern plastic-faced sign, the museum covers it all.

Simmering

American Corn hole Association 4:30pm-5:30pm

Corn hole is one of the Midwest's largest pastimes and some people claim that the sport was modernized in Cincinnati. It's no wonder that the headquarters of the national sports league is based in Camp Dennison, OH. If you're a fan of the sport, enter into a local bags tournament.

Let's get Cooking

MAKING GOETTA
Eckerlin Meats
116 W Elder Street

Why I Choice this Craft

It's not unusual for people to ask, "What the heck is goetta?" Great question, especially because you aren't likely to find goetta available outside of the Cincinnati, Ohio or Northern Kentucky geographic areas.

Here's the answer: Goetta is made by blending a unique mix of ground pork and beef, combined with onion and steel cut pinhead oats, a great blend of spices, and slow cooking it for hours. Eckerlin Meats goetta combines high quality, lean pork and beef products and fresh ground spices. They slow cook theirs in small batches to ensure that quality. After the goetta is cooked, they chill it and form it into blocks. Most people eat it for breakfast.

Topping

Drive through Milford and Indian Hill
5:30pm-6:30pm

Sometimes it's nice to explore outside the suburbs to learn about the everyday citizens of the city. I stumbled into quaint historic business districts, rushing rivers and shady bike trails of Milford and Indian Hill. I've never seen larger mansions in the country, where P&G and Kroger executives live.

A Tasty Choice

The topography of Cincinnati inspires discovery, causing your head to turn and twist, trying to capture the character of each neighborhood as you pass. Mt. Adams, Mt. Auburn, Walnut Hills, Mount Lookout, Vine Street Hill just to name a few hills within the city, separate the city into villages, making the city fun to explore. At one time in history, there was an incline tram that commuters used to go from downtown to their neighborhood up the hill.

OKLAHOMA CITY
RIB EYE

Chef's Note

Oklahoma City has been an integral part of America's interstate and railroad network, making the city a crossroads of unique history and culture. From the Frontiersmen, the Natives and Cowboys to the ranchers and oil drillers, it's no wonder Oklahoma City hosts the most eloquent cultural museums in the country. In addition to the city honoring its heritage, Oklahoma City is also the Modern Frontier, paving the way as a center of entrepreneurship and innovation, keeping its spirit of courage and adventure.

Cook Time: 34 hours

	
8am	Myriad Botanic Garden
9:30am	Bricktown
12pm	OKC National Memorial & Museum
3pm	Nichols Hills
5pm	Stockyard City
Day 2	
10am	National Cowboy & Western Museum
1pm	First Americans Museum

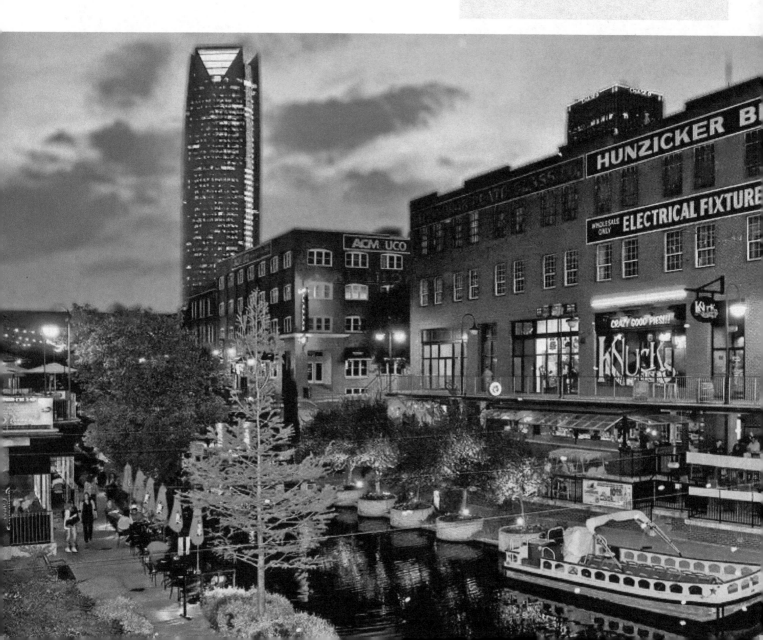

The Cast-Iron Skillet

The Ambassador Hotel
1200 North Walker Ave.

Located within the beautifully renovated Osler Building, this Autograph Collection preserves its 1920s boutique charm while providing a modern experience. This hotel is near a host of popular downtown attractions, including Chesapeake Energy Arena, Zoo Amphitheater and the Bricktown District. After a day spent working or playing, immerse yourself in our upscale rooms and suites, each featuring stylish design and modern amenities. After a good night's rest, get your heart rate up in the fitness center and seasonal outdoor pool, or get down to business in the two elegant meeting rooms.

Pre-heat

Myriad Botanical Gardens 8am-9am
Myriad Botanical Gardens is one of Oklahoma City's most beautiful and vibrant garden and park spaces offering visitors a 15pm-acre natural escape in the heart of downtown. Free and open to the public, the outdoor spaces include: ornamental gardens, a children's garden and playground, Great Lawn, lake, an off-leash dog park, water features including splash fountains for children and walking and jogging paths.

Bricktown 9:30am-11:30am
This thriving urban district is a tourist's dreamland, home to more than 45 restaurants, bars, and retail shops, along with family-friendly attractions, public art, museums, galleries, and even an urban beach for summer fun. The diversity of businesses, educational institutions, housing and leisure activities in this area make it a true 24/7 destination, one of the most distinct and historic in OKC. The canal makes for great views, walks and boat rides. At one time, this area was a dilapidated warehouse district, but now it's a modern treasure. This is a perfect example of how OKC cherishes its history with a modern touch.

Local Inspiring Flavors

Breakfast
Café Cuvee
1200 North Walker Ave.

Casual, romantic and fun bistro that serves hearty portions of authentic French comfort food in a warm and inviting setting.

Lunch
Toby Keith's I Love this Bar & Grill
310 Johnny Bench Dr.

From the oversized artwork to the redneck love seats (which are actually pickup tailgates), everything about this place is bigger and badder, just like the Big Dog Daddy himself!

Dinner
McClintock Saloon & Chophouse
2227 Exchange Ave.

They provide customers with a saloon and restaurant experience of a lifetime. The exquisite woodwork, flowing spirits, and smell of mouth-watering meat make you feel as if you've entered the "Gunsmoke" Long Branch Saloon. Don't expect their saloon to have hitching posts, swinging doors, or dancing girls. They take the saloon experience to the next level with a classy, beautiful atmosphere. The intricate details like our 50-foot long hand-crafted oak and brass bar done by local woodworkers give the saloon an authentic feel. The restaurant offers three dining areas with a mix of tables and booths. The chic new west decor includes elegant chandeliers to blend the old and the new. Step back in time and come on in to enjoy the best steak of your life and a hand-crafted cocktail.

OKLAHOMA CITY
RIB EYE

Seasoning

Oklahoma City National Memorial & Museum 12pm-2pm

620 N. Harvey

I'd argue that this is the best memorial and museum in America. The exhibits take you through a roller coaster of emotions, learning about the tragic Oklahoma City bombing event and commemorating the victims in the most peaceful and respectful way possible. I had the honor to meet and interview the daughter of a victim to learn about her inside perspective. This museum documents every piece and moment of the incident, before and after the event. Surprisingly, it leaves you inspired by the motto "Oklahoma Standard" – Show up to Serve. Rise up to Honor. Step up to be Kind. Oklahomans are proud of how they came together to respond to one of America's most tragic events.

Flipping

Take a Drive through Nichols Hills 3pm-4pm

Off of NW Grand Blvd, there are beautiful affluent neighborhoods, where many of the oil & gas executives live. Take in the pretty setting for a pleasant drive.

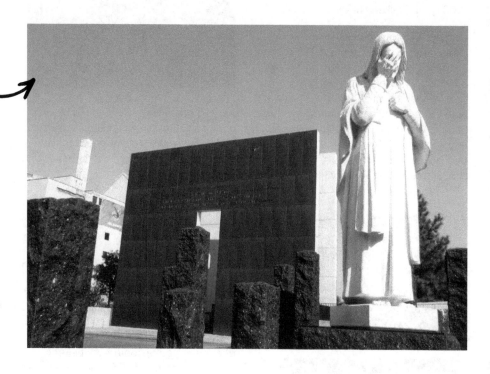

Stockyard City 5pm-7pm

If you want to experience the West or you have a western-themed project or concept, Stockyards City is worth a look, pardner. Stockyards City is the historic home to Oklahoma City's first industrial area (stocking and meat packing), beginning a public livestock market in 1910. Today, the Oklahoma National Stock Yards is still the world's largest feeder and stocker cattle market, with live cattle auctions every Monday and Tuesday.

In addition to the auctions, the district is well-known for its appropriately early 20th-century architecture and decor, western-themed businesses – and famous steaks. Stockyards City is a major tourist attraction for visitors and locals alike.

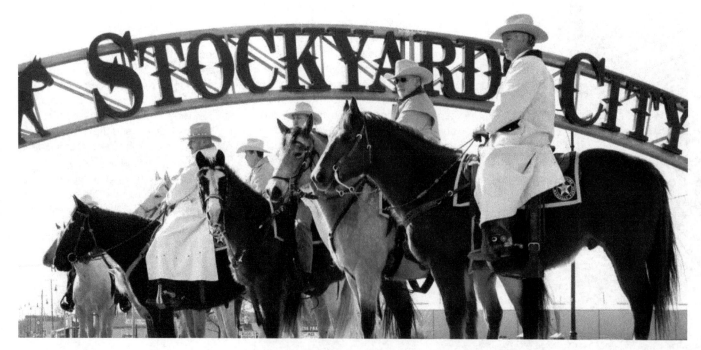

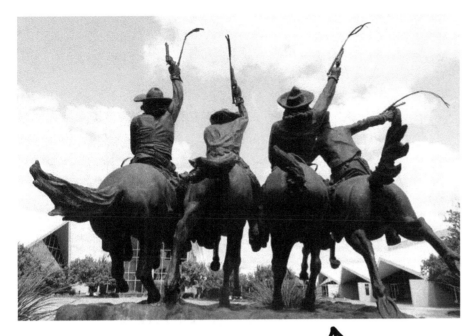

Momento

Resting

Day 2

National Cowboy and Western Museum 10am-12pm

1700 NE 63rd St

Check out America's premier institution of Western history, art and culture. Founded in 1955, the Museum collects, preserves and exhibits an internationally renowned collection of Western art and artifacts while sponsoring dynamic educational programs to stimulate interest in the enduring legacy of the American West.

First Americans Museum 1pm-3pm

659 First Americans Blvd

In one place, visitors experience the collective histories of 39 distinctive First American Nations in Oklahoma today. First Americans Museum shares the cultural diversity, history, and contributions of the First Americans. Only a few tribal Nations were indigenous to what is now the State of Oklahoma. All others were removed from homelands across the contiguous U.S. to Indian Territory. In 1907 Oklahoma became the 46th state to enter the union. The state's name comes from two Choctaw words "Okla" and "Homma" meaning Red People. Oklahoma is the territory of the Chickasaw, Choctaw, and Cherokee Indians.

Let's get Cooking

SERVING TRAY FROM RECLAIMED TRAIN CARTS

Boxcar Woody

1012 S. Agnew Ave.

Why I Choice this Craft

Connecting every city and almost every town across the United States is railways. The rails have seen our nation evolve over the decades. They've connected us, given us opportunities, and pathed the way for our story. The Stockyards of Oklahoma City wouldn't exist the way it has without trains transporting cattle. I wanted to tie in Oklahoma City's industry, transportation and history to make a significant piece.

A Tasty Choice

Oil & Gas companies are prevalent in Oklahoma City especially. Some of the most modern, largest and beautiful buildings are the headquarters of the most well-known oil businesses in the world. Devon Energy and Chesapeake Energy are just a few companies with impressive entrances of water features.

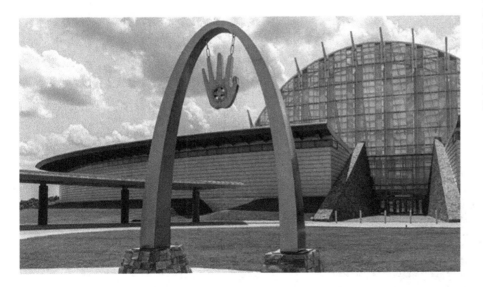

TOASTED
ST. LOUIS

Chef's Note

The Gateway Arch is not just a symbol of the Westward Expansion, but the doorway to one of America's great cities. The Mississippi and Missouri River intersect in St. Louis, flowing inspired ideas, authentic discoveries, energetic greenspaces, and cultured business districts. St. Louis offers a fulfilling life for the aspiring youth and the satisfied elders, making it one of the best places to grow and/or settle.

Cook Time: 26 hours

9am The Gateway Arch

12pm Forest Park

3:30pm Cathedral Basilica

5pm The Delmar Loop

Day 2

9am St. Charles, MO

The Air Fryer

Drury Inn – Forest Park
2111 Sulphur Ave.

A recognized hotel brand headquartered in St. Louis, Drury Inn is a part of the local culture and enterprise. The hotel's central location between South St. Louis neighborhoods is close to world famous Italian restaurants on The Hill, urban nightlife in The Grove and the Missouri Botanical Gardens in Shaw.

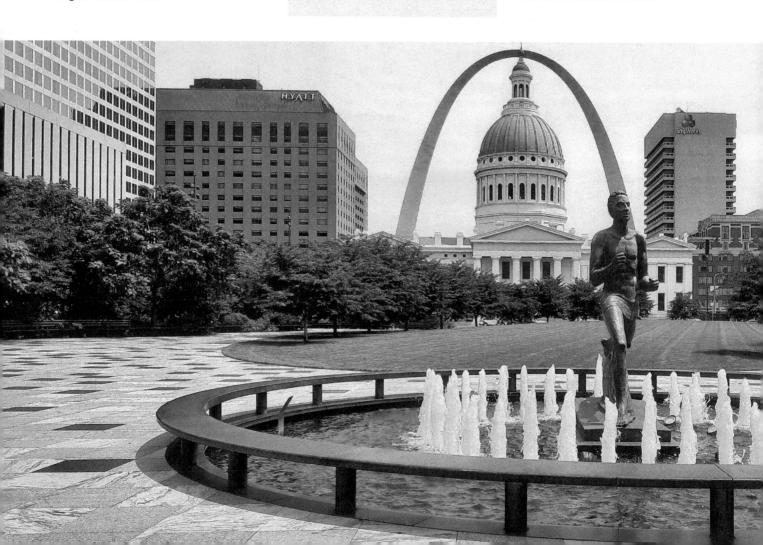

Whisking

The Gateway Arch and Museum
9am-11am

This American Monument is something you'll never forget. The tram to the top is an engineering wonder that has an incredible story of trial and error. After a 4-minute ride to the top, gaze at over 43,000 tons of concrete and steel making an iconic, elegant arc 63 stories high into the Midwest sky. Shaped by the inspired design of Finnish-America architect Eero Saarinen, the Gateway Arch celebrates the westward expansion of the United States and the pioneers who made it possible. Since its completion in 1965, the monument has taken millions of visitors on the trip to the top to enjoy stunning views stretching up to 30 miles to the east and west.

At the museum, trace the story of the Native Americans, explorers, pioneers, and rebels who made America possible. Featuring six themed exhibit areas, this innovative and interactive museum celebrates America's pioneering spirit.

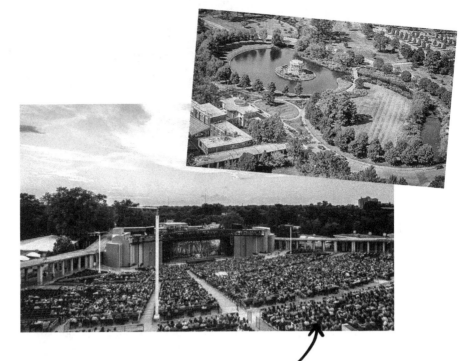

Watch a Show and Explore Forest Park 12pm-3pm

One of America's greatest parks and the heart & soul of St. Louis. It's where the community meets, plays and references. The Park's 1,300 acres feature beautiful landscapes sprinkled with forests, ecosystems, nature reserves, lakes and streams, as well as five of the region's major cultural institutions and endless opportunities for recreation. Forest Park truly offers something for everyone — amazing destinations and institutions that challenge the mind, a Dual Path system that invites both leisurely walks and intense workouts, quiet places to picnic and read, and a variety of popular festivals and events — all set in the background of a city oasis, a place to escape it all.

Welcome to St. Louis' theatre. For over 100 years, The Muny has captured hearts and sparked imaginations through music and movement. Each summer, they fill Forest Park with the sounds of Broadway — and they always leave a seat for you.

Local Inspiring Flavors

Breakfast
Egg Restaurant at Midtown
3100 Locust St.

Get a chance to explore Midtown and eat and an Eclectic brunch and lunch spot with good vibes and good food.

Lunch
Zia's
5256 Wilson Ave.

Located in the Heart of the Hill Neighborhood in South City, Zia's is a landmark Italian restaurant that has been in business for over 30 years and ran by the original owners.

Zia's is known for many dishes among which include Chicken Spiedini,

Seafood Pastas and Award-Winning salad dressing.

Dinner
Chicken Out
6197 Delmar Blvd.

Around here, they like to bawk around to the cool tunes of the great Cluck Berry, and enjoy their chicken sandies pressure-fried. This may be a new style for you, but they're sure the pleasure will be all yours. Pull up a seat and make yourself at home.

Dipping

The Cathedral Basilica 3:30pm-4:30pm

4431 Lindell Blvd.

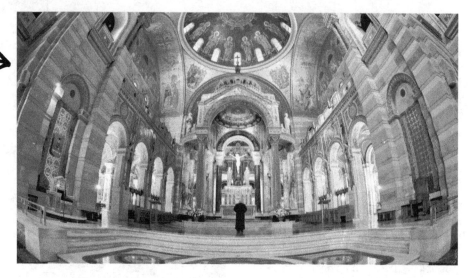

Nicknamed the "Rome of the West," The Cathedral Basilica of St. Louis is a one-of-a-kind work of art. With its lofty vaults and radiant mosaics, the sheer scale of beauty is a thing of awe. More than a dozen architects' and artisans' concepts and works have coalesced in a magnificently well-integrated and harmonious whole. From top to bottom, front to back, the Cathedral Basilica draws one's thoughts and emotions upward toward the contemplation of something transcendent.

The museum and tours offer any visitor a guided overview of just how much there is to see and learn about the historic site. The museum offers a glimpse at the history of the breathtaking church, its community, and events that led to its completion. Tours offer visitors the ability to learn more about the symbolism of many elements of the building while learning more about its rich history.

The Delmar Loop 5pm-7pm

The Loop offers eight blocks of exhilarating one-of-a-kind shops, restaurants, art galleries, live music, café culture, and the St. Louis Walk of Fame.

The Delmar Loop got its name over a century ago from streetcars that came west and "looped around" before connecting to other areas. That movement and momentum continues today, as The Loop expands with exciting new growth and development that has made it a destination.

Day 2

Air Frying

St. Charles, Missouri 9am-11am

A historic suburb worth seeing. Just west of St. Louis you'll find St. Charles, a river city with a unique historical perspective, beautiful sites, friendly people and a pace just a little slower than that of the big city. Founded as Les Petites Cotes (The Little Hills) by French Canadian fur trader Louis Blanchette, Saint Charles, MO grew into a thriving riverfront trading center for a young America. Make memories in the midst of our illustrious history. Saint Charles. A little mysterious - a lot of fun.

Momento

Let's get Cooking

GLASS MOSAIC

The Glass Workbench

318 S Main St, St Charles

Why I Choice this Craft

Upon the walls and ceilings of the Cathedral Basilica are over 41.5 million pieces of glass with 7,000 different colors. Within these mosaics are stories from the Bible and stories that represent the city of Saint Louis itself. I wanted to learn about making a glass mosaic and understand the intricacies of the art.

A Tasty Choice

The Gateway Arch is an iconic display, complemented the St. Louis skyline, giving the city a majestic appeal. The faint stencil in the sky, illuminates even in the gray clouds and can be seen from almost anywhere in the city. It's a backdrop that incidentally bolsters the landscape.

WILD-CAUGHT
SEATTLE

Cook Time: 22 hours

7:30am	Pike Place Market
10am	Ride the Ferry
1pm	The Space Needle
3:30pm	Washington Park Arboretum
7pm	Pike/Pine Corridor

Chef's Note

Drops of rain splash the head of the Space Needle, scouring the sides of the elevator window until it soaks the blinding green grass at its base. As the rain keeps pouring, water is pushed to wet the streets into Queen Anne neighborhood's hills, creeping its way into Discovery Park's shoreline of the Puget Sound, where water meets water. Every drop of rain's journey ends in the Puget Sound, navigating to the city's lifeline. Seattle is nearly an island, surrounded by bodies of water that captivate every demographic of the city, from the fishermen that hoists seafood to the gliding competitive collegiate rowers and the inspired grunge musicians to the coffee enthusiast and tech geeks.

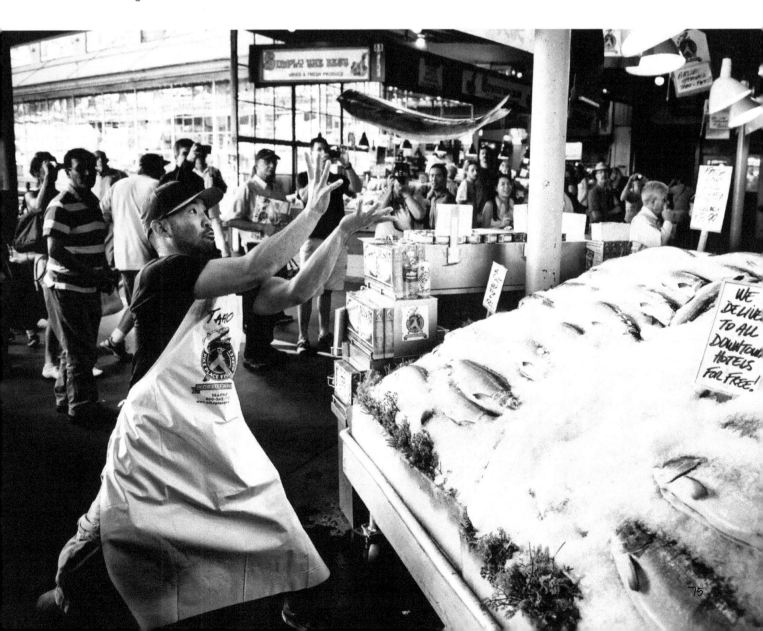

WILD-CAUGHT
SEATTLE

The Skillet

ACE Hotel
2423 1st Ave.

The first-ever ACE, fixed up with the unfussy luxury and intentional design ethos that drive the Pacific Northwest. This former fisherman lodge is a perfect taste of Seattle with great views of Puget Sound. Great wooden stairways to the front desk where you'll meeting welcoming staff. The feel is like your own apartment in the convenient neighborhood of Belltown.

Rinsing

Pike Place Market 7:30-9:30am
85 Pike St.

A Seattle treasure that speaks to the industry, culture, and history of the city. Most people think produce for Farmers Markets, but how about adding fresh fish from the Puget Sound and Pacific Ocean? This place is a tourist's dream, watching the fishermen sling fish to order, colorful lighting, narrow alleyways (one consists of gum on the walls), and an abundance of shops, restaurants, and bars. I enjoyed watching the workers early morning get prepped for the day ahead.

Take the Ferry to Bainbridge Island 10am-12pm
801 Alaskan Way Pier 52

An absolute must experience, crossing the Puget Sound, as many locals use the ferry to commute in and out of downtown Seattle. Driving your car onto the ferry is a unique experience for visitors. You'll have the opportunity to get stunning views from the upper level, as you walk the perimeter. Don't be surprised by the seagulls that follow the boat, trying to catch a rest and some food. Once on Bainbridge, feel free to drive around and get a sense of the local island life. On the way back, the views are even more stunning. If you're lucky, Mt. Rainer will poke through the clouds peering over the downtown skyline.

Local Inspiring Flavors

Breakfast
Macrina Bakery & Cafe
2408 First Avenue

The idea existed long before they opened our doors. The seed was planted while Leslie Mackie was in cooking school and continued to take root throughout her early restaurant career and during her travels. This place is bustling with neighborhood traffic and has a cozy atmosphere.

Lunch
Duke's Seafood
1111 Fairview Ave. N

Offering flavorful, tasty fare that features the very best food we source with painstaking vigilance. While they're known for our 100% sustainable seafood—fresh Dungeness crab, wild salmon, and prawns, to name a few—they also make a killer burger, fresh salads, and 4 award-winning chowders.

Dinner
Kabul Afghan Cuisine
2301 N 45th St.

I'd argue this is the best tasting food in the city. Serving the cuisine of Afghanistan's capital city, Kabul is a unique gem in Seattle's Wallingford neighborhood. As owner Wali Khairzada explains it, the ancient city of Kabul lay at the crossroads of trade between India and Central Asia, where for centuries, merchants, conquerors and explorers passed through, leaving their cultural influences behind, along with the finest delicacies from across the Asian continent.

Browning

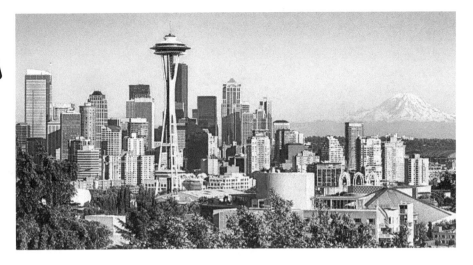

The Space Needle 1pm-3pm
400 Broad St.

One of the most recognizable landmarks in the world and is a treasured Seattle icon. Built for the 1962 World's Fair—the Century 21 Exposition whose theme was "The Age of Space"—the tower's futuristic design was inspired by the idea that the fair needed a structure to symbolize humanity's Space Age aspirations. Since its grand opening on April 21, 1962, the landmark continues to symbolize the innovative and forward-thinking spirit of Seattle. Located at Seattle Center, the Space Needle stands at 605' tall and is one of the most photographed structures in the world.

The tower's 520' saucer-shaped "top house" offers visitors Seattle's only 360-degree indoor and outdoor panoramic views of downtown, Mount Rainier, Puget Sound, and the Cascades and Olympic mountain ranges. If you're afraid of heights, this is a challenge, especially the glass flooring of the restaurant.

Flipping

Washington Park Arboretum
3:30pm-5pm
2300 Arboretum Drive E

The Pacific Northwest's nature is spectacularly rich, and the Arboretum is a welcome oasis on the shores of Lake Washington. Jointly managed by the University of Washington Botanic Gardens and the City of Seattle, its 230 acres contain a dynamic assortment of plants and lush trees. Take a walk through the Arboretum and discover this beautiful living collection.

Draining

Pike/Pine Corridor 7pm-8:30pm
There's no mistaking Capitol Hill's Pike and Pine corridor for any place other than Seattle. It's no wonder the grunge music was founded in this city, as this special neighborhood has an icky feel to it, yet filled with indie boutique shops and restaurants that have intricate quirky interior designs.

Let's get Cooking

Momento

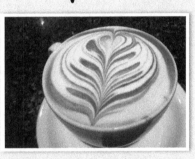

LATTE ART
Espresso Vivace
227 Yale Ave N

Why I Choice this Craft
Seattle is a coffee city. It's perfect for the rainy days, reading a book or meeting up with a friend at a quaint coffee shop. I met with David Schomer of Espresso Vivace, who popularized latte art in America. He learned how to work with foam in Italy and introduced to all the latte lovers putting designs into your cup in the late 1980's.

In his shop, he had a Wall of Fame, showcasing some of the best designs by his artists. I wanted to be on that wall. Here's the problem, this was not an easy creation. It takes years of practice, but it looks simple when demonstrated. What a beautiful touch of presentation to customers, shows a lot of love and care.

A Tasty Choice

In the Pike and Pine corridor, notice that every street pole is plastered with 10x15 paper advertising concerts, fundraisers, and political messages. On the back of every street sign, notice stickers with random messages. This type of advertising is seen on college campuses across the country, but in Seattle, nothing is removed, so these flyers are stacked and thick on the poles and signs. Can't believe there's any room for more.

CLEVELAND
KIELBASA

Chef's Note

From the beaches and marinas of Lake Erie to the Doan Brook Watershed and the Cuyahoga River, the attractions of Cleveland spreads as wide as the body of water it sits on and flows through. A storied industrial icon, Cleveland is a cultural and architectural hub that has created a pipeline of hard-working modest Americans that takes pride in its articulate production.

Cook Time: 26 hours

7:30am	The Flats
10am	Rock & Roll Hall of Fame
2pm	A Christmas Story House
5pm	Cultural Gardens
7pm	Playhouse Square
Day 2	
6am	Edgewater Park
9am	The Arcade

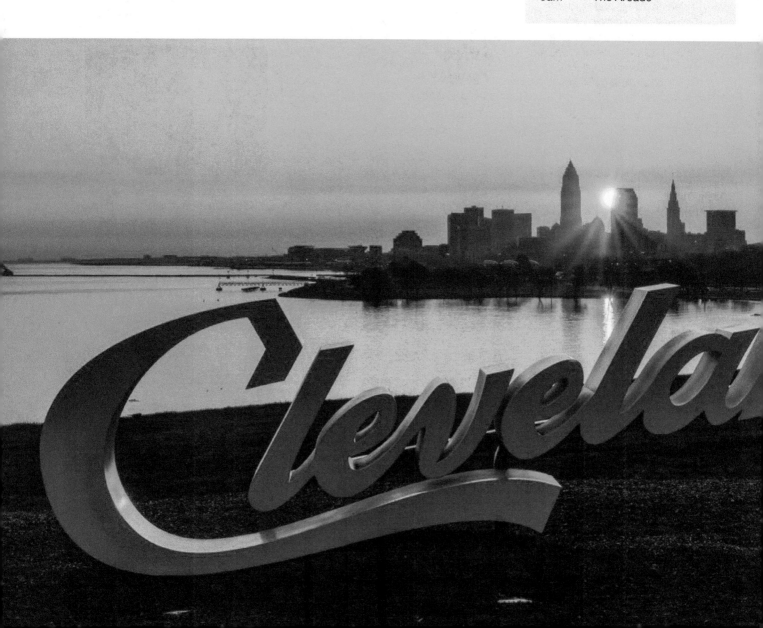

The Wood Smoker

Hilton Cleveland Downtown
100 Lakeside Ave. East

The 600-room Hilton Cleveland Downtown rises more than 30 stories tall and overlooks the downtown skyline and lakefront, including the Browns Stadium and Huntington Convention Center of Cleveland campus. The Burnham is the hotel's premiere restaurant that features an eclectic menu showcasing big flavors from across America. Other amenities include Eliot's Bar, a grab-and-go shop called The Noshery and Bar 32, which sits at the structure's 32nd floor with an indoor bar area and adjoining outdoor terrace proving panoramic views of Lake Erie.

Grinding

Bike or Kayak The Flats 7:30-9am
Beautiful bike paths and parks along the Cuyahoga River, called The Flats. There are tons of tour boats and kayakers in the Cuyahoga River, navigating through industrial plants and warehouses, as you look above in awe. I think this area is the standout attraction of the city. I haven't seen anything like it. People are catching on to this waterfront appeal, as condos and business are developing.

Local Inspiring Flavors

Breakfast
Yonder
3859 Superior Avenue

Visitors to Yonder are welcomed by the smells of bacon and maple syrup to start the day right. The restaurant opened in the St. Clair-Superior neighborhood near Downtown and features breakfast and brunch favorites, including cereal-infused French toast, croissant beignets and egg sandwiches.

Lunch
Slyman's Deli
3106 St. Clair Ave. NE

While certainly not the "haute couture" of upscale culinary, Slyman's Deli is a Cleveland institution that has been serving Cleveland's best and biggest corned beef sandwiches for decades.

Dinner
Collision Bend Brewery
1250 Old River Road

Named after the notoriously hard to navigate river upon which it overlooks, Collision Bend's 1863pm-built building offers guests waterfront dining on the outdoor patio along with a large, nautical-themed dining room and bar space. Former Great Lakes Brewing Company brew master Luke Purcell teamed with famed Cleveland chef and restaurateur Zack Bruell to create this riverfront brewery and full-service restaurant.

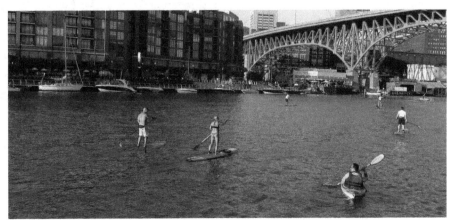

CLEVELAND

KIELBASA

stuffing

Rock & Roll Hall of Fame 10am-12pm
1100 East 9th St.

Lovers of music will melt here. The greatest stories and biggest names in rock and roll shine on at the Rock & Roll Hall of Fame, which celebrated its 25th anniversary in 2020. The experience includes four theaters, multiple interactive stations and seven floors that tell the story of the world's most powerful art form. The Rock Hall is dedicated to exploring the past, present and future of music and the cultural context from which it emerges.

A Christmas Story House 2pm-4pm
3159 W. 11th St.

More than a holiday season favorite, the restored Cleveland house where parts of the classic movie, "A Christmas Story," was filmed offers visitors a chance to take a picture with the famous leg lamp, hide under the sink like Randy did, and stock up on "fra-gee-lay" leg lamps and Lifebuoy soap. The house has been restored to its big screen look and includes original props and images for the public to enjoy.

smoking

Drive The Cleveland Cultural Gardens
Martin Luther King Boulevard and
East Boulevard 4pm-5pm
Northeast Ohio's oldest and most beautiful treasures. Some 33 dedicated gardens, designed and cultivated by distinct cultural or nationality groups, adorn the drive along Martin Luther King Boulevard and East Boulevard in Rockefeller Park. Depicted in the gardens are the poets, philosophers, peacemakers, composers, scientists and others who have contributed to world culture. Also featured in the gardens are symbolic sculptures and replicas of or tributes to sacred monuments in other lands.

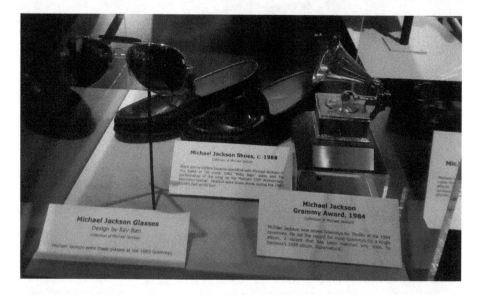

Watch a show at Playhouse Square 7pm-9pm
One of Northeast Ohio's brightest cultural gems, Playhouse Square is where memories are made, dreams are encouraged and excitement never stops. Entertainment is at the heart of what we do, but we are more than the largest performing arts center in the nation outside of New York. Through visionary leadership, Playhouse Square has become the steward of its vibrant downtown district.

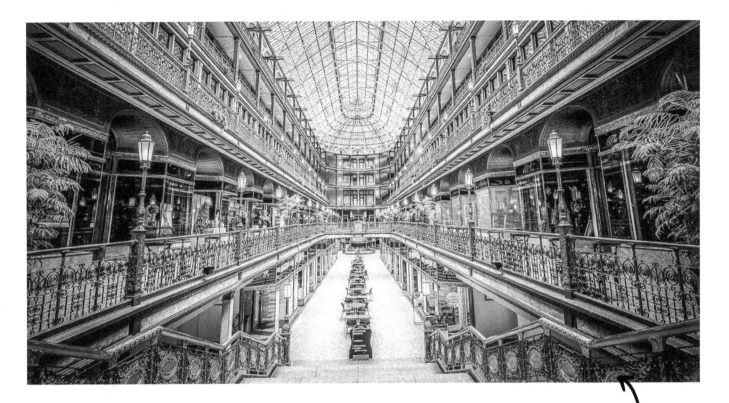

Chilling

Day 2

Watch the Sunrise on Lake Erie at Edgewater Park 6am-7am
Located in the Lakefront Reservation of the Cleveland Metroparks, Edgewater Park features two beaches and magnificent views of Downtown Cleveland within its 9,000 feet of shoreline. Visitors can also stop by the Beach House for beachside fare, refreshments and a seasonal outdoor bar.

Let's get Cooking

VINYL RECORD
Gotta Groove Records
3615 Superior Ave #4201a

Why I Choice this Craft
Considering Cleveland is the Home of Rock & Roll and the city that rocks, I wanted to make a record. Gotta Groove is a manufacturer of high-quality vinyl records and one of the only companies in the world that does everything for musical artists from manufacturing to design services and warehousing (in industry speak that's a fully vertically integrated vinyl manufacturing store). To date, Gotta Groove Records has worked on more than 10,000 individual vinyl releases.

Momento

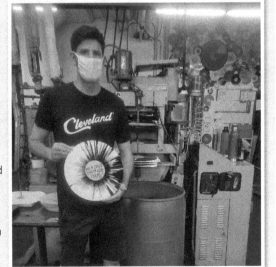

The Arcade 9am-9:30am
Timeless design and architecture frame boutiques and restaurants to create unique shopping and dining experiences. You will never guess how beautiful the interiors of buildings are in Cleveland until you go inside. Cleveland's buildings are massive, taking huge property, but that's the benefits of having great land mass.

A Tasty Choice

I have never seen neighborhoods fly their own flags or have their own symbol until visiting the neighborhood of Ohio City. Not only is there pride in Ohio and then Cleveland, but also in a neighborhood.

CAFFEINE-FREE
SALT LAKE CITY

Chef's Note

A dramatic jagged mountain range shields a diamond in the rough, known as Salt Lake City. The Wasatch Mountains can be a harsh and unforgiving range of desert, ironically the opposite reflection of its people in the valley. Salt Lake City is about image, carried by genuine smiles, cleanliness, and simplicity. The city has been prepared for expansion because Salt Lake City offers extravagant accessibility to nature, distinguished education and health, and a wealth of opportunity that makes for a fulfilled life.

Cook Time: 24 hours

8am	Memory Grove Park and the Freedom Trail
10:30am	Temple Square
1:30pm	The Great Salt Lake
5pm	Sugar House
6pm	City Creek Center and the Gallivan Center

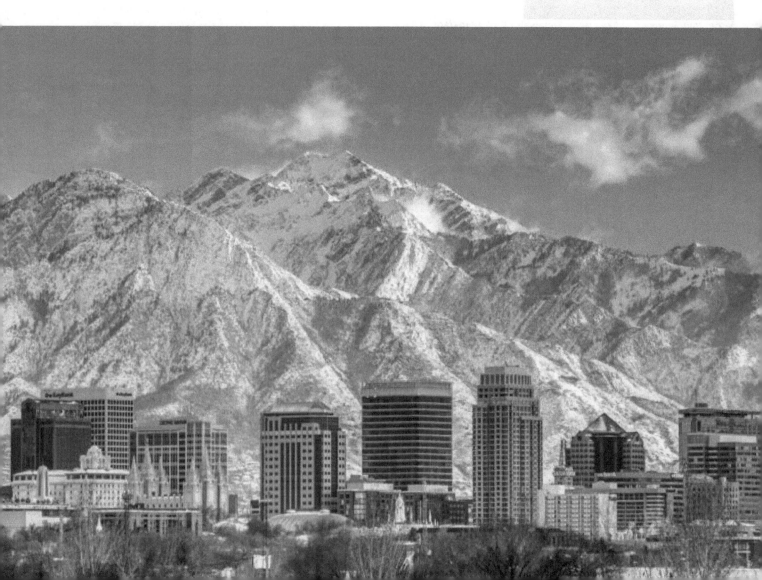

The Bottle

Kimpton Hotel Monaco
15 W 200 S

This hotel believes that life is meant to be fully lived with courageous gusto and no-regrets zest, so they've provided a dramatic, elegant and comfortable environment in which to do just that. Relax in their spirited guest rooms, relish delicious flavors in their restaurant and bar, and mingle in communal spaces that are emphatically eccentric and welcoming to all. They're located in the center of downtown in a walk-friendly city.

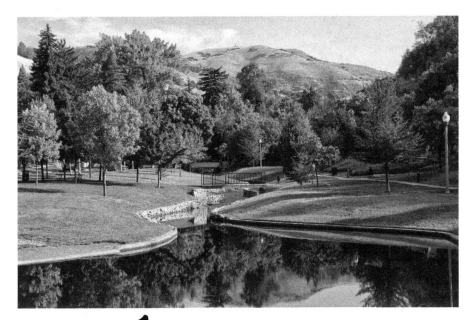

Boiling

Memory Grove Park and the Freedom Trail 8am-10am
300 N Canyon Rd.

A network of trails begins at this hidden gem, Memory Grove Park. Down the hill from the State Capitol Building is an enclave of nature where locals celebrate, play and meditate. Walk the meandering dirt paths along City Creek up into the sun-exposed hilly terrain to capture stunning views of the valley.

Combining

Temple Square 10:30am-12:30pm
50 N Temple

Walk the thirty-five acres of sacred grounds of the Church of Jesus Christ and Latter-Day Saints. Nearly twenty iconic and historic buildings tell the story of the Mormon history and culture that shapes most of the city. See what life was like back in 1856 in Brigham Young's home, listen to the Tabernacle Choir at Temple Square "America's Choir" and appreciate the locally sourced building materials that erected these stunning buildings. Temple Square is much more than a religious icon. It's a collage of fascinating history, singular architecture, and world-class performances. Temple Square

Local Inspiring Flavors

Breakfast
Bambara
202 S. Main St.

History and innovation go hand in hand at Bambara, from the decor to the menus. Critically acclaimed and locally loved, Bambara's grand arched windows, original brass accents and travertine marble blend stylishly with its contemporary design. In Chef Pacheco's dynamic exhibition kitchen, ingredients from local farmers and ranchers are reimagined as inspired New American bistro plates. In a nod to the diversity of tastes and preferences of clients, they offer a range of vegan, vegetarian and gluten-free options in addition to our regular menus.

Lunch
Won Won Kitchen
602 East 500 S suite c103b

Salt Lake City is saturated with Asian restaurants, but Won Won Kitchen is top rated. Located in Trolley Square, enjoy great food and stroll the repurposed historic shopping square.

Dinner
Blue Lemon
55 West South Temple

Just as consumers have grown tired and bored of traditional casual dining, Blue Lemon emerges with its unique dishes that offer superb nutrition without sacrificing taste. Based on the belief that food is the foundation of health, Blue Lemon presents an upscale family-friendly environment with a tantalizing menu. You will leave energized, refreshed, and most importantly, satisfied. And they make sure to leave a small environmental footprint by supporting sustainable farming and using recycled materials.

CAFFEINE-FREE
SALT LAKE CITY

Temple Square continued...

is Utah's most popular tourist destination. Part of its appeal lies in its accessibility: three city blocks in downtown Salt Lake City. Each building, you will be greeted by Mormon missionaries from around the globe that will help guide you through the grounds and answer any questions.

Mixing

The Great Salt Lake 1:30pm-4:30pm
Utah's Great Salt Lake is the largest saltwater lake in the Western Hemisphere and the eighth largest in the world. Sure, it's a geographical masterpiece, but for locals, the capital city's namesake inspiration is most noted for bison-spotting, bird-watching, Instagram-worthy photo backdrops and the boost it sometimes offers snowstorms called the "lake effect."

Lake visitors revel in its diverse ecosystem and abundance of wild animals. Home to both the Great Salt Lake State Park and Antelope Island State Park, Great Salt Lake is a popular destination for boating, swimming, hiking, camping and wildlife viewing. Brine shrimp inhabit the saltwater, bison roam the lake's Antelope Island and millions of migratory shorebirds and waterfowl take refuge in the 400,000 acres of surrounding wetlands. A fun fact: the ocean is around 3% sodium-chloride, while the Great Salt Lake is 30%.

Carbonating

Sugar House Neighborhood 5pm-5:45pm
It might be one of the hippest, most vibrant neighborhoods in town, but Sugar House earned its name from the sugar beets first planted here by pioneer settlers a century and a half ago. Since those humble, verdant beginnings, Sugar House has sprouted into one of the most offbeat, colorfully progressive enclaves in the valley. You'll find plenty of restaurants, bars, breweries, shops, unexpected hangouts, and one big, glorious park with sweeping mountain views. Park your car on one of the tree-lined streets dotted with colorful Victorians and stout bungalows.

Let's get Cooking

FOSSILS

Natural History Museum of Utah
301 Wakara Way

Momento

Why I Choice this Craft

Utah is fossil country. All around the state, from the west desert to Vernal, paleontologists have made fantastic discoveries and only 10% of the state has been surveyed. Experts from the NHMU and other institutions have documented a litany of new species, many only found in Utah. The rocky landscape is the best in the world for preserving fossils for millions of years. I worked with Tylor Birthisel, Paleontology Lab Director on how to prepare fossils that come through the museum's doors. Heavy machinery hauls large boulders encapsulating bones of dinosaurs, alligators, and many other species to be reconstructed and displayed on the museum. I worked on an alligator living over 16 million years ago, using a mini jackhammer to chip away the surrounding rock. Thousands of hours of patience and vision are spent by volunteers to make this art possible.

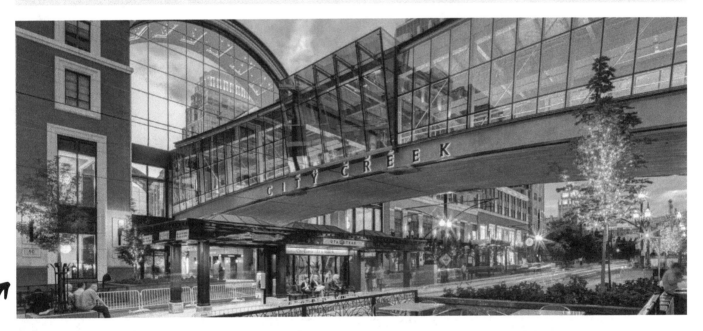

City Creek Center and The Gallivan Center 6pm-8pm

A must-see attraction, with a fully tractable glass roof that opens and closes, unique to any shopping center in the United States. A pedestrian sky bridge over Main Street unifies the center on two city blocks. Water features include a creek that runs through the center, a fishpond with local trout and waterfalls. The Fountain offers hourly shows and feature shows with three choreographed songs at 7 pm and 9 pm. Fire elements are added to the fountain shows after dusk. Check out the alleyways of continued shops with sting lights overhead.

Head to the Gallivan Center for a picture-perfect ice-skating rink setting.

A Tasty Choice

A small stone marker on the southeast corner of Temple Square is the epicenter of Salt Lake City's grid system. With the streets Base and Meridian marking the coordinates 0 East, 0 West, 0 North, and 0 South, the Salt Lake City grid system expands in increments of 100. Moving one block north of the Base and Meridian marker, you'll find 100 North. One block south of the Base and Meridian, you'll find 100 South. This system extends well into the suburbs.

85

DRAFT
MILWAUKEE

Chef's Note

It's no surprise that Milwaukee is known for beer, cheese, and bratwursts. Let's not forget Polka and the Fish Frys. There are many excuses for social gatherings in Milwaukee, whether at the beer halls, beer gardens, concerts, sporting events, and city parks (uniquely marked by wooden posts). The cliché of the Midwestern's friendliness holds true here; warm and open. The city on the lake, also has an impressive intersection of rivers in the heart of downtown, making this a boater's paradise.

Cook Time: 20 hours

8am McKinley Park Pier

11am Brewery Tour

1pm Forest Home Cemetery

4pm Polka lesson

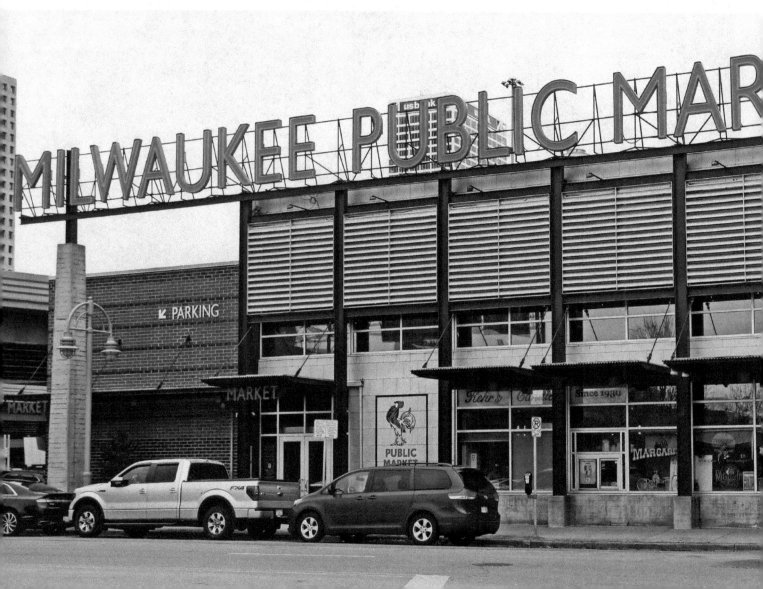

The Brew Kettle

Cambria Hotel Downtown
503 N. Plankinton Avenue

Located in the Westown neighborhood near Historic Third Ward. This central downtown location puts you within walking distance of some of the city's best shopping, dining and entertainment, including the foodie-favorite Milwaukee Public Market and the scenic Milwaukee River—where you can board one of the Milwaukee Boat Line sightseeing tours.

Local Inspiring Flavors

Breakfast
Milwaukee Public Market
400 N. Water Street

A must stop during any trip to the city. For more than 100 years, Milwaukee's Historic Third Ward served as a hub for a bustling procession of grocery commission houses. At the Milwaukee Public Market, the focus is on Wisconsin-products, including decadent, home-made chocolates, artisan cheeses and creamy frozen custard. You'll also find surprises such as sushi, lobster dinners, a wine bar and flavors of the Middle East and Mexico and a demonstration kitchen where Milwaukee's finest chefs share their secrets.

Lunch
Mader's Restaurant
1041 North Old World 3rd St.

Feel like you're in Germany in this part of the city. Founded in 1902, when the majority of Milwaukee's population German immigrants and their beverage of choice was beer. This was an era when "Bucket Boys," toting a wooden pole with buckets of beer dangling along the lengths, would make their rounds within the office buildings. Their refreshing goods were passed around to all – the early beer capital's answer to the coffee break.

In 1920 a crushing blow struck the humble tavern: Prohibition! Charles Mader hung a large sign in his window: "Prohibition is at hand. Prepare for the worst. Stock up now! Today and tomorrow there's beer. Soon there will only be the lake."

Forced to reinvent or close down, Mader's wife, Celia saved the establishment. She turned her full attention to creating the rustic, familiar German dishes of her homeland: Sauerbraten, Wiener Schnitzel, and Pork Shank.

Dinner
Lakefront Brewery
1872 N. Commerce Street

Nestled along the Milwaukee River, Lakefront is home to award-winning brews. Two home brewing brothers founded this microbrewery in 1987. Catering to niche markets has aided the popularity of its beers across its territory of 37 states, Canada, Israel, Australia and Japan. For instance, all of Lakefront Brewery's beers are designated Kosher, which has helped them achieve a small presence in Israel.

MILWAUKEE

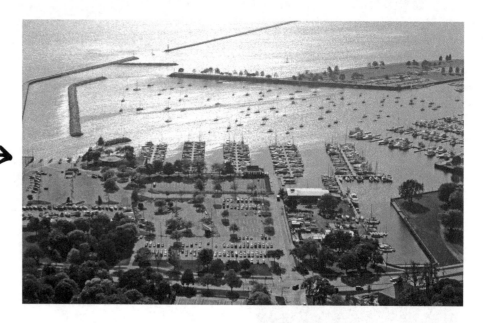

Milling

Walk the McKinley Park Pier
8pm-9:30am

Milwaukee sits along Lake Michigan with stunning views of the city's skyline, lakefront parks and boating docks. If you want to take it all in, walk out onto the lake of the extensive pier. Watch boats sail the waters and fishermen fish from the docks. If the walk is not long enough, try navigating through shady trees on the lakefront paths.

Mashing

Brewery Tour (Many to Choose From)
11am-12:30pm
Miller Brewery
4251 W. State St.

Here in Miller Valley you will experience an indoor/outdoor guided walking tour of over 160 years of brewing history. Experience everything from Fredrick Miller's arrival in Milwaukee to the high-speed production lines used today. Your tour seamlessly blends the rich history of Miller Brewing Co. with the modern technology of today's brewing process. Tours begin with a beer because… why not? Immerse your senses as they take you back in time to their famous underground caves and historic, Bavarian-Style Miller Inn. Don't worry, you will rejoin us in the 21st Century as they move on to their modern operations including their Brew House, Packaging and Distribution Centers. Ice-cold refreshing samples of their finest brews will be served at various stops along the tour (and after!)

Forest Home Cemetery 1pm-2pm
2405 W Forest Home Ave.

Visit the final resting place of many beer barons, like Joseph Schlitz and Frederick Pabst.

Fermenting

Learn how to Polka 4pm-7pm
Lakefront Brewery
1872 N. Commerce Street

Milwaukee is the Province of Polka and could be found at any beer hall and festival. The sounds of the accordion are so cheerful it will get you bouncy, as that's just how it's done. Polka dancing is a must in Milwaukee and a guaranteed a great time.

Momento

Let's get Cooking

FOAM CHEESEHEAD
Foamation: The Original Cheesehead & Factory
1120 S Barclay St

Why I Choice this Craft
Although created for the Green Bay Packers, the foam cheesehead was created in Milwaukee. It's a great example of the American Dream through its innovation, where a home-made project of a couch cushion turns into a sports phenomenon. The secret is the yellow coloring. Pour a batch into the mold, wait 7 minutes for it to heat and press, voila.

A Tasty Choice

Beer gardens or as they say in Milwaukee, Biergartens are prevalent throughout the city. Common meeting spots during the day and nights, where people enjoy drinking and eating at picnic tables under the sunshine with live music. Since temperatures in Wisconsin get frigid, there are plenty of beer halls (indoors) to make this a year-around experience.

HOUSTON
TORTILLA

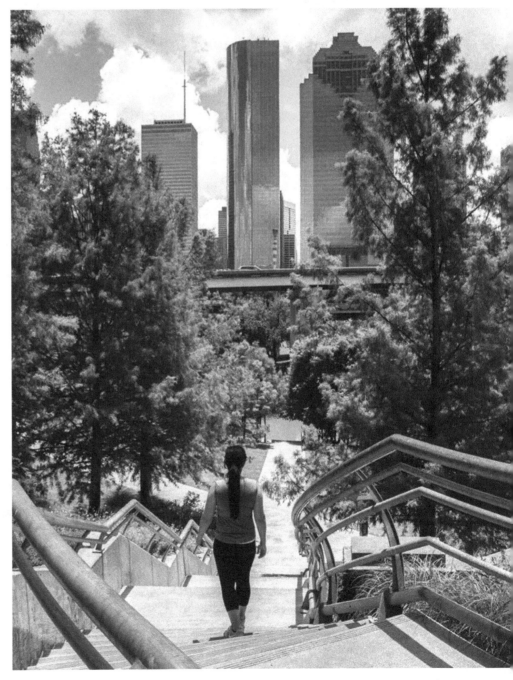

Cook Time: 24 hours

Time	
7am	Buffalo Bayou and Memorial Park
10am	Space Center
2pm	River Oaks and The Galleria Mall
4:30pm	Hermann Park and the Museum District
7pm	Theatre District

Chef's Note

Houston is the template for the future of America's cities. An alluring blend of diverse cultures, co-exiting to redefine the checklist of urban amenities and features that are essential for prosperity and advancement. From the exuberant theatre district and sport arenas, and the innovative healthcare centers, to the manicured green space, Houston considers appealing to everyone, whether working or retired, an immigrant or native.

Pre-heating

Buffalo Bayou Park & Memorial Park
7am-8:30am

At one of America's finest park systems, complemented by a meandering Buffalo Bayou River, I couldn't stop singing and smiling, traversing through dense woods, narrow pedestrian bridges, and public art pieces. It's a breathtaking stretch from downtown to the enormous Memorial Park. A must to capture views, immerse into Houston's nature and adventure through different parts of the city!

HOUSTON
TORTILLA

The Cast-Iron

C. Baldwin Hotel

400 Dallas St.

In the heart of Houston, the C. Baldwin redefines the idea of modern indulgence in a luxe hotel experience. Through a fusion of sensuous materials, sophisticated touches, impressive guest rooms, and incomparable culinary offerings, this hotel holds the secrets of the past and promises of the future.

Whisking

Space Center Houston 10am-12:30pm

1601 E. NASA Pkwy.

Discover the exciting future and remarkable past of America's human spaceflight program set among the largest collection of space artifacts in the southwestern United States. Take a behind-the-scenes tour of the facility, and undergo a special training session just like the astronauts do. You have a unique opportunity to touch a rock from the moon! After visiting here, you'll say, "Houston, we don't have a problem!"

Kneading

Drive River Oaks Neighborhood and The Galleria Mall 2pm-4pm

Occasionally, a drive through an affluent neighborhood is worth the visit. There is no modesty of the homes in River Oaks. I'd say these are the most enormous urban homes in the country.

Nearby, find the upscale and decorative Galleria Mall. The indoor ice-skating rink is quite the feature!

Local Inspiring Flavors

Breakfast
The Breakfast Klub

3711 Travis St.

This breakfast hot spot has become a staple within the Houston community and visiting celebrities, including Comedian Kevin Hart, former Houston Texans receiver Deandre Hopkins, and more. Whether it's the wings & waffles or the katfish & grits, guests can indulge in southern comfort food just like grandma used to make.

Lunch
Blood Brothers BBQ

5425 Bellaire Blvd. Bellaire, TX

The trinity (consisting of two brothers and a best a friend) took their love of food and barbecue to new heights as they put an Asian twist on traditional Texas BBQ. Guests can enjoy some of their smoky favorites, such as brisket fried rice, Thai peanut butter sticky ribs, and smoked turkey banh mi.

Dinner
Xochi

1777 Walker St.

Located in the Marriott Marquis and award-winning chef Hugo Ortega's second restaurant, Xochi provides guests an authentic Oaxacan fare with signature cocktails and homemade Mexican chocolates.

Rolling

Explore Hermann Park and the Museum District 4:30pm-6pm

A bountiful assortment of entertainment: a golf course, an outdoor theater, a jogging track, a beautiful rose garden, picnic spaces, a butterfly exhibit, and even a museum.

Hermann Park, presented to the City of Houston by George Hermann in 1914, is Houston's most historically significant public green space. Over the years, the Houston Zoo, Miller Outdoor Theatre, the Houston Museum of Natural Science, Japanese Garden, Rose Garden and Hermann Park Golf Course, one of the first desegregated public golf courses in the United States, all have added to the Park's importance as a recreational destination.

Hermann Park, located minutes from downtown Houston, is a cultural and recreational hub surrounded by the Texas Medical Center, Rice University, the Museum District, and various residential neighborhoods. The entrance to the park is at the intersection of Main St. and Montrose Blvd. Upon arriving at Hermann Park the visitor is greeted by a statue of one of Houston's founders, General Sam Houston. He points in, towards the park, leading the park visitor in the direction of it's many amenities.

Flipping

Watch a Show in the Theatre District 7pm-9pm

A highly concentrated center for the performing arts in downtown Houston is a must. Like they say, everything is big in Texas, so are the theaters. Find a show at The Hobby Center of Performing Arts, Broadway at the Hobby Center, Alley Theatre, Houston Grand Opera, Wortham Theatre Center, Houston Symphony at Jones Hall, and others.

Let's get Cooking

MODEL NASA ASTRONAUT
Space Center Houston

Why I Choice this Craft

One of America's most famous quotes, "Houston, we have a problem!" communication from the astronauts of the Apollo 13 mission to the Control Center, will always be associated with the city's history. After visiting the Space Center and getting basic astronaut training, I casted a model figure of an astronaut.

Momento

A Tasty Choice

With 10,000 restaurants representing cuisines from more than 70 countries and American regions, Houston's restaurant scene is as ethnically diverse as its more than 6-million residents.

COLUMBUS
FUDGE

Chef's Note

Columbus is the trifecta of a city; college town, capital city and the largest in Ohio. That doesn't happen. Ever. A city themed with arches, bricks and fountains, preserving its historic character, yet modernizing to appeal to the next generation.

Cook Time: 21 hours

7:30am	Scotio Mile
10am	German Village
11:30am	Schiller Park
1pm	The National Veterans Memorial and Museum
2:30pm	Dublin, OH
4:30pm	Columbus Zoo

The Square Pan

Graduate Columbus
750 N High St

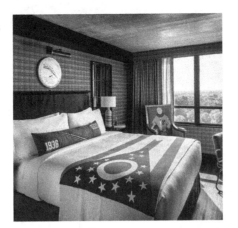

Rekindle the spirit of your alma mater at the smartest place to stay in town. Located in the heart of the Short North Arts District, Graduate Columbus is surrounded by dozens of shops, galleries and restaurants, and is just a hop from The Ohio State University campus.

Settle into our warm, tailored spaces, where plaids in scarlet and gray mingle with punchy pops of color. Our lobby chandelier is in tune with 'The Best Damn Band in the Land' and guestrooms salute the state of Ohio with gold-medal-worthy details. Take in nods to Olympic-icon Jesse Owens and astronaut John Glenn. The custom art collection may give you 'Goosebumps' — or get your stomach growling.

Melting

Walk the Scotio Mile 7:30am-9am
Located in the heart of downtown Columbus, the Scioto Mile is an urban oasis comprised of more than 175 acres of lush parkland. Stretching along the waterfront from the vibrant Arena District to the natural beauty of the Whittier Peninsula, this riverfront parks connect downtown to the Scioto River through an integrated system of parks, boulevards, bikeways and pedestrian paths.

Whisking

German Village 10am-11:30am
One of the most atmospheric neighborhoods in the Midwest. Originally built by German settlers in the mid-1800s, the lovingly restored brick houses, shops, streets and sidewalks are full of historic charm and modern swank. German Village has ample food options, both German and otherwise, as well as bars and breweries for those who imbibe.

Local Inspiring Flavors

Breakfast
Take a stroll down N. High St., where there's plenty of options. High St. is jammed packed filled of boutique shops and local restaurants. I've never seen a more heavily concentration of business on one street.

Lunch
Molly Woo's Asian Bistro
1500 Polaris Parkway

With red lanterns, Asian artifacts, high ceilings, and dramatically flavored Pan-Asian Cuisine, this place reverberates with the incredible energy and big flavors of all things Asia. If you want to experience Columbus outside of downtown, the Polaris Fashion Place is a great location.

Dinner
The Pearl
641 N. High St.

The Pearl showcases made-from-scratch food, classically inspired cocktails and an exclusive selection of Ales, Lagers & Stouts. All within one cozy tavern atmosphere. The variety of food is incredible and the presentation is unbeatable.

COLUMNS

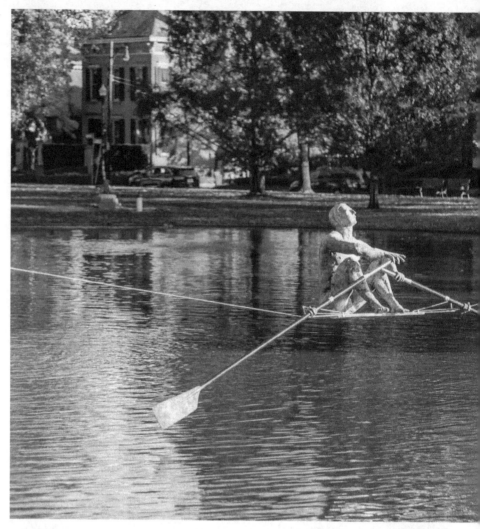

Schiller Park 11:30am-12:15pm
1069 Jaeger St

Take a stroll through a quaint neighborhood park, surrounded by beautiful homes and mature trees. The brick paths are charming, crossing over wooden bridges. The sculptures hang high above you all throughout the park. Very unique and creative.

Pouring

The National Veterans Memorial and Museum 1pm-2pm
300 West Broad Street

There's only one Museum in America that honors ALL Veterans – from all branches of service, and from all eras of our nation's proud history of military service, both peacetime and wartime. The National Veterans Memorial and Museum is a powerful and personal experience designed to give a voice to every man and woman who answered the call for our country.

This is neither a war memorial nor a military museum. The National Veterans Memorial and Museum takes visitors on a narrative journey telling individual stories and shared experiences of Veterans throughout history.

Cooling

Explore Dublin, OH 2:30pm-4pm
Every now and again, suburbs are a must to explore, and Dublin is one you don't want to miss. Beautiful bridges and parks in a historic downtown would make a great stop to see before heading to the Columbus Zoo, which is just a few miles away.

Let's get Cooking

CANDLE

Penn & Beech Candle Co.

751 N High St.

Why I Choice this Craft

Candles have been a part of Ohio's history, considering its natural resources provide the ingredients to make candles and soap. Creating a custom fragrance is a social experience and Penn & Beech is the perfect destination for a date night, girls night out, wedding shower, birthday celebration, bachelorette party or team-building event.

Momento

Columbus Zoo 4:30pm-8pm

One of the highest rated zoos in America period and Jack Hannah transformed this aging collection of pens and buildings into the world-class education and recreational organization the Columbus Zoo and Aquarium has become. With 10,000 animals in six distinct regions the Columbus Zoo and Aquarium is an education and recreational complex that provides a journey for your body and your imagination.

A Tasty Choice

Columbus is the best city for conferences. It's centralized, easy to get around and there's plenty of attractions on just one street; High St. From the historic brick themed district of German Village, through downtown Columbus, the young and energetic Short North District to the Ohio State University campus. You can see it all on one street.

FORT WORTH
CHILE CON QUESO WITH
DALLAS FROZEN MARGARITA

Chef's Note

Dallas, an extravagant modern city combined with Fort Worth's pull up your bootstraps grit, represents everything Texas, and influences the rest of country being home to 'America's Team,' Dallas Cowboys, smoked barbeque, the oil & gas industry, and old western wear. Just a few overpasses and an Interstate-30 drive from one another, Dallas is home to plush shopping districts, neighborhood complexes, elaborate downtown fountain plazas, and clean architectural designs, while Fort Worth is sticking to the authentic historic cowboy appeal, Mission/Spanish Revival builds with hand-laid brick streets. These two cities will always be trending, knowing the power of influence it has culturally and economically.

Cook Time: 28 hours

8:30am	The Katy Trail
10:30am	Drive Highland Park
12pm	Deep Ellum
2:30pm	Fair Park
4:30pm	Sundance Square Stockyards 6:30pm
Day 2	
9am	Dallas Cowboys Stadium Tour

The Skillet

SpringHill Suites at Fort Worth Historic Stockyards
2315 N. Main St. Fort Worth

Offering unparalleled views of the Fort Worth skyline from their rooftop restaurant. Enjoy staying in a comfortable suite, just steps away from experiencing the cowboy life near I-35W in the Fort Worth Stockyards National Historic District. Start your day with a specialty coffee at their spacious lobby bar, then walk to the Stockyards to explore the shops, restaurants, rodeos and cattle drives that keep the spirit of Texas alive. An ideal place to be while in Dallas-Fort Worth.

Browning

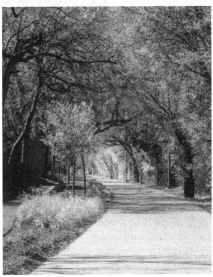

Walk/Bike the Katy Trail 8:30am-10am
What a great way to explore behind the scenes of Dallas on this popular walking, running and biking path through some of Dallas' most popular neighborhoods. Running from near the arena of the Mavericks to North Dallas, the 3.5pm-mile path provides easy access to attractions, restaurants and other things to do in Uptown. Reverchon Park and Turtle Creek Park are along the way, showcasing the best of the city's nature and affluent neighborhoods.

Drive Highland Park 10:30am-11:30am
You just can't miss the north part of Dallas. This extraordinary neighborhood, Highland Park speaks first-class, starting from the Lakeside Park through the Dallas Country Club on Mockingbird Lane to the campus of Southern Methodist University. This area is one of the most prestigious in the country, feeling like a separate society. This is a true flavor of the high-life.

Draining

Deep Ellum Neighborhood 12pm-2pm
A tradition of free expression and creativity lives in the multi-block neighborhood of Deep Ellum. Notice the intense public art sculptures and murals, hip restaurants and bars. Not like the rest of Dallas, history is preserved as a former warehouse district and a place to explore antique shops and live entertainment.

Local Inspiring Flavors

Breakfast
Crickles and Co
4000 Cedar Springs Rd
Suite E, Dallas

A brunch bakery that strives to create classic American foods with an emphasis on healthy options and seasonal ingredients. They are a scratch kitchen, meaning we create all items from raw ingredients, not poured from a can or un-frozen. They create their own salsa, jams, salad dressings, desserts, etc.

Lunch
Vidorra
2642 Main St. Dallas

Celebrating Mexican food, drink and culture. The name means "the good life," the restaurant offers bold and exciting Mexican flavors, along with a large tequila selection, unique cocktail program, and lively social experience.

Dinner
Reata
310 Houston Street, Fort Worth

Legendary Texas cuisine. From the moment you pass through our doors, the unmistakable ambiance of Reata embraces you. Casual elegance abounds, whether you choose to lounge in the bar or take in the view from the rooftop patio.

97

FORT WORTH
CHILE CON QUESO WITH
DALLAS FROZEN MARGARITA

Fair Park 2:30pm-3:30pm
3809 Grand Ave. Dallas

Home of the State Fair of Texas and the world's largest collection of art deco exhibit buildings, the 277-acre complex hosts more than 1,200 activities every year. From festivals and concerts to sporting and gardening activities, Fair Park has somethings for everyone. This is home to the famous Cotton Bowl and the giant Cowboy statue.

Chopping

Sundance Square 4:30pm-6pm
The heart of downtown Fort Worth is Sundance Square, a 35-square-block shopping and entertainment district where charming, beautifully restored buildings stand alongside glittering skyscrapers. Here, you'll find locals, downtown residents and visitors among a multitude of restaurants, shops, galleries and performance venues.

Stirring

Fort Worth Stockyards National Historic District 6:30pm-9pm
One of America's most cherished and popular districts. Fort Worth is where the West begins, and nothing embodies Western heritage better than this historic district. From the original brick walkways to the wooden corrals, every inch of the Stockyards tells the true history of Texas's famous livestock industry. There's always something going on here! Once home to cowboys, cattlemen and outlaws, today filled with music, restaurants, rodeos and the great cattle drive.

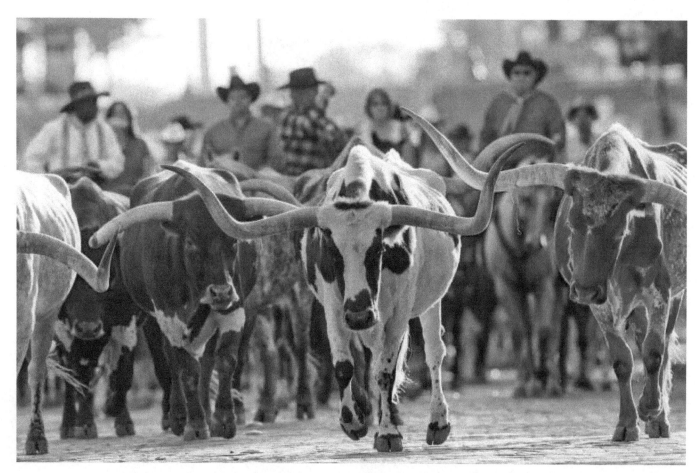

Let's get Cooking

HORSE SADDLE
M.L. Leddy's
2455 N. Main Street Forth Worth

Why I Choice this Craft

Momento in Fort Worth

Fort Worth was part of the historic Chisolm Trail, where cowboys moved cattle from Texas to Kansas. This city quickly became known as 'Cowtown' and an important trading post. When the railroads were built, Fort Worth stayed on top as a major shipping point for livestock, even horse and mule. Of course, the cowboy culture grew and so did handmade leatherwork. I learned how to tool leather, creating custom designs and shapes that typically cost $5000 for a saddle.

Pouring

Day 3

Dallas Cowboys Stadium Tour 9am-11am
One AT&T Way, Arlington

This iconic American sports stadium is more than the home of the Dallas Cowboys, it's a world of facts and figures about the world's largest domed structure, an art museum, a classroom. The things you can do inside the stadium are endless, and with these stadium tours, you can experience them all.

AT&T Stadium offers tours that will appeal to people of all interests and ages, and tours are available daily. Take the morning to throw the ball on the field, soak in the history or admire the works of art displayed throughout the stadium. If you're lucky, you might catch a rehearsal of the most famous cheerleaders in all of sports.

Momento in Dallas

Let's get Cooking

STETSON HAT
Hatco, Inc.
721 Marion Dr. Garland

Why I Choice this Craft

John B. Stetson created a hat that would become the symbol of the pioneering American West and the largest hat manufacturer in the world. Dallas picked up on this trend, being a fashionable city and made it mainstream. The Stetson hat is worn by movie and music stars, presidents, and your everyday American. I visited the manufacturing floor to make a felt hat made from rabbit. Stetson Hats offer straw hats as well. There are 12 steps and workstations to get the hat to the consumer. I enjoyed the humidifying machine, so the hat can be easily shaped.

A Tasty Choice

Texas is one of the hottest states in America, well over 100 degrees with humidity over the summer. Shade is essential, and although most of Texas is bare, Dallas and Fort Worth's neighborhoods are purposely shaded with oak and elm trees. These trees are full, hovering over the streets, serving not just as a coolant, but enhancing charm.

EL PASO
TACOS

Chef's Note

A beautiful lit star representing the Lone Star State marks Franklin Mountain, but there are only a handful of cities in America that feel like a foreign country, El Paso is one of them, sharing the same sunrise and sunset as Mexico. Eighty-five percent of the city is Hispanic or Latino, many signs in Spanish, and Chihuahua license plates make the daily crossing but that's just on the surface. Almost everything whether the food, color palate, architecture, infrastructure, economics, religion, and fashion are all influenced by a rich Mexican heritage, ironically a beautiful representation of America.

Cook Time: 26 hours

6:30am	Scenic Overlook
9am	Bridge to Mexico
10:30am	El Centro
2pm	The Mission Trail
7pm	Plaza Theatre

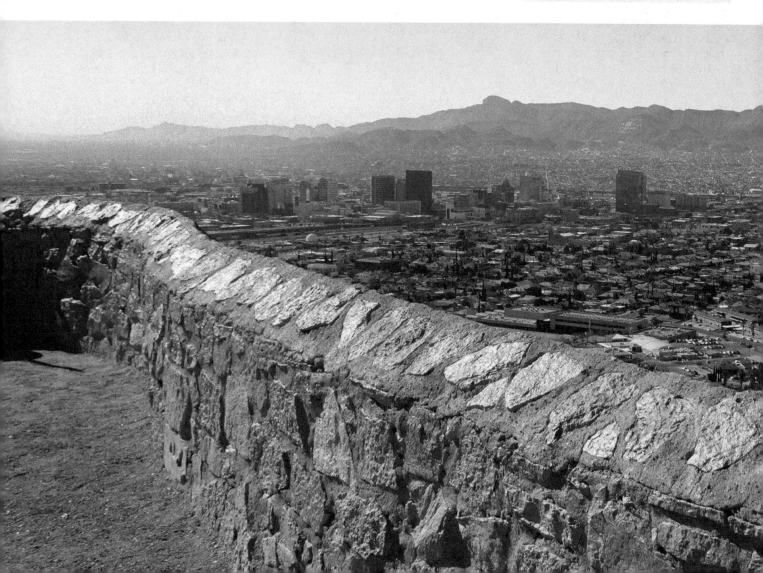

The Sauté Pan

Hotel Paso Del Norte
10 Henry Trost Ct.

Stay at the hotel that represents the soul of downtown El Paso. For more than 100 years, the cultural tapestry of the city has been woven in, through and around the Hotel Paso del Norte, Autograph Collection. The hotel's iconic stained glass ceiling above wonderous grand lobby architecture has been the city's gathering place for generations and is the perfect place for romances, celebrations, reunions, business meetings and even cattle deals. A veritable who's who of the 20th century have passed through our doors, adding their stories to the unique blend of Mexican, Texas and Native American cultures that make this hotel a true gem of the Southwest.

Combining

Sunrise at Scenic Drive Overlook 6:30am-7:30am
One of the best city views anywhere in America, or Mexico for that matter. Take a drive skirting through narrow windy roads, that gets your adrenaline going. At the top, there's a small parking lot to get out and walk around closer to the edge of the mountain. Get a hazy panoramic view of El Paso's mountain desert and into Mexico. Can't beat it!

On the way down, explore the stunning affluent neighborhoods around Billy Rogers Arroyo.

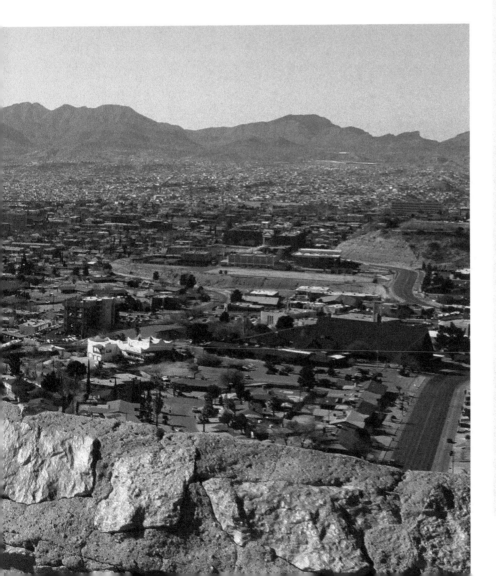

Local Inspiring Flavors

Breakfast
Sabor
10 Henry Trost Ct.

Located inside Hotel Paso del Norte, Sabor is an indoor/outdoor experience centered around an eclectic fusion of southwest Texas and southern comfort foods that bring bold flavors to the forefront of every dining experience.

Lunch
Ambar Restaurante
106 W Mills Ave.

More than downtown El Paso's newest dining destination, Ambar Restaurante also reveals a culinary narrative that mixes Mexican cultures, traditions, centuries-old-ingredients, and modern presentations.

Conveniently located on the lobby level of the plaza hotel pioneer park, the open-kitchen concept lends itself to a spectacular dining experience where flames dance over open wood grills and meals are designed to be shared. Heirloom corn masa, handmade tortillas, whole animal asado, and fresh ceviche's express the culmination of heritage and progress.

Ambar Restaurante also boasts more than 800 bottles of mezcals, tequilas, sotols, bacanoras and raicillas — making it home to the largest agave spirit collection in North America.

Dinner
Cattleman's Steakhouse
3450 S Fabens Carlsbad Rd, Fabens, TX

A large, family-style restaurant on a working ranch. Enjoy a western atmosphere, miles of desert scenery and spectacular sunsets! Children's zoo, movie sets, snake pit, Indian maze, lake walk, children's playground, buffalo, longhorns, and much, much more!

EL PASO
TACOS

Marinating

Cross the Pedestrian Bridge to Mexico 9am-10:30am

Experience the life of many locals that cross the Rio Grande River each day for work, shopping or connecting with friends and family. It costs 50 cents and no documentation to enter Juarez on the Paso del Norte International Bridge, but on the way back be prepared for long lines and presenting your U.S. passport. This is a fascinating experience to compare the scenes of both countries, from the towering skyline of El Paso and the colorful adobe flat homes on the hillsides of Juarez.

Stirring

El Centro 10:30am-12:30pm

El Paso's original shopping district has long been the heart and center of downtown activity and is reflected in the designation of El Centro. The face of El Centro is El Paso Street, with its rich history, thriving culture and shops, it stretches all the way to the border. This is one of the most authentic districts in America, rooted in tradition and livelihood.

The open-air market style shops line the streets of El Centro. The district hugs the border of Mexico as if old friends, co-existing for over 150 years. Cultures have blended in the district, bringing Lebanese, Korean and Mexican immigrants together, amongst others, to create a multi-cultural American atmosphere that makes itself known in the sights, sounds, and scents of El Centro.

Architecture in El Centro spans over a century in some instances, in others the remnants of signage from a post-war boom can be seen above bakeries, eateries and a multitude of retail businesses that still thrive today. Be prepared for non-English speaking businesses.

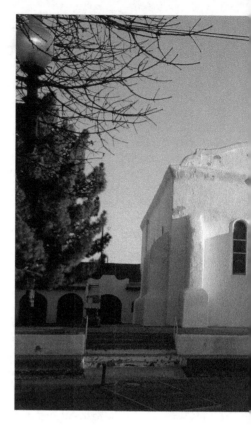

Browning

The Mission Trail 2pm-5pm

The two mission churches of Ysleta and Socorro and the Presidio chapel of San Elizario, located along the El Paso Mission Trail, stand as enduring symbols of the long and rich history of their respective communities, as well as the nations of Spain, Mexico and the United States. All three are privately owned by the Catholic Diocese and are actively supported by their local parishes. These landmarks and their environs are listed in the National Register Historic Places.

Socorro Road (FM 258), which runs from Ysleta to Socorro to San Elizario, is the designated Mission Trail. This nine-mile route represents a segment of El Camino Real de Tierra Adentro (Royal Road of the Interior), the historic trail that extended from Mexico City to Santa Fe, and linked the missions,-agricultural communities, haciendas(landed estates) and presidios (military forts) to distant trade and supply routes. It is the oldest and once the longest road in North America, and was designated as a National Historic Trail in 2000.

Momento
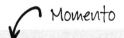

Let's get Cooking

HANDMADE CUSTOM BOOTS

Rocketbuster Boots
115 Anthony St.

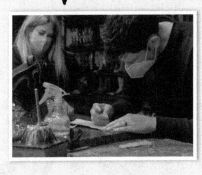

Why I Choice this Craft

While cowboy boots and their classic pointy toes were originally created in the 1800s to help ranchers quickly get their feet into stirrups, they have since evolved into a widespread phenomenon symbolizing culture, comfort and identity. With Texas's rich cowboy history it's no wonder the state is king of the cowboy boot, and Texas offers many skilled custom boot makers creating pieces of art across the state. El Paso has become the 'Boot Capital of the World' being home to several manufactures with talented artist. Rocketbuster is a colorful workshop specializing in bright, eclectic designs anchored by traditional handmade quality. Owned by Nevena Christi and founded by her husband, Marty Snortum, the shop is nestled inside an industrial-chic brick building in El Paso's rising Union Plaza district. More than a dozen workers produce 500-plus pairs of boots a year in the shop, which attracts visitors from all over the world including Celebrities such as Oprah Winfrey, Julia Roberts, Taylor Swift and Steven Spielberg.

Watch a Show at Plaza Theatre 7pm-9pm

One Civic Center Plaza

As a National Historic Building of Significance, built in 1930 and restored to its original atmospheric theater splendor in 2006, the Plaza Theatre Performing Arts Center is conveniently located in downtown El Paso-just a brief walk from the Judson F. Williams Convention Center and the Abraham Chavez Theatre.

The theatre was built with Spanish Colonial Revival architecture and features intricately painted ceilings, mosaic-tiled floors, decorative metal railings and antique furniture. As one of the remaining atmospheric theaters in the United States, The Plaza conveys the illusion that viewers are seated outdoors in a Spanish courtyard. The stars on the ceiling reflect the Southwestern sky in June. In addition to its rich decor, the Mighty Wurlitzer Blaban III Organ is one of only six ever made. The organ has 1,071 pipes and can simulate 15 different instruments.

In addition to the 2,050-seat Kendall Kidd Performance Hall, the Plaza Theatre features the 200-seat Philanthropy Theatre and the Alcantar Sky Garden, a delightful rental venue for private receptions, business parties and family gatherings.

A Tasty Choice

As a major city being footsteps away from the nation's border, there are many exotic features to El Paso, like the border wall itself creating a shadow on the interstate roads or the colorful flashing lights on the overpasses, but I found the string lights on El Paso Street endearing. Sure, there are string lights above many city streets in America, but from an aerial view, you'll notice a similar street in Juarez with the same string lights, inadvertently showing a sign of brotherly love.

HONOLULU
POKE

Chef's Note

Motor scooters whiz through the bustling downtown streets, tourists lay for hours on the fluffy-white sandy beach, hikers traverse an active volcano, and the locals impress a crowd climbing a palm tree to reach a coconut. Imagine, this variety of experience within a five-mile radius. That's Honolulu! One of the world's most exotic destinations never disappoints and the natives are proud to share it.

Cook Time: 30 hours

7:30am	Hike Diamond Head Crater
10:30am	Pearl Harbor
1:30pm	International Market Place
5pm	Polynesian Cultural Center
Day 2	
8am	Waikiki Beach

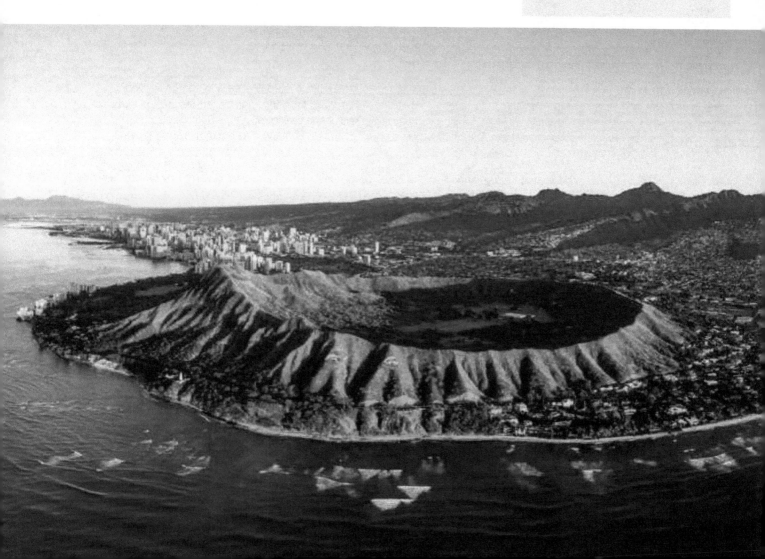

The Bowl

Kaimana Beach Hotel
2863 Kalakaua Avenue

Built in 1963 on Oahu's iconic Gold Coast, this is Waikiki's only boutique property located directly on the sand. With a soul that harkens back to the heyday of Waikiki, and a rejuvenated identity that embraces today's thriving creative community, Kaimana Beach Hotel welcomes global wanderers to connect with Hawaii's world-class sense of place.

Pre-heating

Hike Diamond Head Crater 7:30am-9am
The unique profile of Diamond Head (Lēʻahi) sits prominently near the eastern edge of Waikiki's coastline. Hawaii's most recognized landmark is known for its historic hiking trail, stunning coastal views, and military history. Diamond Head State Monument encompasses over 475 acres, including the interior and outer slopes of the crater.

This broad, saucer-shaped crater was formed about 300,000 years ago during a single, explosive eruption that sent ash and fine particles in the air. As these materials settled, they cemented together into a rock called tuff, creating the crater, and which is visible from the trail in the park. Most of the vegetation and birds were introduced in the late 1800s to early 1900s.

The trail to the summit of Lēʻahi was built in 1908 as part of Oʻahu's coastal defense system. The 0.8 mile hike from trailhead to the summit is steep and strenuous, gaining 560 feet as it ascends from the crater floor. The walk is a glimpse into the geological and military history of Diamond Head.

Pearl Harbor 10:30am-1pm
1 Arizona Memorial Pl

Known the world over as a "date which will live in infamy," the devastating events of December 7, 1941, changed the course of history. It was here that a surprise air attack by the Japanese plunged the United States into World War II, claiming thousands of lives. At Pearl Harbor, that tragic history is never too far in the past. Hear first-hand stories from survivors describing the chaotic scene on Battleship Row. Walk through an airplane hangar that still bears the scars from that fateful morning. And peer into the shallow harbor where the sunken hulk of the USS Arizona rests, still leaking oil that pools on the water's surface like black tears, as they've been described.

Local Inspiring Flavors

Breakfast
Moke's Bread and Breakfast
1127 11th Ave.

The restaurant's humble beginnings are rooted in delicious home-cooked meals: The Lilikoi pancakes are divine, the home-made corned beef hash will hit the spot, and the exclusive Hawaiian roast coffee will wash it all down and gear you up for a great day!

Lunch
Yanagi Sushi
762 Kapiolani Blvd.

Many of Hawaii's visitors come from Japan, so the expectation is extremely high for quality and tasteful sushi. Yanagi is one of the island's best sushi restaurants. Since 1978, people keep coming back and has attracted an entire wall of celebrities.

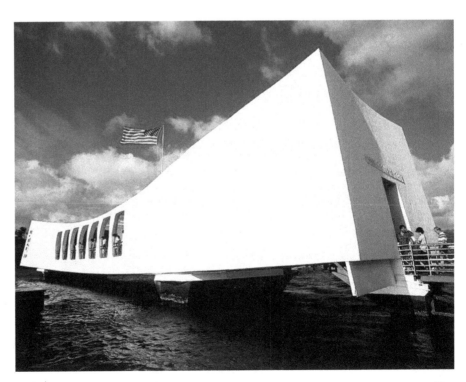

HONOLULU
POKE

Goldening

International Market Place
1:30pm-3:30pm
2330 Kalakaua Ave.

You can't escape shopping in Honolulu.
It's everywhere! This mall is a high-
end retail, dining and entertainment
destination, attracting residents and
visitors alike. The revitalized International
Market Place features shopping in an
open-air environment and opportunities
to experience a unique "Hawaiian Sense
of Place" through the celebration of the
history and culture of Waikiki and its
people. Water features and Hawaiian
landscaping, including an iconic banyan
tree, are featured throughout the center
and the Grand Lanai offers a varied
selection of outdoor dining venues under
the stars.

Drizzling

Polynesian Cultural Center 5pm-8pm
55-370 Kamehameha Highway
Suite 1010 Laie

Take a trip through the six island Polynesian nations, all in one place. This is a
spectacular exploration of the cultures, through music, dance, art, food, fashion,
and language. Each island has representatives, allowing you to immerse into their
traditions.

Stick around for the Lu'au.

Day 2

Waikiki Beach 8am-11am

One of the most famous beaches in the world, Waikiki Beach boasts more than four
million visitors every year and breathtaking views of Leahi (Diamond Head). The Duke
Kahanamoku statue welcomes you to Waikiki, one of the best places in Hawaii to
learn how to surf or paddle a canoe thanks to its small but long-lasting wave break.
Spanning a two-mile stretch, Waikiki is actually made up of a few beaches, including
Fort DeRussy Beach to the west, Waikiki Beach (fronting the Royal Hawaiian Hotel
and Westin Moana Surfrider), Kuhio Beach (along Kalakaua Avenue) and Queen Surf
Beach, home to quieter stretches on the Diamond Head side of Waikiki.

Let's get Cooking

HAWAIIAN (ALOHA) SHIRT
Fabric Hawaii
2065 S. King St. #303

← Momento

Why I Choice this Craft

When your state's name is in the shirt, it must be a big deal. In the early 1900's, Japanese immigrants brought with them, bright kimono fabrics, a material that was more comfortable and practical for Hawaiian laborers. Designs, inspired by the images of the tropical island were put into patterns on the shirt. The Aloha shirt was advertised in the local newspaper and became a fashion phenomenon.

A Tasty Choice

It can be sunny, but somehow a misty rain falls for an hour each day. The climate cools itself from a hot and humid day, keeping the island a tropical green from a drizzle or torrential rain.

SMOK'D
CHARLOTTE

Chef's Note

Charlotte is young, energetic, and trendy. It's setting the standard for the rest of the country, modernizing before our very eyes. Charlotte is moving full steam ahead, leaving only commemorative plaques at former sites. The city appeals to the next generation, providing a vibrant uptown, access to nature, and quaint neighborhood districts. The spirit of the city lights up far and wide, making Charlotte a wonderful place to grow with the changes.

Cook Time: 22 hours

Time	Location
7:30am	Little Sugar Creek Greenway
9:30am	Billy Graham Library
11:30am	Whitewater Center
3pm	NASCAR Hall of Fame
5:30pm	Plaza Midwood and South End

The Smoker

The Dunhill

237 N. Tryon St.

You're looking at the only historic hotel left. Discover sophisticated accommodations enhanced by gracious Southern hospitality, historic setting, and ideal location in the heart of Charlotte's Uptown (Downtown). An oasis of calm amid the hustle and bustle of the city, The Dunhill Hotel is steeped in history and surrounded by modern significance. The Uptown Charlotte location puts guests within walking distance of area art galleries, museums, corporate headquarters, nightlife, shopping, and much more. The iconic boutique hotel is Charlotte's premier venue for upscale events—including elegant weddings, fun-filled family reunions, corporate meetings, and executive retreats.

Rubbing

Little Sugar Creek Greenway 7:30am-9am
Enjoy navigating through Charlotte's nature and urban landscape along 19 miles of trails and land connectors. It's a new trail system that is growing popularity quickly.

Spritzing

Billy Graham Library 9:30am-11am
4330 Westmont Dr.

The Billy Graham Library is a 40,000-square-foot experience where you'll discover the life and legacy of America's pastor. Designed to reflect Billy Graham's journey from a humble farm boy to an international ambassador of God's love, the barn-shaped building is situated on 20 landscaped acres, only miles from where Billy Graham grew up in Charlotte.

Local Inspiring Flavors

Breakfast
The Ashbury
235 N Tryon St.

Named in honor of Louis Asbury, Sr., the Charlotte architect who designed the Mayfair Manor—now The Dunhill Hotel—in 1929, The Asbury celebrates the best of what the South has to offer in ingredients, technique, creativity, and, of course, hospitality. The Asbury is a tribute to the city's Southern roots and the culturally diverse community of the New South.

Lunch
River's Edge at The Whitewater Center
5000 Whitewater Center Parkway

Enjoy quality local food with an amazing scenery of the surrounding nature of the Whitewater Center. Sit outside to hear the rapids.

Dinner
STIR
1422 S. Tryon St.

STIR is the perfect restaurant to sip a cocktail over a dozen oysters and enjoy a night out. Located in the RailYard in South End, they believe great food starts with fresh, local ingredients. Their kitchen prepares everything from scratch, using the finest produce, meats, and seasonal ingredients. They approach each meal with the same creative energy that they bring to the specialty cocktails and community atmosphere.

STIR is famous for cocktails. They freeze and carve 300-pound blocks of artisanal ice, blend their own bitters and syrups, press juices, and slice ingredients. They age certain cocktails in oak barrels for richer flavors, and place other cocktails on draft for crispness and carbonation. The result is categorically elevated cocktails.

CHARLOTTE
SMOK'D

Whitewater Center 11:30am-2pm
5000 Whitewater Center Parkway

Whitewater has been creating opportunities to bring people together outdoors at the U.S. National Whitewater Center in Charlotte, North Carolina. The Whitewater Center is designed and operated as an outdoor center offering over 30 different recreational activities. Every element and activity is focused on supporting an all-encompassing experience around the outdoor lifestyle. Additionally, the Whitewater Center hosts international competitions in a variety of sports along with numerous festivals and events on a recurring basis.

The Whitewater Center is currently comprised of over 1,300 acres of protected land offering 50 miles of trail and access to the Catawba River and Long Creek. The Center's goal is to continue to increase the size of these protected lands and promote even greater access through land acquisition and natural resource management. Whether you visit to ride 50 miles of single-track trail or simply enjoy eating a meal by the whitewater course, we are certain that you will meet new people and connect with old friends in a shared experience outside.

Wrapping

NASCAR Hall of Fame 3pm-5pm
400 East Martin Luther King Jr. Blvd.

The NASCAR Hall of Fame is more than just a museum—it's a shrine to the history, heritage and future of the sport we love.

It's a place where fans can uncover new stories and get in on the action at every turn with more than 50 interactive experiences. Get behind the wheel of an iRacing simulator on your favorite track or see if you have what it takes to make the team in our Pit Crew Challenge. Take part in events that set the stage for the future of the industry and hear intimate, never-before-told stories of the past.

Smoking

Explore Distinguished Districts, Plaza Midwood and South End 5:30pm-8:30pm

Plaza Midwood – A blend between contemporary and quirky, young and established, you'll find lots of charm in this district. Drive down Central Ave and find cute shops, affluent neighborhoods, and lots of mature trees.

South End- This district means business. It's flashy, modern, and energetic. This is where you'll find bougee shops, eloquent restaurants, and lots of bustle. Close to Uptown, makes this the place to go before and after work.

Momento

Let's get Cooking

PIGGY BANK
ClayWorks
4506 Monroe Road

Why I Choice this Craft

North Carolina's internationally renowned pottery tradition reaches back centuries-to the time native inhabitants formed local clay into functional pots and ceremonial vessels. It is said that the state's mud produces the best clay in the world. Combine that with Charlotte's significant banking industry and love of bbq pork, I chose to make a piggy bank. I met with artist, Greg Scott to craft my piece. Starting with a slab of clay, we formed the body, then attached the head, and worked on the extremities. Roughly three hours later, we created a pig before firing it into the kiln.

A Tasty Choice

Like most southern towns, the Civil War was devastating to the city of Charlotte. During the war every bank in the Carolinas failed. However, by the 1870s Charlotte emerged as a rail center and textile hub in need of a local bank. In response, local business leaders started raising money to build banks.

Bank offices have beautified Uptown Charlotte with colorful lightning and playful fountains surrounded by the Tryon St. entertainment district.

DENVER OMELET

Chef's Note

An expressive city with an infinite variety of platforms, channeled through the ballet dancer posing in the creek for a promotional photo and the pianist on 16th Street Mall entertaining pedestrians, to the rock-climbing adventurist and the ambitious beer brewer. Denver nurtures everybody to be anything, creating a city with an incredibly diverse style from one block to the next and one neighborhood to the other.

Cook Time: 24 hours

7:30am	Biking Paths
10:30am	16th Street Mall
1:30pm	River North Art District
3:30pm	Washington Park
7:30pm	Colfax Avenue

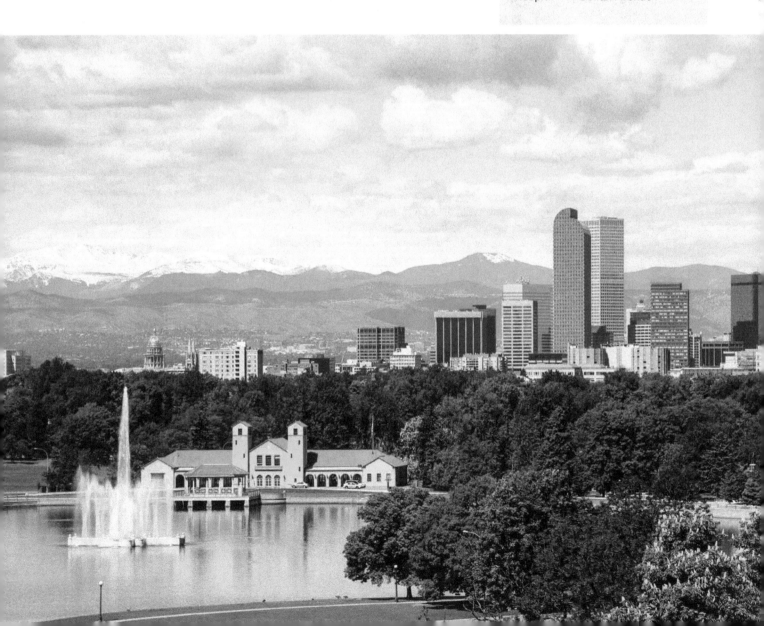

DENVER

The Skillet

The Curtis
1405 Curtis St.

Unforgettable themed rooms, lobby, hallways and even the elevators. Enjoy a cookie on arrival, followed a tour of their pop-culture themed hotel. Expect Britpop, chick-flick, horror, and everything in-between. It will make your stay that much more colorful. The property is across the street from the performing arts complex, three minutes from Colorado Convention Center, and within half-a-mile of 16th Street Mall. Coors Field, Pepsi Center, and the Denver Art Museum within 10pm-minutes.

Pre-heating

Biking the Trails of Denver
7:30am-10am

The best feature of Denver is its paved biking trails, reaching every part of the city from the Red Rocks amphitheater to circling City Park and the Cherry Creek Reservoir to the Broncos Stadium. There are hundreds of miles of connective paths, great for exploring different neighborhoods, immersing with nature, and avoiding automotive traffic. These paths take course alongside beautiful flowing streams, below street-level. The most popular are the Cherry Creek, Highline Canal, South Platte and Bear Creek Trails.

For the most impressive urban biking of your life, begin at Confluence Park and head south on the South Platte Trail until you merge with the Bear Creek Trail. This trail is paradise, mostly shaded through dense woods and portions of open prairies, where you'll run into a field of prairie dogs. Ultimately, this course stretches from downtown to the Red Rocks amphitheater.

Sautéing

16th Street Mall 10:30am-12:30pm
One of America's finest streets, designated for pedestrians to enjoy over a mile-long strip of restaurants, shops, theaters, and other attractions. There is a free shuttle bus that cuts through the strip from the Capitol Building to the lightrail/bus station.

Take a detour through the LODO District, known for repurposing warehouses into luxury condos, upscale bars and restaurants, a bookstore and near the Union Station and Ballpark. There's plenty to explore, and this has quickly become Denver's hottest spot.

Also, check out Larimer Square, where Denver got its start between 14th and 15th in the late 1800s. Named Larimer Square for the pioneering General William Larimer, it was the city's first block, its first commercial district, home to its first residence and first city hall, and was the city's first designated historic district. This charming block gives a sense of peace and delight.

Local Inspiring Flavors

Breakfast
Snooze, an Am Eatery
2262 Larimer St.

I'd argue that Denver has the greatest tasting food in America with a tender touch to its presentation. Snooze is a perfect representation of quality, care and variety. Most breakfast and brunch restaurants start with the same script: eggs, batter, coffee, and a big ol' griddle. At Snooze they've found that scripts are a lot like pancakes, they're best when flipped. They call it breakfast, but different!

Lunch
Linger
2030 W. 30th Ave.

Housed in a former mortuary, the decor layers macabre remnants with posh details in a window-flanked space overlooking the charming Lower Highland neighborhood. The drink menu features sips and seasonings as savory as the dishes with which they're paired. While the rooftop patio—outfitted with 1975 GMC RV as bar and repurposed food truck as kitchen— beckons patrons towards adventure. I'll reiterate the rooftop, since it has the best skyline view of downtown and a special experience to Denver, since rooftop patios are common to the city.

Dinner
Buckhorn Exchange
1000 Osage St.

Denver's Oldest Restaurant. Serving up steaks, buffalo, elk and the Old West since 1893. Considering the city around this establishment is growing and modernized, this is a great step back in time with different dining rooms decorated with various Old Western themes.

Melting

River North Art District (RiNo) 1:30pm-3pm

The district's interesting blend of urban charm and unique industrial revival makes it a great destination for visitors. Historic warehouses and factories now house jazz bars, restaurants, brewpubs, art galleries and working studios. RiNo boasts a diverse mix of creative businesses ranging from visual artists, designers and furniture makers, to craft distillers and brewers, winemakers, creators of unique outdoor gear and small-batch coffee roasters. The art definitely extends beyond gallery walls in this neighborhood, with its colorful and innovative street art murals in alleys and on buildings around almost every corner.

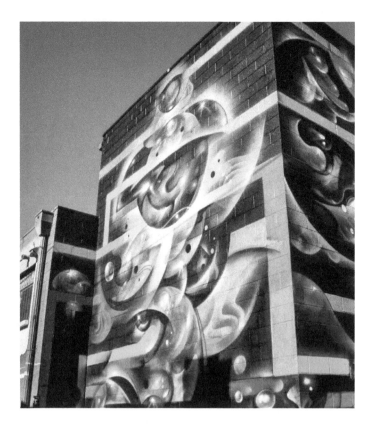

Seasoning

Washington Park 3:30pm-5pm

Denver is known for its parks, each offering something different. City Park has a museum, golf course, zoo and a lake with a gorgeous fountain. Cheesman Park is attached to the botanical gardens around large historic homes and lined with mature trees. Washington Park is expansive, being home to two lakes, tennis courts, a rose garden and a 2.5pm-mile winding dirt trail. It's the most active park, packed with volleyball nets, frisbee enthusiasts and bird feeders. Also, the neighborhoods near the park are the most desirable in the city.

Momento

Let's get Cooking

THE MILE HIGH MARKER

Mile High Laser Engraving
7100 Broadway, Ste. 3F

Why I Choice this Craft

Denver is known as the Mile High City, but there are only a few parts of the city that are 5,280 feet above sea-level, where you can find official Mile High Markers. The most popular marker can be found on the steps leading up to the Capitol Building, but there are four other places, including Coors Field, City Park, the Highline Canal Trail, and the Denver International Airport. I decided to make a custom marker etched into glass with the assistance of a local business.

Flipping

Colfax Avenue 7:30pm-10pm

Explore the longest commercial street in America, filled with quirky shops and theaters, a variety of ethnic foods, and a hotspot for nightlife. An entire day can be spent exploring this historic avenue, dating back to its roots of the Gold Rush in the mid-1800s. The Ogden Theatre, Bluebird Theatre, and the Fillmore Auditorium are great venues to watch a show.

A Tasty Choice

The sidewalks of Denver are unusually uneven and cracked, but charmingly leaves a sense of history at the same time. The city uses flagstone to navigate the many neighborhoods and parks throughout the city. If you are in Denver long enough, don't be surprised if you've earned yourself a trip. It's an unforgiving surface, but make sure to fall in style.

PORTLAND
SOY

Chef's Note

If a tree falls in the rainforest and there's nobody around the hear it, does it still make a sound? Too bad, there are approximately 2.5 million residents in the Portland Metro, that grew this city with branches of non-conformity, intentionally seeking different ways of being and proudly boasting peculiarity. Consider the City of Portland, a collaborative work of wildcards, misfits, and dabblers that are one with nature, so if a tree falls, everyone feels it.

Cook Time: 22 hours

8am	Multnomah Falls
11am	The Grotto
1pm	Hawthorne Street
3pm	Take a Drive
5:30pm	Powell's Books

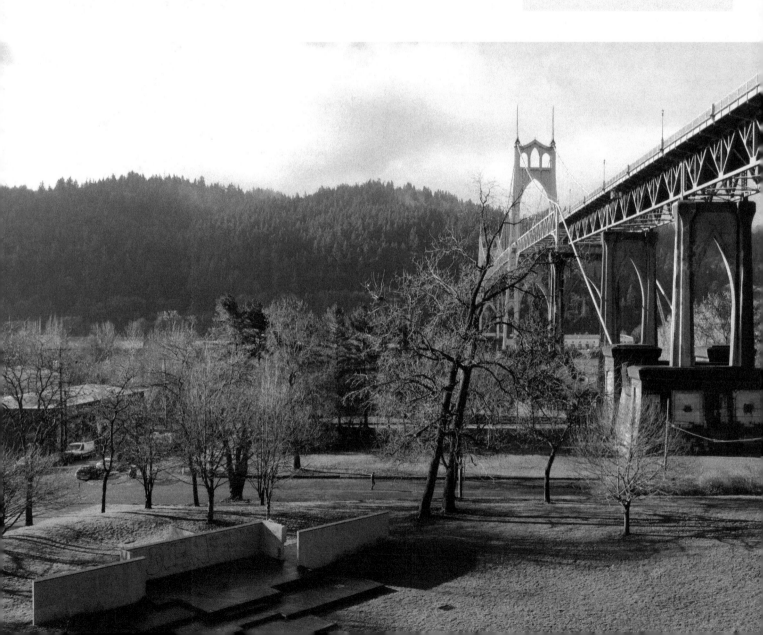

The Pot (no pun intended)

The Jupiter
900 E. Burnside St.

The Jupiter is a boutique hotel centrally located in SE Portland. They offer a unique haven for sleeping, eating, drinking, meeting, partying, or just watching the world go by. Get in the center of action near Doug Fir Lounge at our original Jupiter, or get a little more luxury and enjoy spectacular city views at their modern addition Jupiter NEXT from your room or perch lounge.

Soaking (Also, no pun intended)

Multnomah Falls 8am-10am
One of America's greatest natural features is a short drive from downtown Portland. This breathtaking sight of waterfalls is a humbling flow of life, whether millions of people come to view the falls or not, from thousands of years ago or well into the future, water will still be springing off the edge to make a spectacular show.

The hike to the top is approximately a mile, giving visitors an intimate experience with the falls, crossing over a bridge at its second tier. The falls runs into the Columbia River Gorge, a place so jaw dropping, it's like seeing all the world's most beautiful places at once.

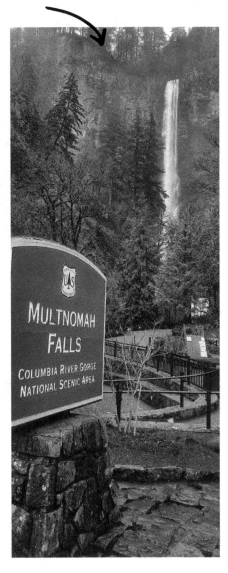

Local Inspiring Flavors

Breakfast
Pine State Biscuit
1717 NW 23rd Ave.

Beginning as a brainchild centered around…what else? The quest for the perfect, buttery, flaky, homemade biscuit. Kevin Atchley, Walt Alexander, and Brian Snyder knew biscuits all too well from growing up in North Carolina, but having relocated to Portland, Oregon, they craved the down¬home¬ cooking they knew from childhood. So they banded together and decided to bring the Southeast to the Northwest.

Lunch
Hawthorne Asylum
1204 SE Hawthorne Blvd

Portland is the food truck capital of the country, consisting of food cart pods across the city. Take your pick from a half dozen trucks located on the east side of town where you can take a stroll down Hawthorne and the nearby Division St. afterwards.

Dinner
Mirakutei Sushi & Ramen
536 E Burnside St

In 2011, sushi chef Hiro Ikegaya opened Mirakutei as a Japanese tapas, ramen and sushi bar. Ikegaya has served the city of Portland a creative combination of traditional and fusion dishes out of his East Burnside restaurant where today, he is writing the final chapters in his career as a chef. His legacy can be traced back decades as Portland residents can remember Ikegaya's past innovating restaurants, Hiro Sushi and Hiroshi's. The meaning of the name Mirakutei, which means a place to eat and enjoy

PORTLAND
SOY

Draining

Explore Hawthorne Street 1pm-2:30pm

Spanning 43 blocks, in old store fronts find thrift shopping, cozy bookstores, fine and casual dining, and a perfect espresso as you wander this locally beloved Southeast Portland neighborhood. Always quirky, represents the city's culture well.

Blending

Drive the Loop on N. Williamette Blvd to NW St. Helens Road 3pm-5pm

Take in the scenes, high above the Willamette River on a beautiful road through neighborhoods, Adidas Headquarters, and the University of Portland until you reach the iconic St. Johns Bridge. This one-of-a-kind suspension bridge is a treasure to the city. Drive across until you reach NW St. Helens Road, where you'll meet with Forest Park, another local treasure. This park includes 5,200 acres and serves as a critical refuge for hundreds of native wildlife and plant species and acts as an important air and water filter. With more than 80 miles of trails, it also provides invaluable access to nature, exercise, and educational opportunities for the region.

The Grotto 11am-12:30pm
8840 NE Skidmore Street

The National Sanctuary of Our Sorrowful Mother, is Roman Catholic ministry of the Order of Friar Servants of Mary. The 62pm-acre shrine that offers a sanctuary of peace, prayer and natural beauty for all people.

Let's get Cooking

CUSTOM BICYCLE
Ahearne Cycles
108 N Page St.

Momento

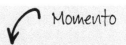

Why I Choice this Craft

Portland has quickly become known as Bike Town. As the culture started to evolve into an eco-friendly and minimalist lifestyle, the locals demanded for path to be created and roads to be shared. Now, on a bicycle, you can go as many places as cars and in some cases, never have to encounter any on the commute. I wanted to learn the process of building a bike from Joseph Ahearne, who lives and breathes them. Starting with the fork and then to the triangle frame, part by part gets brazed, until 6 months later you have an $8,000 mode of transportation.

Straining

Powell's Books 5:30pm-7pm
1005 W. Burnside St.

Think about the last good book you read. Did it make you feel more connected to others? Maybe it served as a welcome escape. Maybe it helped you rediscover the beauty in life. Did it surprise you?

As the world's largest independent bookstore, they strive to offer the same variety and richness of experience as the books on our shelves. And because the only people they're beholden to are our customers and ourselves, we can focus on what really matters — promoting diverse perspectives, upholding the free exchange of ideas, championing the enduring power of books, and bolstering the great community of readers and authors they're lucky to be a part of.

A Tasty Choice

Considering Portland has such a unique identity, many features spread across the city like its non-vascular plants, moss. From the food cooperatives and the Victorian homes used for businesses to the neighborhood rose gardens, nothing stood out more than the sidewalk dining areas. Inside the lines of the bike lanes, many food establishments have covered picnic table dining areas. It's an airy environment, good for enjoying the outdoors and being a part of the flowing traffic.

STEAMED
BALTIMORE

Chef's Note

Baltimore's long history as a shipping port, defined this city's infrastructure and culture, built tight and durable, laying the foundation and erecting its structures with reddish brick. The people exemplify the city's build, ingrained with sturdy pride, loyalty and bond. There's a beauty in each neighborhood, that's possibly only recognized by locals.

Cook Time: 24 hours

8am	Patterson Park
10:30am	Fells Point
2pm	The Inner Harbor
7pm	Power Plant Live!

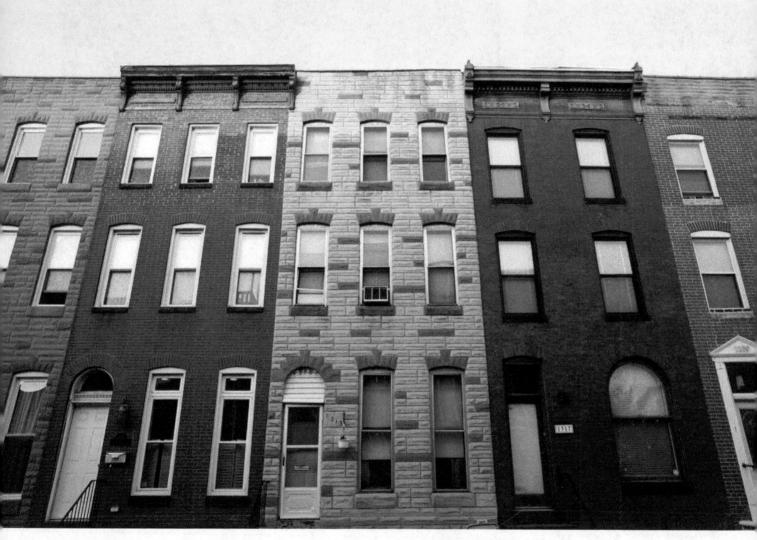

The Stockpot

1840s Carrollton Inn

50 Albemarle Street

A boutique hotel comprised of a series of interconnected row homes, dating back to the early 19th century. This luxurious hotel boasts historic quality antiques and decorative furnishings. Established in 2007, the 1840s Carrollton Inn surrounds a courtyard adjacent to the 1840s Plaza, an authentic Baltimore event venue.

Located in the historic Jonestown neighborhood, 1840s is just steps away from the Inner Harbor, Restaurant Row at Harbor East, and Little Italy. 1840s Plaza is a hidden gem in the middle of a busy city with devoted staff ready to go above and beyond to ensure a flawless event from beginning to end. The iconic red cast iron façade was one of twelve that survived the great Baltimore fire in 1904 and was restored for the opening of the Baltimore City Life Museum. Rich in history and culture, this venue gives guests a glimpse of Baltimore's distinct history combined with today's modern luxuries.

Local Inspiring Flavors

Breakfast

Miss Shirley's Cafe

750 E. Pratt St.

Established and created in 2005 by longtime restaurateur and Baltimore native, Eddie, as he was affectionately known, Miss Shirley's Cafe was named in loving memory of a personal friend & inspirational team member, Miss Shirley, who passed away in 2001. Shirley, a food professional at The Beef Inn & The Catering People, was known for her sassy charm and sheer joy of preparing dishes for catered celebrations in the community. The Miss Shirley's Cafe Culinary Team crafts bold original recipes and seasonal menus that reflect both a southern flare, as well as the team's love of Maryland ingredients. The menu offers specialties including: Chicken 'N Waffles, Shrimp & Grits, Crab Cake & Fried Green Tomato Eggs Benedict & Coconut Cream Stuffed French Toast.

Lunch

Lexington Market

400 West Lexington St

Baltimore's best place for food. Whatever you like to eat, they've got something for you. Lexington Market has more than 100 vendors, offering everything from world famous crab cakes to fried chicken, corned beef, fresh seafood to verdant produce. In this iconic building, you can get a snack, buy some groceries, or sit down for a memorable meal. But Lexington is a great place to visit for any reason, with over 230 years of history and atmosphere to feed curious minds. It's easy to get to Lexington Market by road, sidewalk, or rail.

Dinner

Phillips Seafood

601 E. Pratt St.

Few family-owned food and restaurant companies have been around for 100 years and achieved the levels of success of Phillips Seafood. From their humble beginnings on the Chesapeake Bay, to the opening of their first restaurant in 1956, to their overseas expansion into sourcing high-quality crab meat, the Phillips family has become a powerful force on the global seafood market. Located on the beautiful Inner Harbor, this establishment has become a Maryland staple. On a side note, I worked here during my 50 Jobs in 50 States endeavor.

Defrosting

Patterson Park 8am-10am

An absolutely beautiful 133pm-acre park located in southeast Baltimore. It is the oldest and one of the most historic parks in all of Baltimore City. The most iconic part of the park is its famed Pagoda – a three story observatory that sits atop historic Hampstead Hill. It is not uncommon to see pictures of the Pagoda used in a variety of different media, artwork and marketing materials.

Patterson Park is right in the middle of the dense neighborhoods of Canton, Butchers Hill, Upper Fells, Highlandtown and the Patterson Park Neighborhood. Being surrounded by these neighborhoods, Patterson Park is heavily used by the residents for a variety of activities including organized sports, festivals, small concerts and summer camps. The park is so popular it is often referred to as The Best Backyard in Baltimore. You'll have a chance to see the rowhomes in the nearby neighborhoods.

BALTIMORE

Seasoning

Fells Point 10:30am-12:30pm
1632 Aliceanna St

A dynamic, must-see destination for locals and visitors alike embodying the true spirit of Baltimore. Nestled along the cobblestone streets and charming waterfront. Fell's Point Main Street is home to more than 100 small businesses where you can eat and drink, stop and shop and stay and play. Fells Point includes Broadway Square which feels like an old European seafood dock.

Steaming

The Inner Harbor 2pm-5pm
One of America's most beautiful destinations. Walk along the harbor with stunning waterfront views and cute pedestrian bridges. Try iconic seafood restaurants, museums, and boat rides, all while in the shadows of the Baltimore skyline. Take in the views from Federal Hill Park and watch the massive ships enter the harbor.

Power Plant Live! 7pm-9pm
34 Market Place

A great entertainment block to catch a show or listen to music.

Momento

Let's get Cooking

CRAB MALLET
Mark Supik & Co.
1200 N. Macon St.

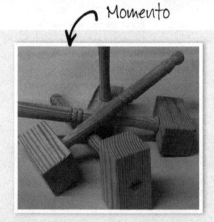

Why I Choice this Craft
Blue crabs are homegrown in the Chesapeake Bay, making Baltimore the largest hub of crab harvesting in the country. Eating crabs have become a tradition in the city, so I wanted to make a wooden crab mallet, which is necessary for cracking them open. Learning how to woodturn from Mark Supik was an art that takes lots of practice. It's a delicate and precise process to make beautiful handles and heads.

A Tasty Choice

There are 16 styles of rowhomes in Baltimore, showcasing a timeline of neighborhoods and architecture. Built for efficiency and practicality, most of the locals were able to become homeowners. The Federal-style in particular, designed windows and doors to be similar vertical heights. From afar, it's hard to tell where the entrance of the home is.

INDIANAPOLIS
TENDERLOIN

Chef's Note

Shaped like an oval race track around the city, Indianapolis' beltway intersects several major interstates, making it the Crossroads of America, but for rural Indiana, the city is the urban escape. Indianapolis has high expectations, dazzling their residents with the best entertainment, high-end shopping, lavish dining, magnificent museums, and big city architecture. Indianapolis never disappoints, as it continues to draw some of the country's largest and significant events.

Cook Time: 21 hours

7am	Memorials and Monuments Scavenger Hunt
10am	White River State Park and the Canal Walk
1pm	Children's Museum
3pm	Motor Speedway
6pm	Massachusetts Avenue

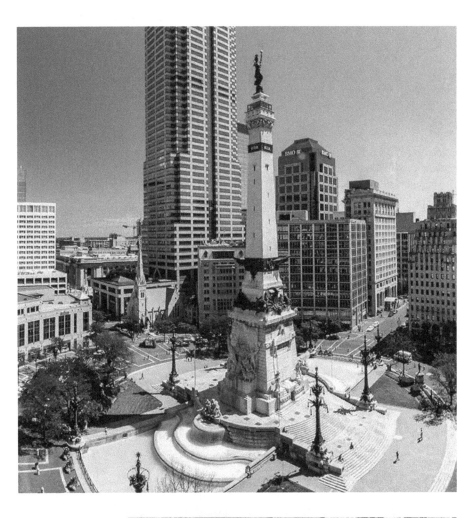

The Broiler

Crowne Plaza – Union Station

123 W. Louisiana St.

Union Station in Indianapolis was the first Union Station in the United States and it remains today as a working train station. Union Station is also home to the Crowne Plaza Hotel where you can stay in a normal hotel room or you can check in to one of the authentic 1920's Pullman Train Car guest rooms that are actually on the real train tracks that trains once traveled on.

121

INDIANAPOLIS
TENDERLOIN

Pre-heating

Memorials and Monuments Scavenger Hunt 7am-9am

25 acres filled with one museum, three parks and numerous monuments and memorials, Indianapolis ranks first in the nation in the number of acres dedicated to honoring our veterans, and second only to Washington D.C. in the number of monuments.

Explore the War Memorial Plaza National Historic District and learn the stories of ordinary Hoosiers who have done extraordinary things. Ordinary Hoosiers like Helen Purviance who was the first "doughnut girl" in WWI. And Indiana natives like General John J. Pershing, who courageously commanded the American Expeditionary Forces in Europe in WWI. Or the countless Hoosiers who made the ultimate sacrifice, from the Revolutionary War to the conflicts of today.

Visitors can enjoy the walkability of the District, which spans five blocks and includes green space areas to stop and enjoy the view. Come and learn more about the bravery and valor of Hoosier service men and women, as well as Indiana's important role in our nation's conflicts. Together—right here in Indianapolis, the crossroads of America—we honor and remember those who've worked to preserve our great nation.

Local Inspiring Flavors

Breakfast
Good Morning Mama's Cafe
1001 E. 54th St.

Ex-gas station turned hopping 1950s brunch spot complete with a jukebox, formica tables & kitsch.

Lunch
Fat Dan's Chicago-Style Deli
410 E. Michigan St.

Great American food with a lively atmosphere. There's a lot of Chicago influence and similarities in Indianapolis, so it's no surprise this establishment serves Chicago-style. It's near the historic Lockerbie District and the popular Mass. Ave.

Dinner
Take your pick on Massachusetts Avenue. This 5-block area is a local's favorite, which many tourists don't know about. There are plenty of restaurants to consider.

Bagging

White River State Park and the Canal Walk 10am-12pm
801 W Washington St

White River State Park boasts world-class attractions and destinations that offer distinctive experiences for every visitor. Greenspaces, trails, trees, and waterways co-mingle alongside cultural, educational, and recreational attractions across 250 beautiful acres in downtown Indianapolis.

The Canal Walk is part of the Indiana Central Canal, which was dug in the early 1800s, in an effort to facilitate interstate commerce. Today, the refurbished Canal Walk (stretching north through White River State Park to 11th Street) serves the downtown community as a waterside promenade for walkers, runners, bikers and sightseers (while the canal itself includes a steady stream of pedal boats, which may be rented west of the Indiana State Museum).

These two features are musts to experience and a great way to see the best views of downtown and urban nature.

Beating

The Children's Museum of Indianapolis 1pm-2:30pm
3000 N. Meridian St.

If you want to see the world's largest children's museum, here it is. Even if you're not a kid, this museum will take you back. Features five floors of fun and interactive learning that have the power to transform the lives of children and families across the arts, world cultures, sciences, and humanities.

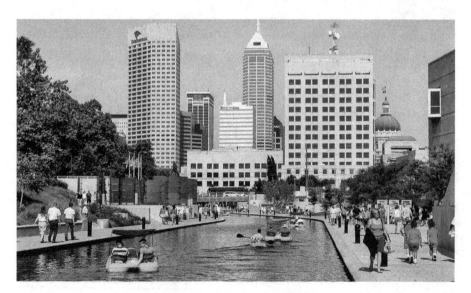

**Indianapolis Motor
Speedway Museum 3pm-5pm**
4790 West 16th Street

The Indianapolis Motor Speedway
Museum's mission is to preserve
and share one of the world's premier
collections of automotive and motor
racing vehicles and artifacts, with special
emphasis on the Indianapolis 500-Mile
Race. You'll have an opportunity to see
the famous 2pm-mile circle track and
hear the buzzing of the race cars.

Whisking

Massachusetts Avenue 6pm-7pm

Known affectionately as Mass Ave, this
five-block area is ripe with theaters,
restaurants, art galleries, and, most
attractively for shoppers, a number of
eclectic, independent boutiques. You'll
encounter unique finds on each block,
from Stout's Shoes (the nation's oldest
shoe store, established in 1886), to Silver
In The City/At Home In The City (offering
silver jewelry and unique gift items), to
The Best Chocolate In Town (which is
fairly self-descriptive). Venture to the
Athenaeum for a stein of German lager
in the historic Rathskeller biergarten, try
local craft beers at Ralston's Drafthouse,
or sip a cocktail at the prohibition-era
ball & biscuit. Foodies can indulge
in American-modern cuisine at Mesh
or take down a platter of tacos at
Bakersfield. Take in Indy culture at its
finest on Mass Ave, "45 Degrees from
Ordinary."

Let's get Cooking

A ROAD SIGN
Indianapolis Public Works

Why I Choice this Craft
When your city is titled, The
Crossroads of America, you better
have good road signs. Indianapolis
is busy marking their interstates,
streets, and parkways. The city is
also known for commemorative road
signs of iconic Indy 500 drivers,
where they have large parades
and celebrations, when the signs
are erected. I had the opportunity
to make a street sign with my last
name, making this one of the most
memorable pieces of America.

Momento

A Tasty Choice

Sports, athletic fields, recreational
space, I don't know how else to put it.
Indianapolis is obsessed with sports.
The world's largest sporting event, the
Indianapolis 500, takes place here, the
Colts and Pacers have a loyal following
and successful past, the National
Collegiate Athletic Association (NCAA) is
headquartered here, and there are plenty
of sporting arenas, fields, and stadiums
throughout the city. Lastly, Indianapolis
hosts many national and world athletic
events, bringing tons of fans from
all-over, ever-increasing Indianapolis'
fanbase.

123

KANSAS CITY
BURNT ENDS

Chef's Note

Kansas City represents the best of Midwest's features, a vital river source for commerce, reclaimed industrial warehouses into luxury condos and storefronts, a concentrated nightlife, massive parks and forest preserves, charming neighborhood districts, affluent parkways with historic mansions, and a diehard sports scene. And, there are lots of hills and rooftop patios to take in the views.

Cook Time: 24 hours

8:30am	Union Station
10:30am	Ward Parkway
12pm	Country Club Plaza
3pm	Fountain Scavenger Hunt
8pm	Power & Light District

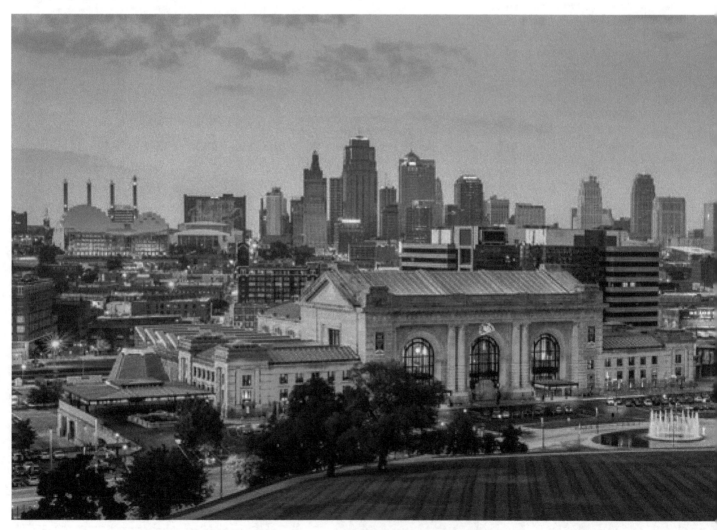

The Smoker

Crossroads Hotel
2101 Central St.

Crossroads is a thoughtful reimagining of the Pabst Brewing Depot, built in 1911. A time when Percheron horse-drawn teams paraded the streets with wagons loaded with beer. When Prohibition came, KC political boss Tom Pendergast bought both buildings, using them as an office and, according to legend, to bootleg liquor. Mixing Midwestern charm with unforgettable characters like Tom Pendergast and Johnny Lazia, it's their goal to keep the spirit of this building, the neighborhood, the city and its citizens thriving at the Crossroads and infuse it with the energy of all who visit. The entrance is absolutely grand and the rooms match the brick decor.

Sifting

Union Station and Penn Valley Park
8:30am-10am

The Kansas City Terminal Railway, a company formed by the twelve railroads serving the city, built the limestone and granite Kansas City Union Station that we see today. Excavation began in 1911; and on October 30, 1914, Kansas City Union Station opened as the third-largest train station in the country. Designed in the grand Beaux-Arts style, it reflected the city's status as major Midwestern metropolis and a significant passenger and freight rail hub with links to all parts of the nation. Step inside for plenty of attractions and be in awe by the vast architectural design.

Across the street, you'll find a beautiful fountain at the base of Penn Valley Park. Hike to the top for the greatest view of the Kansas City skyline. This is an absolute must, even if the hill can be steep to hike.

Local Inspiring Flavors

Breakfast
XR Café
2101 Central St.

When you tell people to gather at your hotel or a favorite neighborhood bar, you nest have the perfect spot - XR at Crossroads Hotel is just the place.

XR is open every morning for a coffee, breakfast sandwich, or a Black Hole Bakery pastry while you catch up on e-mails, connect with a friend, or study for the big day.

Lunch
Jack Stack Barbeque
4747 Wyandotte St.

This Country Club Plaza location brings world-class barbecue to Kansas City's premier shopping and tourist destination. Stop by and enjoy The Plaza's Spanish architecture from the outdoor patio. It has become a popular gathering spot for friends and family. Inside or out, this is the place to experience our legendary hickory-roasted barbecue. They offer memorable dining beyond expectation.

Dinner
The Rockhill Grill
2000 Grand Blvd.

A classic American restaurant serving familiar staples with a modern flair. Situated in Kansas City's Crossroads Arts District, our restaurant is designed to have an upscale, yet approachable vibe. Come as you are and enjoy downtown city views from their stylish second-floor lounge, settle into a delicious meal downstairs, or celebrate a special occasion at the private event space.

KANSAS CITY
BURNT ENDS

Drive Ward Parkway 10:30am-11:30am

One of America's greatest parkways can be found in Kansas City. Cruise on a curvy road, along an extensive green space covered with dense trees and gaze at the largest homes in the country. This stunning 12-mile stretch begins at the Country Club Plaza and continues through the affluent Mission Hills and Prairie Hills. You won't be disappointed!

Trimming

Country Club Plaza 12pm-2:30pm

I'd say this is the best outdoor shopping district in America. Kansas city's premier retail center is renowned for a reason. Stroll through 15 city blocks of spanish-inspired architecture to discover dozens of fountains, shop trendy designer brands and dine at beloved restaurants ideal for special date nights—proving the district to be an essential experience worth revisiting time and again. The lighting on the buildings are uniform, making a beautiful and tasteful setting.

Scavenger Hunt of Fountain 3pm-5pm

Chances are, you've already seen a few fountains. Visitors will find more than 200 fountains scattered throughout the metro, large and small, artistically intricate and cleverly simple. These showpieces grace courtyards, parkland and tree-lined boulevards.

Kansas City's first fountains date back to the late 1800s, when they served a purely utilitarian purpose: thirsty dogs, horses and birds drank water when passing to and through the city.

Soon thereafter, the city began erecting drinking fountains—each with their own distinctive architectural styles, features and themes—throughout the Downtown area to provide its citizens with safe drinking water. Enterprising individuals integrated intricate sculpture into fountain designs to both beautify properties and add distinction.

Momento

Let's get Cooking

BBQ SAUCE
Spicin' Foods
111 SW Blvd.

Why I Choice this Craft

Kansas City's claim to fame is its BBQ, which makes sense being in the heart of America's cattle ranches. BBQ has become a part of KC's culture and industry; you wouldn't be surprised if your local resident had a smoker and a grill at home.

Spicin Foods is a specialty food manufacturer based in Kansas City, carrying on the Original Juan tradition of making high-quality sauces, salsas, and drink mixes. For over 20 years, we have been a leading producer of micro-batch sauces. Our award-winning sauces can be found in grocery stores, restaurants, and you can probably even find a bottle or two of our sauce in your own pantry.

Separating

KC Live! in the Power & Light District 8pm-11pm

The Midwest's premier entertainment destination. An entire city block with two levels of world-class restaurants, taverns and night spots, KC Live! is where Kansas City goes to play. KC Live! also features a full-concert stage where the country's most premiere musicians and bands perform weekly during the summer and for special events throughout the year.

A Tasty Choice

KC Parks manages more than 135 miles of boulevards and parkways that wind their way through and provide green connections for this "city within a park". The George Kessler-designed system balances the need to move traffic while maintaining the reputation as the "Paris of the Plains". The city is fun to drive, especially on these boulevards and parkways. There's the Bush Creek Parkway, Ward Parkway, and The Paseo are just a few.

127

SAN ANTONIO
MARGARITA

Chef's Note

Texans didn't just battle for The Alamo, but also the unforeseeable allures that captivates the world's curiosity, from the River Walk to the legendary San Antonio Spurs and the dynamic confluence of cultures. It's a city seeking any reason to celebrate, already prepared as an annual host of one of the largest festivals in America, the Fiesta. America is grateful that Texans and Tejanos fought for this city over a hundred years ago.

Cook Time: 16 hours	
8am	Brackenridge Park
10:30am	Historic Market Square
1pm	The Alamo
4pm	The River Walk

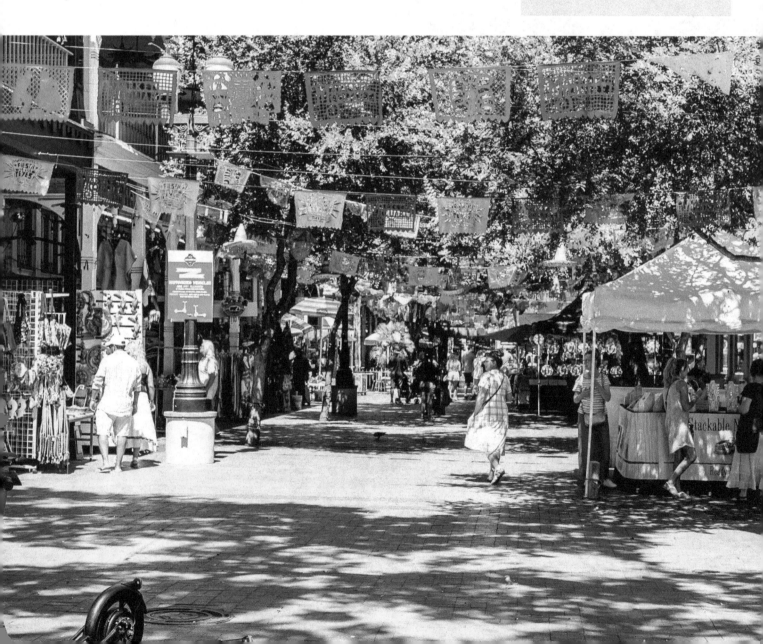

The Cocktail Shaker

Hotel Contessa

306 W Market St.

An intimate, all-suite retreat set directly on San Antonio's beloved River Walk, Hotel Contessa delights arriving guests with stylish suites that take their design cues from San Antonio's rich history and vibrant culture. Guests can enjoy a reimagined restaurant and bar serving up agave cocktails and authentically Texas fare.

Shaking

Brackenridge Park 8am-10am

Established in 1899, this park is home to some of San Antonio's most beloved attractions. The rustic character of the 343pm-acre park remains today with tree-lined paths and picnic areas along 2.2 miles of the San Antonio River, playgrounds and softball fields, a miniature train, historic structures, the Witte Museum, the San Antonio Zoo, and the oldest municipal golf course in Texas.

Brackenridge Park is on the National Register of Historic Places and is a Texas State Antiquities Landmark. The Japanese Tea Garden, a footbridge and other works by artist Dionicio Rodriguez, and the Water Works Pump House No. 1 are individually listed in the National Register of Historic Places.

Local Inspiring Flavors

Breakfast
The Guenther House

205 E. Guenther St.

The founder Carl Hilmar Guenther's family home, better known as The Guenther House; opened up to the public in 1988 as a Restaurant, Museum, Banquet Facility and Gift Shop. The Guenther House is a showplace of the traditions and history of C.H. Guenther & Son. They serve an all American breakfast using they Pioneer products and they exclusive San Antonio River Mill brand in they restaurant.

They present long time requested products, practices, and principles upon which C.H. Guenther founded and ran his company since 1851. Fast forward nearly 30 years worth of stacks of Pancakes and Biscuits topped with Gravy, The Guenther House now serves over 200,000+ guests every year while maintaining they promised value of the best possible services and products.

Lunch
There are plenty of local and authentic food establishment in the Historic Market District to consider.

Dinner
Explore the San Antonio River Walk, where you'll find plenty of options along the canal. Make sure to find a seat outside to enjoy most of the ambiance.

Historic Market Square 10:30am-12:30pm

514 W Commerce

Enjoy the sights and flavors of old Mexico at Historic Market Square, a favorite of locals and tourists for generations.

Explore over 100 locally owned businesses that provide a unique market place experience. The Historic Market Square is where the culture of San Antonio comes alive.

Nearly every weekend of the year, Market Square is filled with live entertainment, delicious food, and fun for the whole family; and talk about shopping... with unique multi-cultural merchandise you can find something for everyone. The market is decorated with vibrant colors, including the papel picado banners hanging from above.

SAN ANTONIO
MARGARITA

Pouring

The Alamo 1pm-3pm

Centrally located on Alamo Plaza in downtown San Antonio, the Alamo San Antonio features interactive tours, exhibits, and a Living History encampment where you can experience and learn more about frontier life in early Texas, watch demonstrations, and get your hands on history. Founded in 1718 as the first mission in San Antonio, the Alamo served as a way station between East Texas and Mexico. In 1836, decades after the mission had closed, approximately 200 Texan defenders held the Alamo from over 2,500 of General Santa Anna's troops from Mexico. For 13 days in 1836, close to 200 Texas defenders held the Alamo from approximately 2,500 of General Santa Anna's troops from Mexico. The most famous of the defenders, William B. Travis, James Bowie, and David Crockett, died fighting overwhelming odds for freedom. "Remember the Alamo!" became a rallying cry for Texans fighting for independence during the Texas Revolution.

Today, visitors are invited to rediscover the gem of Texas history, stroll through the 4.2pm-acre complex and Alamo Gardens. It is said that The Alamo is to Texans as D.C. is to America.

Garnishing

The River Walk 4pm-8pm

One of America's unforgettable tourist destinations. Experience the magical powers of the River Walk as you relax, play, and reconnect. Stroll the lush riverside paths lined with towering Cypress trees, restaurants, hotels, shops, museums, and recreation spots. Soak in the history and ambiance of this authentic San Antonio destination. It's a colorful and bustling part of town, day or night, mostly designed for leisure for visitors.

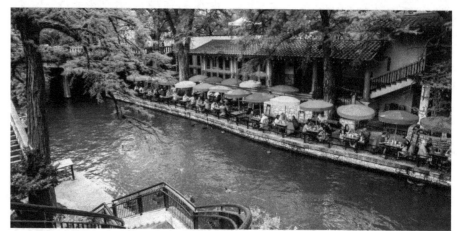

Momento

Let's get Cooking

PAPEL PICADO
Amol's Fiesta Supplies
227 Fredericksburg Road

Why I Choice this Craft

Inspired by Market Square's decorations, I reached out to Amols' party supplies and decor company to make the traditional papel picado. Originating from Mexico, locals from San Salvador started cutting paper flags, but it was only during the late 1920's that they traveled to a neighboring town to sell their paper flags. After many years, it had become a tradition to decorate the Day of the Dead with papel picado. The cutting of colored tissue took many forms, flowers and pinatas to name a few. It's a beautiful craft that involves cuts and bends of paper.

A Tasty Choice

Colorful is an understatement to characterize San Antonio. Watch the jovial dancers, wearing traditional Mexican Jalisco dresses. Take in the views of the radiant umbrellas along the River Walk. How about the stimulating atmosphere of the Market District? There are plenty of settings to lifts your spirits with eye-catching colors.

PITTSBURGH
PIEROGIES

Chef's Note

Founded on courage and industrious thinking, Pittsburgh is not just a natural wonder but a city-wonder. Nestled in and around The Alleghenies and at the confluence of three vital rivers, developers burrowed tunnels, erected bridges, and inclines to make this a city a 3-dimensional postcard. Pittsburgh has a one-of-a-kind hipster mountain culture and prides itself on its heritage and the onetime bustling steel industry. Known for its 90 distinct neighborhoods, there's always something new to discover and you can find the many staircases throughout the city to get there.

Cook Time: 24 hours

7am	Staircase Scavenger Hunt
10am	Duquesne Incline
12pm	Heinz History Center
4pm	Take a Drive

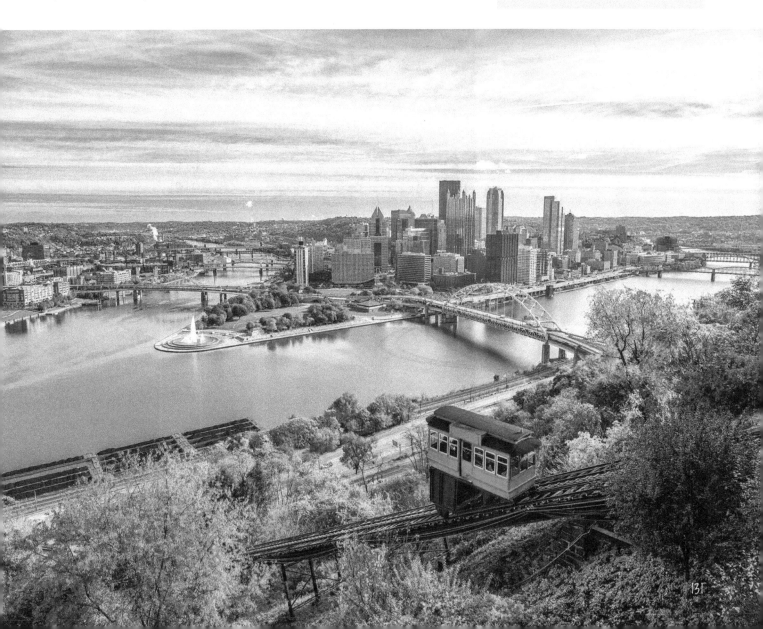

PITTSBURGH
PIEROGIES

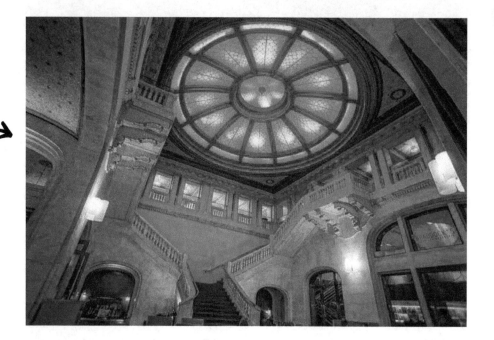

The Skillet

Renaissance Pittsburgh

107 6th Street

Located in the historic Fulton Building, this iconic luxury hotel delivers contemporary style in an exceptional atmosphere. Centrally located in the Cultural District, home to the city's premier theaters and concert halls, they're only steps away from Heinz Hall, Benedum Center, August Wilson Center and the David L. Lawrence Convention Center. If you are looking to attend a game or a concert, this riverfront hotel is in walking distance to PNC Park and Heinz Field. At night, enjoy the lighting of the bridges and the residential neighborhoods on the mountain.

Pre-heating

Staircase Scavenger Hunt 7am-9am

Explore dozens of historic steps throughout the city. It's truly a unique experience and a great way to see different neighborhoods and views of the city. They are necessary for commuters, otherwise you're asking to add another mile + on a road with no sidewalks.

Shaping

DUQUESNE INCLINE 10am-11am

1197 W. Carson St.

Enjoy a spectacular panorama of Pittsburgh and its three rivers. Ride to the incline's observation deck in the 140-year-old incline car to see one of the best views in America. Coal-filled trains pass right underneath your ride to the top.

Local Inspiring Flavors

Breakfast
The Speckled Egg

501 Grant St.

Inside the Union Trust Building, experience eating in a historic office lobby setting.

Lunch
Primanti Bros.

46 18th St

Founded in Pittsburgh's historic Strip District in 1933, Primanti Bros Strip District location is your go-to for delicious handcrafted sandwiches piled high with house-made coleslaw and perfectly seasoned fresh-cut fries. This is the iconic sandwich of the city.

Dinner
Wigle Whiskey

2401 Smallman St

Did you know American whiskey was born in Pittsburgh? Learn about the history of whiskey in Western Pennsylvania at Wigle Whiskey before tasting the award-winning spirits and grabbing a bite to eat in the warm, beautifully designed restaurant.

Boiling

Senator John Heinz History Center
12pm-2pm

1212 Smallman St.

If you recognize the name Heinz, the famous ketchup company named after the former senator is based in Pittsburgh. This Smithsonian affiliated museum will impress you with exhibits you may not have known started in Pittsburgh. Mr. Rogers, Roberto Clemente, and the iconic We Can Do It! WWII campaign all had a role in America's history.

Frying

Take a Drive 4pm-6pm

Pittsburgh is a fun city to drive, and you'll want to experience the bridges, tunnels, and hills. Check out the sloped Schenley Park, old steel mills, find the steepest road in America, and see much of the city on 5th Ave and Forbes Ave.

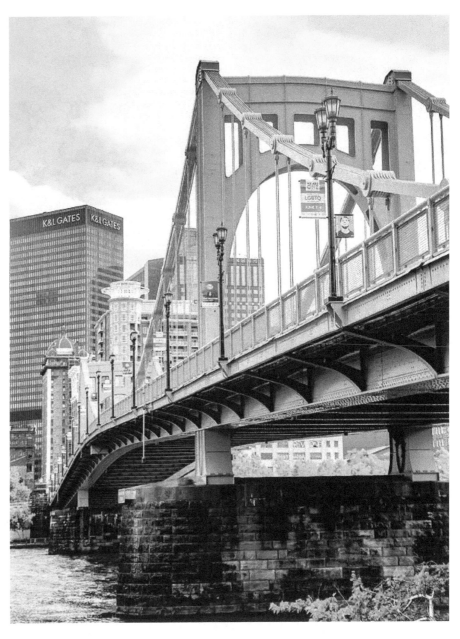

Momento

Let's get Cooking

PITTSBURGH STEELERS TERRIBLE TOWEL
Little Earth Productions
2400 Josephine St #1

Why I Choice this Craft
It's one of the most sold items in sports, and the Steelers have one of the largest followings in the world, alongside the Green Bay Packers and Dallas Cowboys. It was originally a gimmick, created by the local sportscaster, but now it's a rally towel. I had a chance to learn about the graphic designs, printing and pressing. The recent design, was won through a contest, featuring the skyline and I was there when the Steelers team ordered 20,000 towels for their upcoming season.

A Tasty Choice

Pittsburgh took the phrase, 'let's go paint the town' a bit too serious. Black and Gold distinguishes the city's pride, and it's not just blanketed at sporting events of the Steelers, Penguins, and the Pirates. Many of the government buildings, beautiful bridges, even stoplights are painted Goldish Yellow and Black. It's truly stunning when lit up at night.

LAS VEGAS
BUFFET

Chef's Note

One of the world's most inner competitive cities collectively benefiting every business and every person of Las Vegas. Three, eight-hour work shifts per day keeps this city running comprised of the world-class entertainment, accommodations, and electrifying ambiance that only exists here. Those red rock canyon hikes, casino gambling nights or the stimulating neon flashing lights overshadow time, but don't blink, the city is like a quick-change magic show.

Cook Time: 24 hours

8am	Red Rock Canyon
11am	Fremont Street
2pm	The Neon Museum
5pm	The Strip
8:30pm	Catch a Magic Show

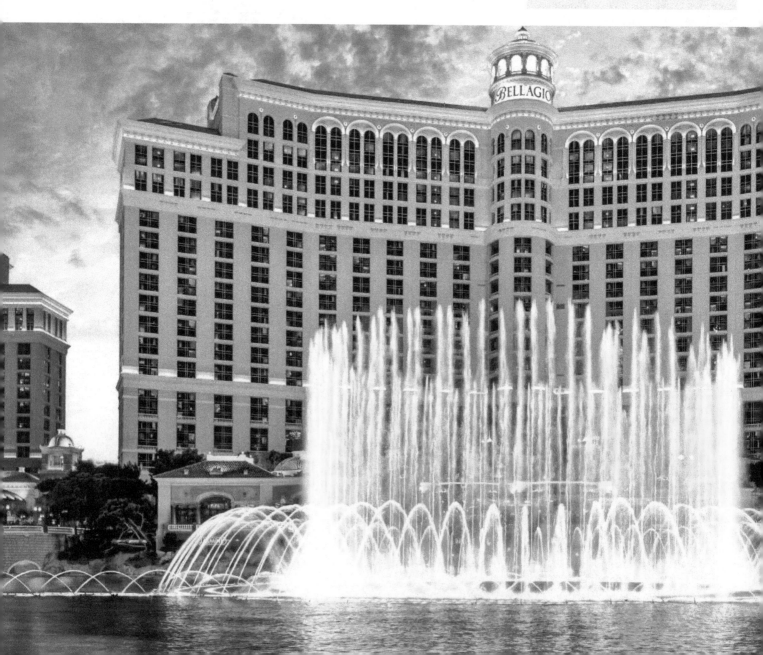

The Chafing Dish

Fremont Hotel & Casino
200 Fremont Street

Located in the heart of the Fremont Street Experience, the Fremont Hotel & Casino serves as the backdrop for movie and TV shows, special events and nightly high-tech sound and light productions. Inside the lively casino, friendly team members serve up plenty of gaming action, not to mention delectable, award-winning dining selections and comfortable accommodations.

Local Inspiring Flavors

Breakfast
Rachel's Kitchen

150 Las Vegas Blvd N

After the great success and notoriety of what were ultimately seven restaurants in Los Angeles, the owner made the decision to relocate to the newest culinary capital of the world, Las Vegas. Home to more celebrity chefs than possibly anywhere else in the world, she couldn't have picked a better location for her latest venture to provide a fresh casual eatery.

Lunch
Park on Fremont

506 E. Fremont St.

Amidst the neon at the world-famous entrance of Fremont East, you'll find a corner bar & restaurant incongruous in its surroundings. A front patio boasting views of in-your-face neon downtown hustle gives way to a 5000 sq foot wooden haven of calm. Indoors, a refreshing enclave of dark wood, comfortable banquette seating, eclectic art, and an innovative menu for dining and drinking.

Dinner
The Buffet at Wynn Las Vegas

3131 Las Vegas Blvd.

Redefining the eating experience with a feast of options, including an all-new eggs Benedict station and a Latin Street Food station among the 16 tantalizing food kitchens designed by Executive Chef Jason Duarte. All the classics are here too, from butcher-inspired cuts to shrimp cocktail, sushi and more. The Buffet at Wynn Las Vegas will satisfy every craving.

Guests at The Buffet enjoy new services added for greater ease and convenience, including the ability to obtain priority seating online and the option to pay in advance or at the table for a seamless dining experience.

More than 90 delicious dishes, including a wide range of made-to-order choices, all served in a bright and airy environment.

LAS VEGAS
BUFFET

Appetizer

Red Rock Canyon 8am-10am
889 S Rainbow Blvd.

When you think of Las Vegas thoughts of a man-made city of casinos, towering hotels, neon signs, bustling traffic and streets packed with people comes to mind. It's the city where you can visit Paris, New York and Venice without ever leaving the Vegas Strip. The city where nothing is real, where people go wild and escape their everyday lives. But you do not have to go far outside the city to find an area that is a different kind of wild.

Red Rock Canyon is a National Conservation Area only 15 miles from the Las Vegas Strip featuring Vegas hiking trails, amazing wildlife in Vegas and much more. Occupying one of the easternmost parts of the Mojave Desert, it features over 600 species of plants and is home to wild burros, bighorn sheep, and protected desert tortoise. Over the millennia, six different Native American cultures were present at Red Rock, making the area culturally and historically abundant, and blessing every fortunate occupant with unexpected encounters with petroglyphs, pottery fragments, and agave roasting pits. The combination of complex geology, history, and dramatic landscape create a truly idyllic atmosphere.

Entrée

Fremont Street (Downtown) 11am-1:30pm

Known as the original Las Vegas, way before gambling was legal, Fremont Street was the first paved road in the city. This 6pm-block district is not competing with The Strip because it has deep routed history and its own organic appeal, being home to many original hotels and casinos, close to the iconic wedding chapels and art scene.

Many features have been added, like a zip-line right through the street and a canopy lightshow. People enjoy this area because its low key, yet still offers the Vegas experience.

The Neon Museum 2pm-3:30pm
770 Las Vegas Blvd. N

Founded in 1996, dedicated to collecting, preserving, studying and exhibiting iconic Las Vegas signs for educational, historic, arts and cultural enrichment. The Neon Museum campus includes the outdoor exhibition space known as the Neon Boneyard, a visitors' center housed inside the former La Concha Motel lobby and the Neon Boneyard North Gallery which houses additional rescued signs and is available for weddings, special events, photo shoots and educational programs.

Dedicated individuals from the private sector, as well as corporate and government entities, worked collaboratively to promote the preservation of these national treasures as significant pieces of artistic and historical importance. Each sign in The Neon Museum's collection offers a unique story about the personalities who created it, what inspired it, where and when it was made, and the role it played in Las Vegas' distinctive history.

Dessert

Features of the Strip 5pm-8pm

The Las Vegas Strip has more attractions than any city in the world on one boulevard. Each hotel and casino compete for your time, alluring you to ride the indoor roller coaster at New York New York, the exploding volcano at The Mirage, Greek God statues in Caesar's Palace or the observation deck at The Stratosphere. Here are a few other hightlights:

-The Chandelier at The Cosmopolitan

A multi-story visual wonder housing three unique lounge experiences, The Chandelier expresses elements of playground, art exhibit, and cocktail haven all at once. The Chandelier is a living, breathing architectural wonder created by shimmering, beaded curtains of light.

-Grand Canal Shoppes

Be enchanted and inspired at Grand Canal Shoppes at The Venetian Resort, with window shopping by gondola via the indoor quarter mile-long Grand Canal where you'll enjoy more than a dozen world-class and award-winning dining venues in addition to over 160 signature stores and premier luxury brands.

Let's get Cooking

NEON SIGN

Hartlauer Signs

3900 W. Dewey Dr.

Why I Choice this Craft

Neon signs are a symbol of Las Vegas. They have become instant attractions that have worked for nearly a hundred years. Some have stayed, some restored, but always new ones are created. I stopped by Hartlauer Signs, a local boutique that has brightened Las Vegas for years with iconic imagery. I learned how to bend glass, one of the most intriguing arts in the country. Neon gas is naturally orange, and argon is purple. These gases, combined with filtered tubes creates vibrant colors that gets anyone's attention.

Momento

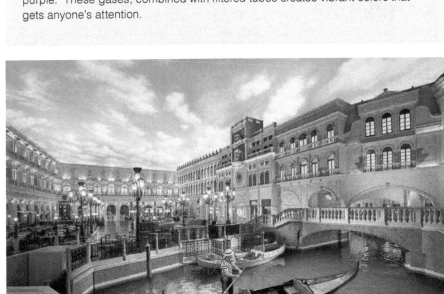

-The Fountains of Bellagio

There is nothing like seeing them in person. The Fountains of Bellagio were destined to romance your senses. It is the most ambitious, complex water feature ever conceived and it's absolutely free for any visitor to enjoy. Step back, or find a comfortable perch to sit, and watch against the backdrop of the Las Vegas lavender sky. Each performance is unique in expression and interpretation so no matter how many times you have seen the Fountains, they always have more in store to wow you with. Fall in love with this unprecedented aquatic accomplishment.

Late-night Snack

Catch a Magic Show 8:30pm-11:30pm

Practically every block and every stage there's a magic performance in Vegas. These mesmerizing performers are the city's original showstoppers. Be a part of the tradition by catching a show at one of the venues on the Strip.

A Tasty Choice

Las Vegas is constantly developing and redeveloping attractions, keeping this city on top. It has always been changing and always will. One day it's a new hotel, then a stadium, and a series of class acts that compete for a sport on the biggest stage. America's Got Talent is a perfect sample of that.

WASHINGTON, D.C.
CUPCAKE

Chef's Note

The nation's capital should be required for every American and prospective citizen to visit. It's a place that instills pride through majestic historical landmarks, federal government bureau and agency headquarters, and treasured museums of the country's most precious items. It's also the center of non-profits, legacy media, and international embassies. Washington D.C. has something for everyone, a museum for everything, whether an avid stamp collector, dinosaur enthusiast, history buff, or art and poetry admirer. As historic of a destination it is, it's pristine and modern with lots of character throughout its many diverse neighborhoods.

Cook Time: 24 hours

Time	Location
7am	Rock Creek Park
9am	Georgetown
11:30am	Embassy Row
1:30pm	Gravelly Point
3pm	The National Mall and Smithsonian Museums

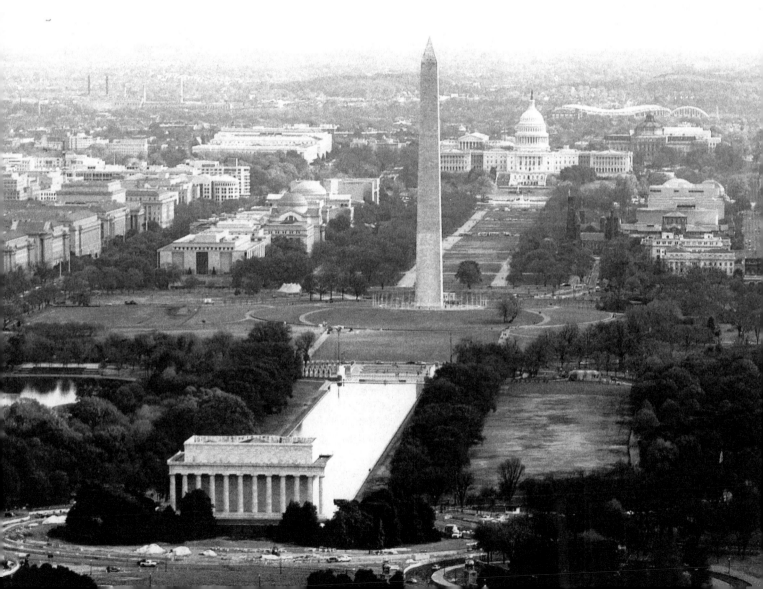

The Oven

Kimpton Hotel Monaco
700 F St. NW

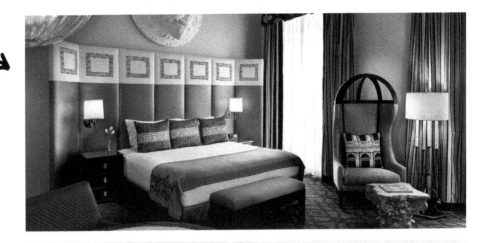

Life gets painted with a vibrant brush and a colorful palette at Hotel Monaco. Nothing is ordinary in our grand downtown building, built in 1839 as the city's original General Post Office. It's since been beautifully modernized (with a very recent refresh) to flawlessly meld the old and the new. Guests delight in our period architectural details, soaring ceilings, tall windows, and long, wide hallways that create an aura of drama and grandeur. At this location, you'll find yourself in the center of it all.

Pre-heating

Walk/Run Rock Creek Park
7am-8:30am

Founded in 1890 by the United States Congress as a recreational resource for the nation's capital, these 1,700 acres cut a wide swath through Northwest Washington DC, providing a haven for people and wildlife. An oasis in a bustling city, mostly consists of hardwood trees, a boiling brook, and rocky outcrops. But nestled inside the park are exciting activities to put on your must-do list, like the Smithsonian Zoo.

Whisking

GEORGETOWN 9am-11am
The beauty of Georgetown's cobblestone sidewalks, grand homes and peaceful C&O Canal are only part of the draw to this tree-lined historic neighborhood.

Georgetown is home to some of the city's top shops, tastiest restaurants and most luxurious hotels, and it's a walkable. It's one of the most popular neighborhoods to explore.

Local Inspiring Flavors

Breakfast
Dirty Habit
700 F St. NW inside the Kimpton Hotel Monaco

An intoxicating addition to DC's thriving restaurant and bar scene, Dirty Habit is anchored in expertly crafted cocktails, innovative social plates, edgy design, and a dramatic urban patio. Ideally situated in downtown Penn Quarter — and positioned as the centerpiece of Hotel Monaco Washington DC — this luxe venue pulsates with disarming twists and provocative touches that make for mesmerizing evenings.

Lunch
Kramers
1517 Connecticut Ave. NW

First opened their doors amid the Bicentennial celebrations of 1976. At the time of its opening, it was the first bookstore/café in Washington DC. Over the years, through expansions, subpoenas, and innumerable neighborhood changes, much of their business has remained constant, notably their commitment to providing their patrons with access to the best books they can procure and to the most delicious, varied food they can produce. In addition to possessing a lively, convivial atmosphere, and a full-service bar, Kramers stages hundreds of book-related events each year, both in the store and elsewhere. From theorists to neighbors, college students to the political elite, there is something for everyone at Kramers!

Dinner
Old Ebbitt Grill
675 15th St. NW

Washington's oldest saloon, was founded in 1856 when, according to legend, innkeeper William E. Ebbitt bought a boarding house. Today, no one can pinpoint the house's exact location, but it was most likely on the edge of present-day Chinatown.

As a boarding house, the Ebbitt guest list read like a Who's Who of American History. President McKinley is said to have lived there during his tenure in Congress, and Presidents Ulysses S. Grant, Andrew Johnson, Grover Cleveland, Theodore Roosevelt and Warren Harding supposedly refreshed themselves at its stand-around bar.

WASHINGTON, D.C.
CUPCAKE

Beating

Embassy Row 11:30am-1pm

Stretching from 18th Street to 35th Street and as its name suggests is where many nations have their embassies and diplomatic missions. Lining both sides of this very upscale road is a collection of dazzling mansions, from early 20th-century palatial residences to highly original modernist structures. In fact, there are no fewer than 150 embassies here, housed in beautiful and occasionally highly original buildings. Many of these structures were once the homes of millionaire investors, speculators, politicians and business titans who were forced to sell their mansions when the Great Depression hit.

A walk down Embassy Row provides a mesmerizing insight into how some of the wealthiest people in the United States used to live. As well as their flags, some of the embassies can be identified by other external features and adornments. For example, the British Embassy has a red telephone booth in front of its building, just like the kind you used to be able to see on many street corners in the UK. Outside the South African Embassy, there is a statue of Nelson Mandela.

Mixing

Watch Planes Land at Gravelly Point 1:30pm-2:30pm

North of Ronald Reagan Washington National Airport and across the Potomac River from Washington, D.C., you'll find the best spot in the country to watch planes land.

The park is a primary intersection on weekends of boaters, cyclists, and airplane-spotters. Its unique location just a few hundred feet from the north end of Reagan's runway, makes for breath taking, body rattling experiences.

Baking

The National Mall and Smithsonian Museums 3pm-7pm

Seeing the Washington Monument rise majestically to the sky, surrounded by the stately U.S. Capitol Building at one end and the dignified Lincoln Memorial at the other, it's hard not to think of America's history. Explore the swath of land nicknamed "America's front yard" and you'll find inspiring monuments and memorials, museums and family fun.

The monuments and memorials in this park honor American forefathers and heroes who paid the ultimate sacrifice in service to this country. From the "I Have a Dream" speech to the AIDS Quilt, the Mall is the national stage where movements and celebrations take place, where people gather to have their voices heard.

But the National Mall is much more than a lesson in history through memorials made of stone. East of the Washington Monument lies world-class museums with something for everyone, including the Smithsonian National Museum of African American History and Culture, the United States Holocaust Memorial Museum, interpret the meaning of original Da Vinci and Van Gogh works at the National Gallery of Art or pick your own adventure from the many Smithsonian Institution Museums.

Momento

Let's get Cooking

WRITING A POEM

Busboys and Poets with Dwayne-Lawson Brown

Why I Choice this Craft

Washington D.C. has a deep history of reflection and activism. It's a place where change is made and influencers can be heard. Every night, you can find a poetry reading or slam, where the community comes together to learn new ideas, feelings, and perspectives. I met with Dwayne-Lawson Brown, a DC native that performs the spoken word. His biggest advice was to make the audience feel. Many iconic poets and writers came from D.C., including Walt Whitman, Langston Hughes, Fredrick Douglas, and F. Scott Fitzgerald.

A Tasty Choice

There are approximately 36 circles (roundabouts) named after American Civil War generals and admirals throughout the city. Many of the circles are centered with a fountain and statue, as some are used for parks. These circles have several busy roads merging and are a beautiful road feature. Most notable are Dupont Circle and Logan Circle.

NORFOLK
CROMER CRAB <u>WITH</u>
VIRGINIA BEACH
ORANGE CRUSH

Chef's Note

The Elizabeth River, running through Norfolk is a tributary of the James River and is located at the bottom of the Chesapeake Bay and at the mouth of the Atlantic Ocean, located in Virginia Beach. Navigating these impressive bodies of water by the nation's first settlers, developed rich nautical cultures and industries; naval shipyards, sailing and marine science. Norfolk and Virginia Beach are both essential for America's defense, but they serve differently. Norfolk is a quaint historic city, lined with mature trees and narrow roads, while Virginia Beach is largely modern and expansive beach city.

Cook Time: 24 hours

8am	Chesapeake Bay Bridge-Tunnel
9:30am	First Landing Park
11am	Virginia Beach Boardwalk
2pm	Nauticus and the Battleship Wisconsin
4:30pm	Drive Colley Ave.
6pm	Downtown Norfolk

The Pint

Hyatt Place, Town Center
335 Independence Blvd, Virginia Beach

Spacious guestrooms offer flexible workspace and areas to relax with a separate living area featuring a Cozy Corner sectional sofa sleeper. Additionally, all bathrooms are nicely appointed with a roomy walk-in shower and oversized eco-quartz vanity with one sink. Walking distance to The Town Center of Virginia Beach which features a sophisticated blend of lifestyles including the best in retail, dining, entertainment, and offices in a beautifully landscaped environment.

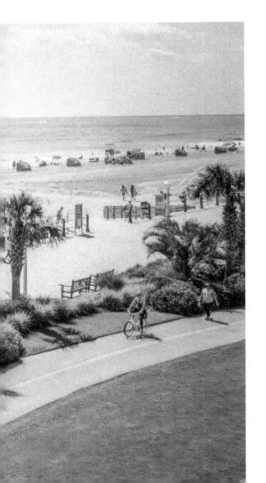

Crushing

Drive the Chesapeake Bay Bridge-Tunnel 8am-9am
Both a tourist attraction and a travel convenience, this bridge-tunnel connects the Virginia mainland at Virginia Beach near Norfolk with Virginia's Eastern Shore. This 17.6 mile toll facility is an award-winning engineering marvel and is considered one of the seven man-made wonders of the world. A scenic overlook provides an opportunity to stretch your legs and enjoy the natural beauty, sights and sounds of the Chesapeake Bay as well as provides a great vantage point for camera buffs. From above, the bridge appears to have a section missing. However, as you approach the tunnel by car, you'll see this "missing" part is actually the tunnel itself that dips underwater to allow the countless ships to pass over easily.

First Landing State Park 9:30am-10:30am
A 2,888-acre park that fronts the Chesapeake Bay and features 1.25 miles of beach and more than 19 miles of interpretive hiking trails through protected salt marsh habitat, freshwater ponds, beach, dunes, forest, tidal marsh and cypress swamp. A registered Natural Landmark, First Landing is the most visited state park in Virginia and contains one of the most endangered habitat types in the world, the maritime forest community.

On April 26, 1607, some 100 English settlers landed here and established the first elective government in English America before pushing up the James River to establish Jamestown.

continued

Local Inspiring Flavors

Breakfast
Chick's Oyster Bar
2143 Vista Circle, Virginia Beach

A dockside staple of Virginia Beach, serving local seafood. This rustic calm shack has a perfect vibe for enjoying the local nautical culture.

Lunch
Barrel 17
1706 Mediterranean Ave., Virginia Beach

Providing high quality American cuisine with a quaint, causal, local atmosphere in the Artsy Vibe District, just a short walk away from the beach! From their award winning Jammin Goat Burger to their craft cocktails down to their vegan options, there is something for everyone!

If you're in the mood for an old fashion bourbon they've got you covered along with a variety of other adult beverages to fit everyone's fancy (who's eligible of course) If you want to bring the kids out they have an area with table games that will entertain them while your food is being prepared. You don't have to go far to get quality in this community.

Dinner
The Grilled Cheese Bistro
345 Granby St., Suite B, Norfolk

An incredible assortment of grilled cheese sandwiches, that of course melt in your mouth. The sidewalk dining underneath a canopy makes this place a pleasurable experience.

NORFOLK *CRONER CRAB* WITH
VIRGINIA BEACH
ORANGE CRUSH

This historic event is reflected in the name of Virginia's most visited state park. Along with its historical significance, the park offers opportunities to explore a unique habitat featuring lagoons, large cypress trees and rare plants. More than 19 miles of hiking trails wind through the natural area, guided kayak ecological tours allow exploration of the marshes and bays, and the visitor center exhibits explain much about this coastal environment. Cabins, campsites, picnic areas, a swimming beach, boat ramps, kayak rentals and tours, and a bicycle trail are offered in the park.

Bike the Virginia Beach Boardwalk 11am-1pm

The Virginia Beach Boardwalk, at the Oceanfront, is a 28-feet wide marvel that stretches three miles from 2nd to 40th Street and features a separate bike path, ideal for strolling, roller blading and biking. Entertainment is offered nightly during the summer months and four oceanfront stages at 7th, 17th, and 24th and 31st Streets provide live musical acts. Along the boardwalk, there's a variety of quaint outdoor restaurants and vendors offering bike and surrey rentals. Nautical sculptures adorn many of the side streets which lead to Atlantic Avenue. While there, don't forget to swing by and see King Neptune – a twenty-four foot, twelve-ton bronze statue that stands at the gateway to Neptune Festival Park on 31st Street. This is perhaps one of the most popular photo opportunities in the resort area.

Squeezing

Nauticus and the Battleship Wisconsin 2pm-4pm

A maritime discovery center located along the waterfront in downtown, Norfolk, VA, offering a unique form of experiential learning for all ages. Through interactive exhibits and STEM to STERN programming, Nauticus uses the museum, Battleship Wisconsin, sailing center, and Schooner Virginia to tell the story of the maritime environment, industry, and the military. This region of America, known as the Hampton Roads has several shipbuilding companies and is quite a sight to see thousands of workers getting off their shift, like kids getting out of school.

Splashing

Drive Colley Ave. 4:30pm-5:30pm

The Ghent Neighborhood is filled with character, culture and delicious cuisine with lots of history. Its main thoroughfares of Colley Avenue and 21st Street are lined with eclectic eateries, unique shops, art galleries and antique stores.

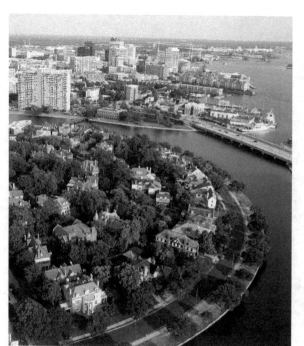

Downtown Norfolk 6pm-8pm

A vibrant, urban waterfront hub where creative grit and traditional Southern hospitality merge. Visitors will find abundant water activities and an extensive local and international dining scene with eclectic art woven through, all situated among historic attractions, unique museums and sweeping water views. Housing the world's largest naval base, NATO North American headquarters and an expansive seaport, the city is a melting pot of cultures and ideas that shine through in its diverse people, cuisines, attractions, shopping and entertainment venues – and Downtown Norfolk is where it all culminates to offer an experience like no other.

Momento in Norfolk

Let's get Cooking

MERMAID FIGURE
The Mermaid Factory
919 A West 21st St. Norfolk

Why I Choice this Craft

Norfolk's mermaids have existed for two decades and have become their iconic symbol. A local bronze sculptor, Kevin Gallup, mass produced 130 mermaids which were then designed and painted by local artists. Today, these mermaids have doubled in quantity and are scattered throughout the city for residents and visitors to enjoy. There is no final count on the number of mermaids in Norfolk, but it would make for a challenging scavenger hunt. At The Mermaid Factory you can paint your own mini mermaid on plaster products, which makes for a fun social event.

Let's get Cooking

Momento in Virginia Beach

ROPE KNOT ART
BYOB Creative Connections
928 Diamond Springs Rd Unit 113, Virginia Beach

Why I Choice this Craft

Ships and sailboats are a large part of the culture and industry of Virginia Beach. I met with Mike Moreau, a retired Navy Officer to learn different ways of knotting rope that he used in the service to tie massive ships and sailboats. I was first introduced to the terminology of the basics, like a bight, turn and round turn. Then he had me try the figure eight, reef knot, sheet bend and bowline. It got a little harder when tying the rope around an object, using a round tuner and two half hitches, the clove hitch and cleat hitch. He shared with me, that he always carries 6 ft of rope in his pocket to practice and possibly use for an unexpected event.

A Tasty Choice

Naval aviation, Navy Seal and sailor sculptures are tributed throughout Norfolk and Virginia Beach, honoring those that serve and served in the Navy. I first noticed a few along the Oceanfront boardwalk in Virginia Beach then near the Battleships in Norfolk. It's obvious that the residences of this area respect each and every serviceman's sacrifice and dedication to their country.

JACKSONVILLE
OYSTERS

Chef's Note

The meandering waterways, stately bridges over the St. John's River, and the serene Atlantic Ocean offer an idyllic natural playground. Jacksonville can be defined as the Great Outdoors, but it's also the most sprawling city in America. Large and wide commercial roads connect downtown, twelve miles to the beach. Residents can live on a resort and commute for business in downtown, a fortunate lifestyle blend.

Cook Time: 24 hours

6:30am	Atlantic Beach
9am	Paddleboarding
1pm	San Marco
5pm	Downtown Art Walk
7pm	Alhambra Theatre

The Ice Bed

The Hotel Palms
28 Sherry Dr. Atlantic Beach

Originally built in 1947, Hotel Palms is a renovated motor court inn three blocks from the Atlantic Ocean that includes 11 guest rooms, shared courtyard, and lounge. The property and experience are extensions of the destination our guests are visiting. Focused on design, architecture, and culture, Hotel Palms is personal, authentic and guests leave inspired.

Scrubbing

Walk to the Atlantic Beach 6:30pm-7:30am

Catch the stunning sunrise on a low-key pristine beach, mostly non-commercial. There's an entrance to the beach from almost any block throughout the neighborhoods, where there's also a paved path for biking and running.

Paddleboarding 9am-11am

An absolute treason for anyone visiting or living in Jacksonville. Just like hiking trails, Jacksonville's waterways are setup with marked trails. The Jacksonville Surf and Paddle instructors are at your service 365 days a year! They specialize in SUP flatwater, surf, long distance, fitness race training, and travel. Most people are curious about paddleboarding and just need a little help getting started. Come try paddleboarding with them. Start at the Dutton Island Preserve to reach the intercoastal waterways from a quiet and remote launch. There's a pretty decent chance to catch dolphins!

Local Inspiring Flavors

Breakfast
Le Petit Paris
363 Atlantic Blvd. Suite 14
Atlantic Beach

Be away from your every day and step into little Paris. The sights, sounds, and smells of a traditional Parisian café await you at Le Petit Paris. Join them for breakfast, brunch, lunch, and the ever-French aperitif- the magical moment in the afternoon to grab a small bite, a glass of wine, and take life in with friends. Offering a wide selection of fresh-out-of-the-oven French baked goods, macarons, gourmet salads, quiche (a family recipe), and sandwiches served on fresh baguettes or croissants.

Lunch
Seafood Island Bar & Grille
1959 San Marco Blvd.

Their concept is an alternative to fast food that's still reasonable on the wallet, quick and enjoyable. They offer a dining experience that is different than others, If you're looking for a quick but still enjoyable bite to eat on lunch break or for a nice relaxing friendly place to dine they can assure you that you will find it here with us at Seafood Island

JACKSONVILLE
OYSTERS

Shucking

Explore San Marco 1pm-3pm

This historic district is a quaint, yet lively few blocks to explore. The park with lion fountains is a perfect place to take in the scenery. Definitely the neighborhood with the most character and authenticity.

Jacksonville Downtown Art Walk 5pm-6pm

With more than 40 galleries, museums, cultural venues, restaurants, bars and businesses, in addition to dozens of artist booths at James Weldon Johnson Park, street performers and live music, this art walk is more than 20 years old. If the timing doesn't work for your visit, there are other Art Walks within the city any day of the week.

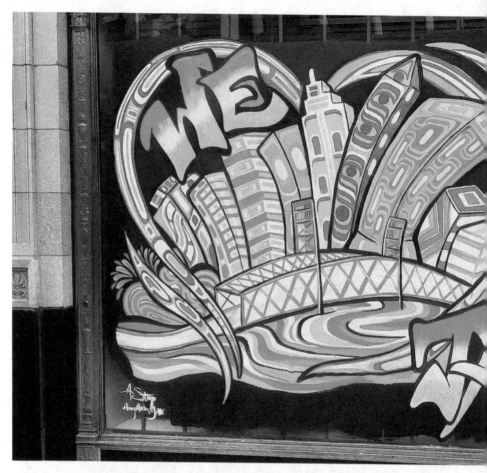

Garnishing

Alhambra Theatre & Dining 6:30pm-8:30pm

12000 Beach Blvd

At a table set for two, covered by an elegant lace cloth and adorned with matching napkins, silverware, stylish china plates and coffee cups, a vision of the future arose. Founders Ted Johnson and George Ballis were confident in their concept of a new theater.

Since 1967, Alhambra Theatre has been a place where friends and families can come together to enjoy a broadway-quality show and a delightful meal.

Through the years, the theater has dazzled generations of guests and even a few celebrities. If these walls could talk, they would have some fun tales to share.

Today, the Alhambra stands proudly as the nation's oldest continuously-operating dinner theater.

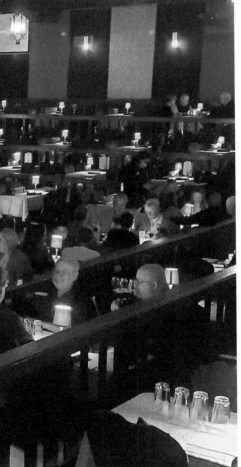

Momento

Let's get Cooking

OYSTER SHELL ART
The Gilded Shell

Why I Choice this Craft

Oysters are abundant in Jacksonville's ocean and waterways. The founders of the Gilded Shell collect washed up oysters along the shore and create meaningful beads. Their hospitality beads and the decision to place an oyster at the end of each one is more than a reflection of our beachy style. They specifically chose oysters because they can represent so many positive things depending on the person and what they want

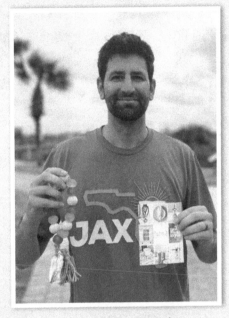

to see. They are a reminder that beauty can come from the unexpected.

Did you know oysters create pearls from specks of dirt and sand? When facing things that may at first appear to halt or harm us, this truth about oysters can remind us that those same obstacles can evolve into triumphs. Bad situations can become beautiful ones.

Oysters are a gentle reminder to live in the present, giving our full attention to our immediate surroundings and to find contentment in that. The oyster cleans and filters its current surroundings. It has no prey and remains calm and peaceful even in turbulent waters. While the oyster is small, its shell is tough and very strong. The shell is built to withstand outside forces and turbulent waters. The strength of the oyster is a reminder that we are built to withstand much more than we think can handle and can recover from events even stronger than before. The inside of an oyster has a beautiful iridescent glow and, on a rare occasion, a pearl that is even more brilliant.

A Tasty Choice

The bridges are stunning engineering marvels. Driving to the apex of the bridge, makes your heart race. The St. Johns River and San Pablo River carve through the city so there must be many crossing points throughout the city. From just one room of the Bank of America tower (Jax's tallest building), you can see 9 bridges. Each bridge has a unique story from inception to construction, repair, replacement, and renewal.

TULSA CHILI PIE

Chef's Note

Tulsa is changing, figuring out its identity or maybe that's how it's always been. Route 66 has made this city a throughway, bringing all types of people and ideas in and out. Traditionally, known as the Oil Capital of the World, attracting roughnecks for work, has integrated an over-the-top creative arts scene. Sitting at the buckle of the *Bible Belt* to becoming the liberal city of the heartland. From the enormous 1920's art-deco buildings to hip retail spaces used from shipping containers. The recovery of the *Black Wall St.* caused by the largest massacre in America to a once again thriving district on Reconciliation Way. Now, there are more interstates than one leading people to Tulsa, but this time, they're staying.

Cook Time: 20 hours

7am	Gathering place
10am	Art Deco Tour
11am	Arts District
12pm	Greenwood Rising
3pm	Philbrook Museum

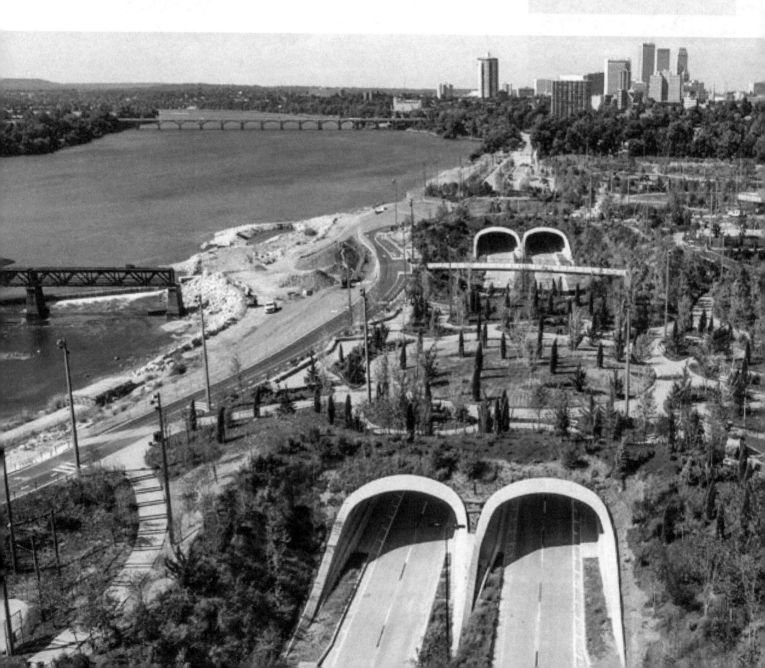

The Skillet

Hotel Indigo

121 South Elgin Ave.

Located on Santa Fe Square in the Blue Dome District, this 93pm-room hotel shares its space with bars, restaurants, retail shops, commercial properties, fine dining, an art studio, salon, comedy club, bowling alley and residential developments, so you'll feel like a local immediately. You can take it all in from their indoor-outdoor rooftop bar with stunning sunset views and their very own Prospect Local Bar & Kitchen. The lobby has locally inspired art from its oil industry and the rooms are too comfortable to leave.

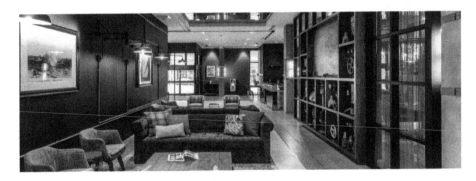

Pre-heating

Gathering Place Park 7am-9am

2650 S John Williams Way East

Built in 2018, Gathering Place has been voted by the most notable publications, as the best city park in America. Since, I'm a sucker for city parks, I had to see this place and judge for myself. It was the most well-maintained park I've seen, almost like an amusement park with the layout of a zoo. There are indoor facilities used as conference rooms and study lounges, hence gathering place. The playground is a children's paradise, for toddlers and up. Lastly, the most impressive is the boathouse, where you can take a canoe or paddleboat for free. Their motto is that everyone should have an equal opportunity to experience what they desire.

Local Inspiring Flavors

Breakfast
Dilly Diner

402 E 2nd St

Tulsa's favorite diner located in the Blue Dome District! Across the street is the Blue Dome, site of the filling gas station in Tulsa off Route 66. Why not fill your stomach, next to the original station to fill your tank?

Lunch
Wild Fork

1820 Utica Square

An iconic Tulsa restaurant in the heart of Utica Square outdoor shopping center. It has a 25 year long reputation of serving upscale food in a beautiful atmosphere.

Dinner
Mother Road Market

1124 S Lewis Ave.

Eat! Sip! Shop! Mother Road Market is Oklahoma's first food hall! They are focused on good food, unique retail and offering Tulsa a vibrant space for our community to gather. Foodies, artists, musicians, travelers and YOU have a space to try local food and shop for unique finds plus you might even find a cooking class going on in their demonstration kitchen or a beer tasting happening at The WEL Bar! Did I mention their huge back patio with ample seating, live music and Route 66-themed mini golf? On top of all this, they are also a nonprofit focused on allowing entrepreneurs the opportunity to test out their latest food and retail concepts without the financial risk of opening their own space. They are supporting LOCAL, right here on Route 66, so come join them at the corner of 11th and Lewis in Tulsa!

TULSA
CHILI PIE

Layering

Tour Art Deco Architecture
10:00am-11am

Downtown

Much of Tulsa's downtown skyline consists of 1920's art-deco architecture. Notice the faint beige color theme of the buildings with gold trimmings that gives Tulsa its unique identity. Visit the insides of Philtower, Philcade, Mid-Continent Tower to appreciate the ornate craftsmanship.

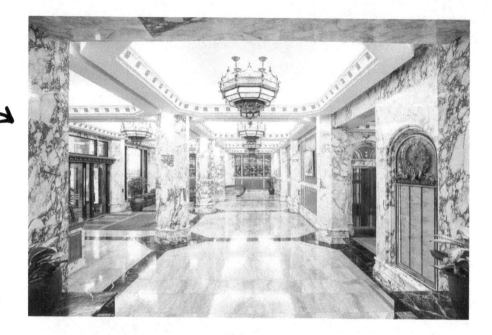

The Tulsa Arts District 11am-12pm

On the other side of the train tracks, the Tulsa Arts District is a diverse, culturally robust district in Downtown Tulsa. Grown from a historic oil-rich past with icons including The Tulsa Theater and Cain's Ballroom, the district has evolved over time to become a creative, community-driven engine of the Tulsa economy. With a variety of retail and service shops, restaurants, bars, clubs, galleries, museums, parks, private businesses, and historic music venues they welcome you to Arrive Early and Stay Late in the Tulsa Arts District!

Greenwood Rising Exhibits (Formerly Black Wall St.) 12:00pm-1pm

23 N. Greenwood Ave.

Learn about the history of Black Wall St. and the largest massacre in American history, the 1921 Tulsa Riots.

Baking

Philbrook Museum of Art 3:00pm-5pm

2727 S Rockford Road

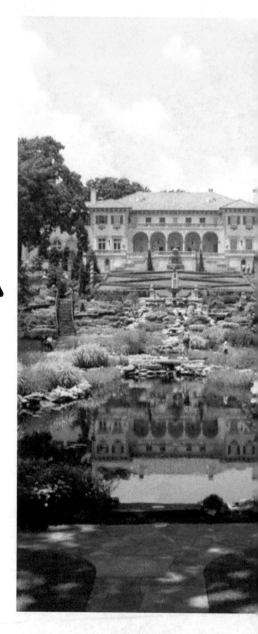

Committed to being Tulsa's most welcoming and engaging cultural institution, providing a unique trifecta of experiences: a historic home, world class art museum, 25 acres of gardens.

Philbrook Museum of Art opened on October 25, 1939. The addition of a 70,000 square foot wing in 1990 turned the historic home into a modern museum complex. A major garden renovation in 2004 cemented the Museum's reputation as "the most beautiful place in Oklahoma."

Through bold action and strategic investment, we create a space for new ideas, diverse stories and perspectives, and social connection. The Philbrook Collection features more than 16,000 objects with a focus on American, Native American, and European art. Serving over 160,000 visitors annually, Philbrook shines a light on Tulsa's storied and complex past while building a diverse and creative vision of the city's future.

Let's get Cooking

PUCKER TOE MOCCASINS

Gilcrease Musesum

1400 N Gilcrease Museum Rd,

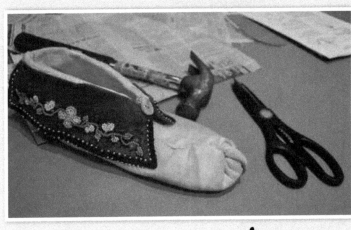

Why I Choice this Craft

Thomas Gilcrease, a citizen of the Muscogee Creek
Nation, established Gilcrease Museum in 1949
in Tulsa, Oklahoma. Today the interdisciplinary
collection contains more than 350,000 items.
The museum represents hundreds of Indigenous
cultures from across North and South America,
with material culture and archaeology ranging from
12,000 BCE to the 21st century. The collection includes more than 350 years of American paintings,
sculptures and works on paper, including the largest public holdings of art of the American West.

Momento

I wanted to learn a traditional craft with leather that reflects the Native wardrobe.

A Tasty Choice

Tulsa is broken up by districts. There's no district in the country devoted to such an
impressive concentration of churches and cathedrals, quite like Cathedral District.
Believer or not, visit these 6 iconic places of worship to appreciate the tranquil nature
and influence on a community.

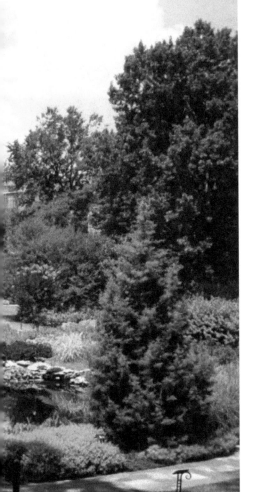

PINA MIAMI

Cook Time: 21 hours

6am	Miami Beach Walk
10am	Design District
12:30pm	Little Havana
3pm	Lincoln Road Mall
7pm	Ocean Drive

Chef's Note

Miami is an art piece, vibrant with colors seemingly unreal. The Biscayne Bay's emerald green and the Atlantic Ocean's peacock blue, meshed with the blinding green blades of thick grass and nourished palm trees, exotic birds soaring high above attracting attention to the unique contrasting pale architectural skyline. There's nothing modest about Miami, in some cases over the top, but when you got it, flaunt it.

The Blender

Mandarin Oriental
500 Brickell Key Dr.

A unique urban resort located on the three-acre, exclusive island of Brickell Key. Providing lush open spaces and light sea breezes, the Five-star hotel and spa offers an ideal location within walking distance to the finest shopping, dining and nightlife experiences in Miami while providing the ultimate tranquil oasis for an escape. All guestrooms and suites come equipped with private balconies from which guests can enjoy stunning views of Biscayne Bay or Brickell Skyline. The hotel also boasts high-energy Food & Beverage concepts with breathtaking views and alfresco options.

Pouring

Miami Beach Walk 6am-8am

One of the most fantastic features of this city is the path that runs along the eastern shore of Miami Beach, which consists of paver roads, boardwalks, sandy stretches, biking paths and promenades. This 10 mile stretch is a perfect way to explore the beach, high-rises, people-watch and enjoy the ocean breeze.

Miami Design District 10am-12pm

26700 SW 8th St.

A creative neighborhood where you can shop, dine, experience contemporary art and design, enjoy amazing events and get inspired. The District is home to more than 120 flagship stores like Balenciaga, Hermes, Fendi, Dior, Cartier, Louis Vuitton, and more – making it one of the world's greatest shopping areas. In the District, you are also be surrounded by some of the best architecture in the country, right down to our award-winning Museum Garage. Shop design showrooms like Poliform and Holly Hunt. Visit three cultural institutions — ICA Miami, the de la Cruz Collection and Locust Projects — within blocks of each other, or explore the rigorously curated and totally Instagrammable public art program woven throughout our streets. In the Miami Design District, every building and every pathway has to the potential to become a canvas for great design and art.

Also a dining destination where world renowned chefs have set up shop, they have low-key spots like OTL and Michael's Genuine Food & Drink and the food hall concept of Mia Market, where you can always enjoy a good time with friends. They also have buzzy hotspots like Swan, L'Atelier de Joel Robuchon, and Le Jardinier that make any night out special And let's not forget the multiple artisanal ice cream experiences on hand in the District.

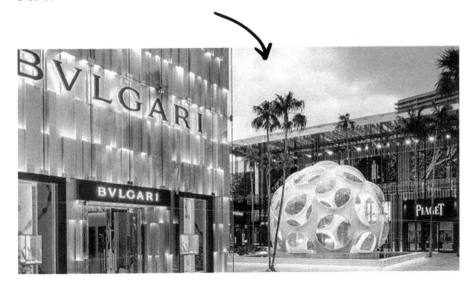

Local Inspiring Flavors

Breakfast

Granier European Bakery & Café
1064 Brickell Ave.

Their story begins in 2010, when the first Granier Bakery opened in Barcelona Spain. Since then, they have been striving to bring pastries, coffee and European breakfast around the world to their guests. They are very proud to say that you can find them in more than 380 locations around Spain, Portugal, Italy, England, and the U.S.

Lunch

Sala'o Cuban Restaurant & Bar
1642 SW 8th St.

Sala'o combines its Cuban roots & seafood with an homage to the honorary Cuban himself, Ernest Hemingway and his book "The Old Man and the Sea". Right here, in a little corner of Miami's popular Calle Ocho, you are transporting yourself to a dimly lit ambiance reminiscent of the early 1950's. Enjoy bold dishes created by Chef Alejandro Porben, which burst with flavor as you sip on a selection of handcrafted, tableside gin & tonics specially created to invoke adventure in their guests. From seafood to quality meats, the chef has curated a menu that ties his signature twist with traditional Cuban seafood dishes. The Cuban vibe, also know as "son", of our live entertainment accompanies the feeling of a nostalgic Cuba, what they know as a "Cuba Libre", that can only be complimented by an authentic daiquiri in true Hemmingway fashion.

Dinner

Explore the European style promenade of Lincoln Road on South Beach. Plenty of exotic outdoor dining options.

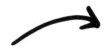

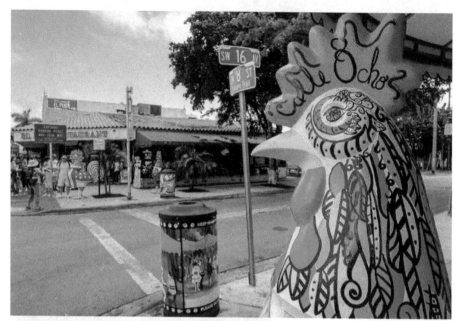

Crushing

Little Havana 12:30pm-2pm

The heart of Miami's Cuban diaspora – is part of what makes Miami such a dynamic cultural destination. The neighborhood is centered around Calle Ocho (Southwest Eighth Street), a vibrant thoroughfare lined with Latin-inspired restaurants, bakeries, fruit stands, cigar shops, rum bars, art galleries and music venues. It's also where you'll find the famed Máximo Gómez Park (known as Domino Park),where locals gather to talk politics over heated games of dominoes. The street is lined with murals and other artwork, from the mosaic tiles near Domino Park depicting classic symbols of Cuban heritage – cigars, musical instruments and tropical fruit – to walls covered with portraits of Cuban legends, including revolutionary poet José Martí and beloved singer Celia Cruz.

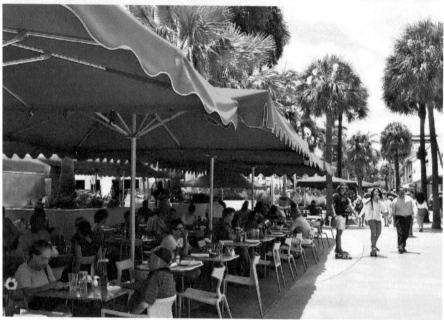

Blending

Lincoln Road Mall (Outdoor Promenade) 3pm-6pm

This epic outdoor Miami Beach pedestrian thoroughfare features premier shopping, restaurants, and nightlife as well as South Beach classic architecture and Miami style. Lincoln Road Miami Beach is also a cultural hub with the elegant Art Deco-era Lincoln Theatre and incredible music and theatrical productions at the Colony Theatre. ArtCenter/South Florida showcases cutting-edge local artists while Books & Books often has guest appearances by noted authors. Feel the sunlight on your face and smell the ocean air as you sip cocktails over a tasty dining experience after a day of strolling around the galleries and shops lining the walkway. These one-of-a-kind boutiques, art galleries and trendy shops make Lincoln Road a retail adventure. Best of all, stores and cafes stay open late for a crowd that never sleeps! There's simply never a dull moment on Lincoln Road—a fabulous place to eat, hang out and, of course, shop till you drop!

Let's get Cooking

SAND ART

Momento

Why I Choice this Craft

South Beach is one of the world's most famous beaches. I wanted to build a sandcastle, but couldn't take it home with me, so I used sand from the beach to line the words, Miami and an image of a rooster, which is a symbol of strength to the Cuban people. It's a nice framed piece, but here's a talented piece of sand art inside a glass bowl.

Stirring

Ocean Drive 7pm-10pm

On dreamy Ocean Drive, iconic beach views, cafe-style dining and Art Deco architecture form the backdrop for your fun-filled day.

When travelers first think of Miami, no doubt the colorful image that comes to mind is Ocean Drive. Lined with quaint, pastel-hued Art Deco buildings and hotels, restaurants that spill out onto the streets, festive travelers, boutique beach shops and more, this oceanfront street is the place to go for a quiet cup of coffee, an oversized margarita and some excellent people-watching. It only makes sense that such a beautiful destination has served as the backdrop for some of Hollywood's most iconic films and TV shows, like Scarface, The Birdcage, Miami Vice, Reno 911: Miami, Bad Boys, There's Something About Mary, Dexter, Burn Notice, Magic City and Moonlight.

A Tasty Choice

Miami's architecture was always extreme. A city built around real estate, its industry was land and housing — both producing and consuming the like as it expanded. Each new development acted as a billboard for its own modernity, the next big thing. The city is best known for its Art Deco: the remarkable repository of 1920s and 1930s hotels, diners, houses and storefronts which make up the greatest concentration of this style of architecture anywhere in the world. It's a panoply of curving corners, streamlined shops and stepped cotton-candy neon. But Miami also developed its own version of modernism, a unique, louche, lounge style that defined a certain kind of mid-century aspiration. MiMo (Miami Modernism), as it is now known, is a fusion of the outright commercial and the avant-garde — a cool but occasionally bizarre cocktail of Brazilian tropical modernism, sculptural park pavilions, European postwar socialist public architecture and Vegas sprawl. It is easier to recognize than it is to describe. You know it when you see it.

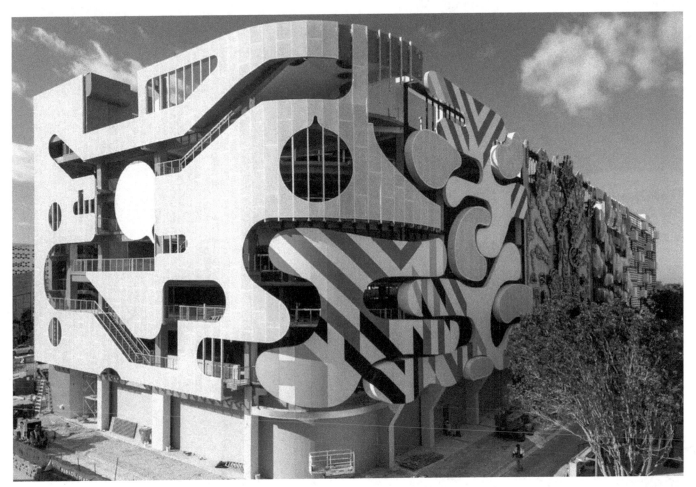

OMAHA
REUBEN

Chef's Note

Lewis & Clark's expedition led to Omaha's first discovery, but thanks to the city's makeover, Omaha can be rediscovered. It's become a modern gem, reconstructing it's Missouri Riverfront parks, entertainment districts, educational centers, corporate campuses, the airport, and residential communities. The only thing left from its past, is in the name Old Market District, a destination favorite.

Cook Time: 20 hours

	
6:30am	Pedestrian Bridge and the Heartland of America Park
9am	Blackstone District
11:30am	Take a Drive
1:30pm	Lauritzen Gardens
4pm	Old Market

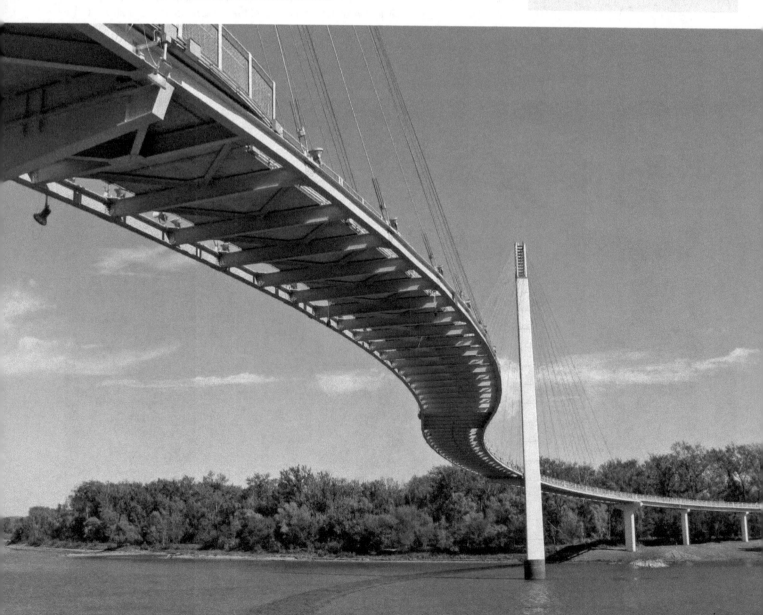

The Skillet

Hilton Omaha

1001 Cass Dr.

The ideal stay for conference goers, Creighton University guests, and sports fans since the Baseball College World Series and the U.S. Olympic Swimming Trials are a few blocks away. It has a beautiful lobby that connects to the convention center. It's a large hotel with long hallways to your room. Expect views of downtown or the baseball stadium.

Dressing

Bob Kerry Pedestrian Bridge and the Heartland of America Park
6:30am-8:30am

This stunning, 3,000-foot-long walkway stretches across the Missouri River to Iowa, giving pedestrians a spectacular view of Omaha's skyline and an almost airborne experience. On the Nebraska side, enjoy the 3-acre Omaha Plaza with an interactive water jet fountain, and access to the National Park Service Visitors Center. The bridge is connected to more than 150 miles of nature trails – visitors love to bike and walk on Bob. Underneath the bridge, lives Omar, a cute blue troll to take pictures with.

At the Heartland of America Park, expect to see one of the greatest riverfront parks in the country. The lake and fountain have been welcoming visitors as they crossover from Iowa since the early 1990's. These elements are joined by a Skate Ribbon, lakeside amphitheater, bocce courts, an extensive event lawn and picturesque pier that extends out to the Missouri River.

Local Inspiring Flavors

Breakfast
Early Bird Brunch
3824 Farnam St. Suite 120

Ready to serve not your everyday brunch, every day. Home to a daily brunch serving from 6:30am to 2:30 pm daily. Great food and great friends make the perfect brunch! Located in the hip and upscale Blackstone District.

Lunch
Ethnic Sandwich Shop
1438 South 13th Street

When a line is that long for a sandwich, it's a must try. Located in the Little Bohemia neighborhood, grab a sandwich and stroll 13th St.

Dinner
Plank Seafood Revisions
1205 Howard St.

Discover your sea legs in Omaha. You'll find that dash of sea-life luster with coastal character you been looking for in this landlocked state. Their refined seafood restaurant offers fresh, high-quality seafood and oysters and a full-service bar stocked with craft beer, cocktails and their eco-friendly tap wine system. Join them for a briny salt-water snack, a spiked lemonade and an unforgettable fish dish.

Whisking

Blackstone District 9am-11am

This classic Omaha location is especially appealing to those who have a great appreciation for the history and integrity of one of the city's oldest and coolest neighborhoods. The Blackstone District now showcases contemporary dining, nightlife, shopping and living experiences as diverse as the area itself. A great place to go for a walk, and one of the highest points of the city.

OMAHA
REUBEN

Drive the other Business Districts and Neighborhoods 11:30am-1pm

There are many neighborhoods to explore outside of downtown. Start with the College World Series Ballpark area, where there's blocks of new restaurants and bars.

I enjoyed Country Club Ave. near the Benson neighborhood. Lots of mature trees and grass fields, with neighborhood paths and parks navigating beautiful properties.

Lastly, arrive at Little Bohemia on 13th Street to explore another strip of restaurants and coffee shops.

Grilling

Lauritzen Gardens 1:30pm-3:30pm
100 Bancroft St.

If you're in Nebraska, a state known for growing and vegetation, it's best to see a living museum of unique four-season plant displays, maintained to the highest standards consistent with environmental stewardship. It provides memorable educational and aesthetic experiences for all.

Escape to an urban oasis of beauty and tranquility to experience the glory of the garden. Discover a hidden sanctuary in the heart of the city. Relax while cultivating your mind in this living plant museum, conveniently located in the beautiful riverfront hills.

The Old Market 4pm-6:30pm

There's still a historic district left in Omaha and it still has cobblestone streets, wooden framed brick buildings, old western sidewalk roofs, and plenty of charm. It's a place for the arts, dining, and shopping. No matter how modern Omaha becomes, this district is not going anywhere.

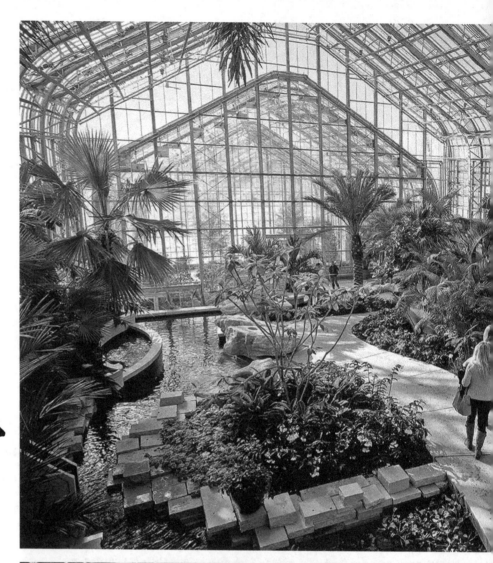

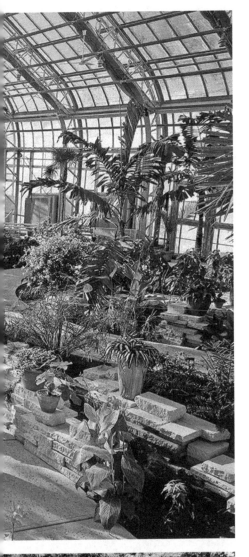

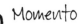
Momento

Let's get Cooking

NEBRASKA PRODUCE

The Omaha Farmers Market with Ed and Donna Welchert

Why I Choice this Craft

Nebraska is one of America's largest crop growers, making Omaha's Farmers Market one of the largest and freshest in the country. I had the honor to work on a private farm, where Ed and Donna grow different types of produce just for the weekend market.

The Omaha Farmers Market traces its roots back nearly 100 years, beginning at the turn of the last century on the corner of 11th and Jackson Street. This was the site of Omaha's "City Market," a very popular farmers market that local residents and grocers relied on for their produce and fresh goods. Until 1964, this was where growers came to sell everything from fruits and vegetables to herbs and honey.

After a hiatus of 30 years, the Omaha Farmers Market was revived in 1994 on the very corner lot where the original market thrived. Fresh, locally grown produce, baked goods and flowers were once again available each Saturday morning from May to mid-October. Today, the Market has expanded to fill 11th Street from Jackson to Howard streets with approximately 100 vendors each Saturday and introduced a second location at Aksarben Village.

A Tasty Choice

Omaha pays homage to the pioneers of the western migration throughout the city, on murals, education center and sculptures. The Fertile Ground mural represents the growth of the city by its people's courage and innovation. The Mormon Trail Center teaches the story of the migration to Utah, where Omaha was a temporary settlement. But none, more spectacular than Pioneer Courage Park, recognizing the bravery, courage, and entrepreneurial spirit that defined the generation and left an indelible impact on the American character. Visitors are meant to interact with this sculpture. The audience is encouraged to walk along with the larger-than-life pioneers and to envision what it must have been like to set off on a journey unlike any other. This sculpture park is the largest installation of bronze and stainless-steel work of art in the United States and one of the two or three largest in the world.

LOS ANGELES
COBB SALAD

Chef's Note

A city that has been through it all, like a third marriage, as a host of the Olympic Games and winning national championships to the L.A riots and extreme homeliness. Emotions run high, it's no wonder there are so many songs have been inspired by and written about Los Angeles, from the bubbly hit, *All I Want to Do* to hardcore gangster rap, *Straight Out of Compton* and to the defeated, *Say Goodbye Hollywood*. Los Angeles will always be an envy in living rooms around the world, influencing glamour and natural beauty, but cameras can play tricks, as there's always two sides of the tale.

Cook Time: 24 hours

7am	Ocean Front Walk
10am	Drive San Vicente Blvd.
11am	Shopping
2pm	Griffith Park
4:30pm	Grammy Museum
7pm	Nightlife in Hollywood

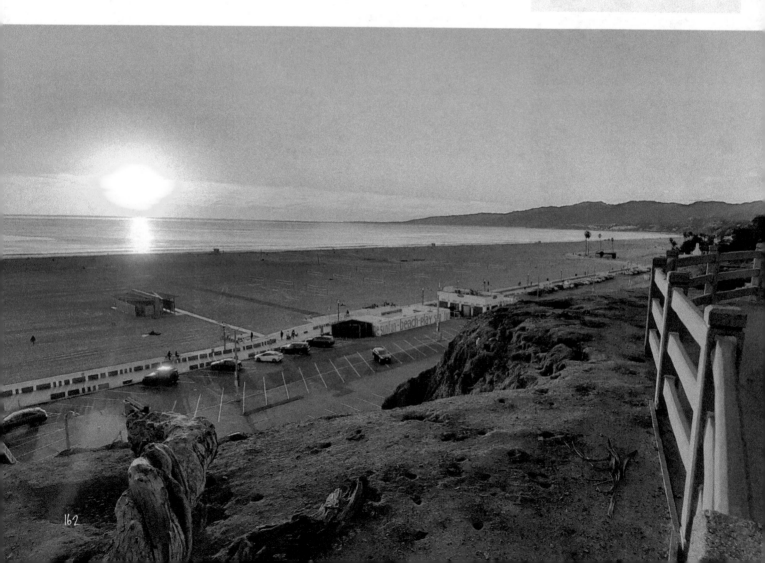

The Bowl

The Ambrose Hotel
1255 20th Street, Santa Monica

Travelers will find few spaces more inviting than those at The Ambrose Hotel. The 77 rooms feature an updated California Craftsman style that lends a cozy residential feel. Subtle design touches please the guests at every turn, from the fresh color palette to the lighting. Some rooms feature vaulted ceilings, hardwood floors, and terraces or patios -- perfect for soaking up the temperate climate we enjoy most of the year. Modern, welcoming, and brightened by natural light, all studios and rooms also have spacious bathrooms with luxurious showerheads, bath products by L'Occitane, and plush La Bottega cotton robes and slippers. They've crafted their interiors with guest delight in mind. And the view looking off towards the ocean, skylines of palm trees is idyllic Los Angeles. Make sure to check out a bike and cruise the Santa Monica ocean path.

Chopping

Ocean Front Walk 7am-9:30am
Santa Monica to Venice

One of America's most beautiful paths between two iconic destinations, Santa Monica and Venice. This 5k distance along the Pacific Ocean and Highway 1 has been featured in movies and music videos, perfect for a morning sunrise adventure. If you decide to go the other direction, that will head to picturesque Malibu.

Drive San Vicente Blvd. 10am-10:30am
From Santa Monica to Brentwood is one of California's most expensive boulevards, surrounded by mega-mansions, country clubs and a manicured grass divider. At the top of the hill, are high-end boutique shops and restaurants.

Local Inspiring Flavors

Breakfast

Coast Beach Café
1 Pico Boulevard Santa Monica

A casual beachfront café, offering wonderful food and service, but most importantly the ocean view. Enjoy a wide variety of California-inspired dishes by imaginative chefs, while people watching those on bikes, rollerblades and beachgoers.

Lunch

Old Gyumri

4441 San Fernando Road Glendale

A perfect family restaurant with an ancient Gyumri touch, that takes your tastebuds to old Armenia.

Dinner

Gwen Butcher Shop & Restaurant
6600 Sunset Blvd.

For this venture, Curtis partnered with his brother, Luke Stone. Gwen is both an old-world, European-style butcher shop and an elegant restaurant that is redefining fine dining in LA. A menu that calls on fire-based cooking techniques, guests have flexible options including á la carte or a five-course menu. A stone's throw from iconic Hollywood venues, a pre-theatre menu is also available for guests looking for a quick bite before a night on the town.

LOS ANGELES
COBB SALAD

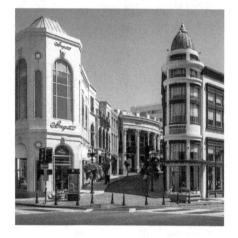

Seasoning

Shopping in L.A. (Beverly Hills)
11am-1pm

No surprise here, that Los Angeles in one of the world's most fashion trendsetters and Beverly Hills is the place to shop. Whether you want to explore Rodeo Drive, the Beverly Center or The Grove, these are the places the celebrities go. They're all within that few miles of each other.

Griffith Park 2pm-4pm

Looking for the Hollywood Sign? This is the place. Spanning more than 4,200 acres of land, Griffith Park is one of the largest municipal parks with urban wilderness areas in the United States. Originally a part of the Spanish land grant, Rancho Los Feliz, the park was named for its former owner, "Colonel" Griffith J. Griffith, a Welsh industrialist and philanthropist. In 1896, Griffith bequeathed five square miles of his Rancho Los Feliz estate to the people of Los Angeles. Since Griffith's original gift, further donations of land, along with city purchases and the reversion of private land to public domain, have expanded Griffith Park to its present size.

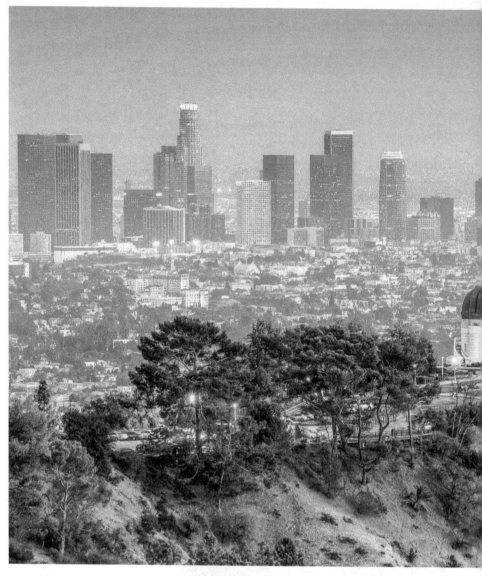

Composing

Grammy Museum
4:30pm-6pm

800 West Olympic Blvd

The GRAMMY Museum Foundation™ is dedicated to cultivating a greater understanding of the history and significance of music through exhibits, education, grants, preservation initiatives, and public programming. Paying tribute to our collective musical heritage, the Museum explores and celebrates all aspects of the art form—from the technology of the recording process to the legends who've made lasting marks on our cultural identity.

Today, the GRAMMY Museum fulfills its mission of making music a valued and indelible part of our society through exhibits, education, grants, and public programming.

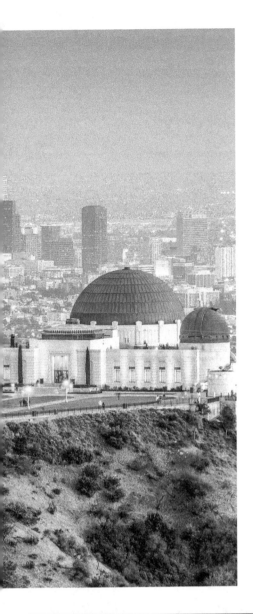

Let's get Cooking

Momento

CLAPPERBOARD
Hollywood Clapperboards
421 E. 6th St. #609

Why I Choice this Craft

The clapperboard or film slate is one of the most iconic symbols of the cinema. Although instantly recognizable as a beacon of the film realm, most people don't know its purpose. The clapperboard is to aid in the synchronization of picture and sound. The slate generally displays the date, the working title of the film, the names of the director and the cameraman, and the scene and take numbers. It was traditionally made of actual slate but evolved into whiteboards for the sake of practicality. The clapper consists of two hinged sticks with either black and white stripes, or more recently, calibrated color stripes. The sharp clap made by the sticks indicates when recording has started or stopped. The sound of the clapper, along with the information displayed on the slate, is used to match sound and movement in order to pair the right audio and video segments together.

Drizzling

Nightlife on Hollywood Blvd.
7pm-10pm

At night, Hollywood Boulevard is a catwalk lined with velvet ropes, stylish socialites and paparazzi. Hollywood's vibrant nightlife features some of the coolest bars and hottest lounges in LA., all located a short distance from each other, for the ultimate Tinseltown bar crawl.

A Tasty Choice

Drive 10 miles and you'll be in 10 different cities. Los Angeles County has a high concentration of cities, and it seems every mile that you drive on the interstate, you're in another city. From Long Beach to Pasadena, only 30 miles a part will take you through 16 cities.

PHOENIX
TEQUILA SUNRISE

Chef's Note

Phoenix is the *Valley of the Sun's* core, drawing millions of people to live and visit this ever-growing metropolis. Phoenix is centered around government, professional sports and fitness, arts, culinary and the international airport. The city's unwavering appeal has been the weather and exotic desert terrain, while modernizing its downtown infrastructure and fostering a new sense of community within its own city limits.

Cook Time: 28 hours

	
7am	Hike Camelback Mountain
10:30am	Biltmore Fashion Park
1pm	Roosevelt Row
3pm	Heard Museum
5:30pm	Entertainment District

Day 2

	
7:30am	Arizona Canal
10am	Baseball Spring Training

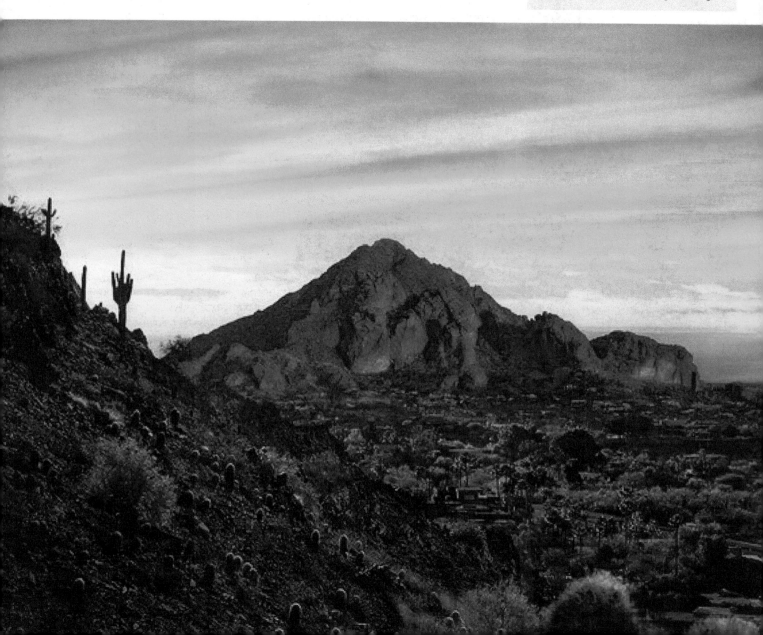

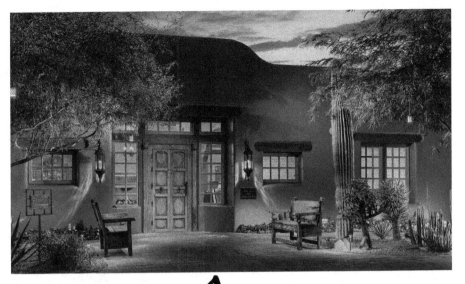

The Highball Glass

The Hermosa Inn

5532 N Palo Cristi Rd, Paradise Valley

Once the private, turn-of-the-century escape of painter Lon Megargee, the intimate and luxurious Hermosa Inn in Paradise Valley retains all the magic that inspired Arizona's "dean of cowboy artists." Today, this secluded AAA Four-Diamond boutique hotel nestled in the foothills of Camelback Mountain casts its spell on art lovers and adventurers who appreciate flawless service and the finest amenities. The grounds are adorned by manicured gardens and cactus, a glaring pool and courtyard fountains. This place is so elegant, it seems like you're at the final rose ceremony of The Bachelor.

Pouring

Hike Camelback Mountain 7am-9:30am
An unforgettable hiking trail, just 20 minutes from downtown Phoenix. Choose between two routes to the top, making for a well-deserved view of Sun Valley. This is one of those fitness bucket-list items, climbing a laborious 1,420 feet over 2.5 miles. There's nothing dull about this hike, whether navigating through natural rock, smiling at passers, or catching glimpses of the different views.

Biltmore Fashion Park 10:30am-12:30pm
2502 E Camelback Rd.

Boasts a collection of the finest retailers in the region including Saks Fifth Avenue, Ralph Lauren, Sephora, lululemon athletica, Arhaus and delicious restaurants including Capital Grille, Seasons 52, Cheesecake Factory, California Pizza Kitchen, and Breakfast Club. Enjoy a shopping and dining experience like no other in our relaxed, park-like atmosphere.

Local Inspiring Flavors

Breakfast

LON's at The Hermosa Inn

5532 N Palo Cristi Rd
Paradise Valley

The greatest southwestern ambiance you'll find. Outdoor seating smothered with nature, lined with adobe walls containing a fireplace, and romantic overhead lighting. It's comfort beyond imagination. Oh, and the food is good too.

Lunch

The Churchill

901 N 1st St

Founded as a sustainable development and local community gathering space inspired by creativity, collaboration, and community. In addition to hosting weekly service outings, artisan pop-ups, community events and continuous non-profit fundraisers, each tenant completes at least four hours of community service each month as part of their 'social rent.'

At the heart of The Churchill is a 9,000 square foot courtyard designed to be shared space to dine, drink, socialize, and connect.

Dinner

The Arrogant Butcher

4455 E Camelback Rd, Ste B100

All you have to do is step inside the doors to realize that you've found something special. An iconic landmark that effortlessly captures the classic downtown vibe, The Arrogant Butcher offers impeccably crafted bar bites, seafood and cocktails. It's a haven of cool and comfort where you'll always be in good company, and offered the very best.

PHOENIX
TEQUILA SUNRISE

Mixing

Roosevelt Row 1pm-3pm

Downtown Phoenix's walkable arts district, home to art galleries, restaurants, bars and boutique shops in a landscape dotted by colorful street art. It's nearly impossible to turn a corner on Roosevelt Row without seeing a mural.

Heard Museum 3pm-5pm
2301 North Central Avenue

Since its founding in 1929, the Heard Museum has grown in size and stature to become recognized internationally for the quality of its collections, world-class exhibitions, educational programming and its unmatched festivals. Dedicated to the advancement of American Indian art, the Heard successfully presents the stories of American Indian people from a first-person perspective, as well as exhibitions that showcase the beauty and vitality of traditional and contemporary art.

The Heard Museum sets the standard for collaborating with American Indian artists and tribal communities to provide visitors with a distinctive perspective about the art of Native people, especially those from the Southwest.

Legends Entertainment District 5:30pm-7pm
401 East Jefferson Street

The first of its kind partnership between two professional sports teams, the Arizona Diamondbacks and the Phoenix Suns, designed to encompass award winning restaurants, events and entertainment within landmark downtown facilities such as the Talking Stick Resort Arena, Chase Field, CityScape, Collier Center and the Phoenix Convention Center.

The District is home to over 700 diverse events each year such as legendary concerts, games, shows and events. Many legendary artists have performed in the Legends District and is home to legendary sports franchises and multiple championships including the Phoenix Suns, Arizona Diamondbacks, Phoenix Mercury, and the Arizona Rattlers.

Day 2
Garnishing

Arizona Canal 7:30am-9am
Covering well over 100 miles of trail throughout the urban sprawl of Greater Phoenix, visitors and residents can access a network of canal trails that pave the way for fun and recreation. From running and walking to biking, fishing and more, the city has designed and constructed paths on both sides along the canals that offer everything from lights for evening strolls to commissioned public artwork. I suggest exploring the portion of the Arizona Biltmore Estates during the evening for the extravagant resort lighting.

Cactus League Spring Training (Seasonal) 10am-2pm
2200 W Alameda Dr, Tempe

Over 15 Major League Baseball teams gear up for their upcoming professional season through the Cactus League, scattered throughout the Phoenix Metro. You can either be loyal to your team or observe them all. Each stadium offers a unique setting, while basking in the sun and having your favorite ballpark foods. I enjoyed the backdrop of the Tempe Diablo Stadium. Founded in 1968, this stadium has been the Angels' Spring Training home since 1993. Though it is one of the older ballparks in the Cactus

Let's get Cooking

WINDBELLS

Cosanti
6433 E Doubletree Ranch Rd.
Paradise Valley

Why I Choice this Craft
Cosanti Originals bronze windbells are individually handcrafted by skilled artisans in the same time-honored tradition introduced by architect and artist Paolo Soleri in the early 1960s. Featuring vibrant colors, organic textures, and design motifs that vary from piece to piece and artisan to artisan, each one is a true "original." Made in a variety of sizes, complement both indoor and outdoor spaces, and come in a glossy, iridescent burnished finish as well as a matte verdigris patina.

The significance of the bells has always played a big part in human history, and these bronze windbells have such presence in Phoenix, they're even gifted by realtors to new homeowners.

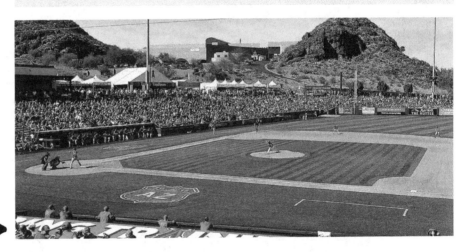

League, extensive renovations were carried out in 2005 to keep it aging well. The main field -- which was christened Gene Autry Field in 1999 in honor of the former Angels owner -- is set against a memorable backdrop, with a hillside butte jutting out toward left field. Popular concessions include the nachos, which are heaped inside an Angels helmet, and the Tempe Tap Room, a beer tent that serves Four Peaks craft beer, among other offerings.

A Tasty Choice

Greater Phoenix is in the Sonoran Desert with large bouldering mountains ranges creating North America's wettest and greenest desert valley. You'll be surprised by all the native plant species, like the Emory oak, desert willow, Arizona cypress and Gregg Ash. If you care to see the world's largest collection of desert plants, the Desert Botanical Gardens has them all on display.

SAN JOSE BANH MI

Chef's Note

The work and play culture has made San Jose one of America's most desirable places to live. Surrounded by hiking trails, bike paths and lakes that an ambitious and talented workforce can connect with before or after work, and during lunchbreaks. The city is a sprawling, boasts a variety of neighborhoods, that are more like suburbs, The city is sprawling, boasting a variety of neighborhoods, that are more like suburbs. People flock here for the consistent weather, high income jobs and accessibility to the ocean and mountains.

Cook Time: 22 hours

8:30am	Hike Alum Rock Park
11:30am	The Tech Interactive
2:30pm	San Jose Flea Market
6pm	Santana Row

The Oven

Hotel Nia
200 Independence Dr, Menlo Park

Bringing a superior level of service and high-end hospitality unique among Redwood City hotels. Located in the Menlo Park Gateway — a community rooted in business, technology, and development — this Bay Area hotel's exquisite shared spaces and luxury accommodations are loved by leisure and business travelers alike. Travelers delight in our one-of-a-kind amenities, including a lending library of innovative products from b8ta, a pristine outdoor pool and bar area, and quintessential California cruiser bikes for rent.

Plus, with famous neighbors like Facebook, Apple, and Google, Hotel Nia has become a destination for business professionals visiting Silicon Valley who enjoy our business-focused amenities, immaculate indoor and outdoor meeting spaces, and delicious catering from our onsite restaurant, Porta Blu.

Pre-heating

Alum Rock Park 8:30am-10:30am
15350 Penitencia Creek Rd.

Founded in 1872 and is one of California's oldest municipal parks. Nestled within the Alum Rock Canyon in the foothills of the Diablo Range, the Park's 720 acres of natural, rugged beauty, provide visitors with many leisure outdoor activities including hiking, horseback riding, bicycling, family and group picnicking, and of course just relaxing. Picnic tables, barbecue pits, water and restrooms are available in most picnic areas, with lawns and a children's playground in the mid-canyon area.

From 1890 to 1932 the park was a nationally known health spa with 27 mineral springs, an indoor swimming pool, tea garden, restaurant, and dance pavilion. At the time you could ride from downtown San Jose to the park on the Alum Rock STEAM Railroad. Today, remnants of the railroad bridges can be seen, some of the stone grottos that contain mineral springs are still accessible, but now the charms of the park focus on nature, wildlife, and hiking.

Local Inspiring Flavors

Breakfast
Whispers Cafe & Creperie
150 S. 2nd St.

Airy, counter-service bistro serving up crêpes, omelets & sandwiches, plus an outdoor patio. Afterwards, explore the quaint tree-lined streets of the Paseo de San Antonio in downtown..

Lunch
San Pedro Square Market
San Jose is in many ways, a new place even though it was founded over 200 years ago. The city exhibits the rich culture of Spain and Mexico and is home to a vast number of immigrants from all over the world who have built their homes and their future here. They're home to one of Spanish California's oldest structures and the last of an original settlement, the Peralta Adobe. Built in 1797 by Manuel Gonzalez, an Apache, it is the last remaining structure from El Pueblo de San José de Guadalupe and was the long time home of Luis Maria Peralta. It is now the heart and soul of the San Pedro Square Market.

San Pedro Square began a new era with restaurants and bars, such as the Tower Saloon and The Old Spaghetti Factory, opening in 1972. Now, SPS Market is your local food hall with a mix of local artisan restaurants and food-oriented boutiques offering a diverse assortment of cuisines from around the world all under our three roofs. The Three Sisters Hall in the Perazzo Building celebrates the assimilation and union that makes this City special with the honoring of the three Castro-Fallon children and the strength of that merger of the many peoples who came here.

continued…

SAN JOSE
BANH MI

Local Inspiring Flavors

Dinner
Amber India

377 Olsen Drive, Suite 1140

Amber India has come to represent an inviting atmosphere of modern elegance, comfort and sophistication. An inspired menu boasts delectable Indian Cuisine of both traditional and contemporary dishes made with the finest and freshest ingredients. The cuisine emphasizes fresh local produce, regional Indian specialties and Californian flare.

Slicing

The Tech Interactive 11:30am-1:30pm
201 S. Market St.

A family-friendly science and technology center in the heart of downtown San Jose. Their hands-on activities, experimental labs and design challenge experiences empower people to innovate with creativity, curiosity and compassion. The Tech is a world leader in the creation of immersive Steam education resources to develop the next generation of problem-solvers locally, nationally and globally. They believe that everyone is born an innovator who can change the world for the better. This has been the culture of the Bay Area for several decades. I remember when the first IMAX Theatre opened at this location and was the wave of the future to watch movies. Make sure to check that out as well.

Tossing

San Jose Flea Market 2:30pm-5pm
1590 Berryessa Rd.

Flea Markets are common in the South Bay Area and nearly 4 million people a year visit the San Jose Flea Market. In 1959, while working in the solid waste and landfill business, George Bumb had an idea. There had to be a profitable way to keep the perfectly usable items he saw tossed out from ending up in landfills. Hearing of the success of swap meets just getting started in LA, Bumb headed south to research how these So Cal meets were run and organized.

He saw a way to improve on the idea. He took what he saw and expanded it to include individual merchant stalls, and made the whole process simpler for vendors by offering on-site product storage during the week.

In March of 1960, with a meager investment, the San Jose Flea Market opened on farmland on Berryessa Road in San Jose, a narrow country lane surrounded by orchards. The first office, built and staffed by Bumb and family members, housed the only restroom and limited snack bar.

They celebrate over 60 years of providing our community with a way to make money selling great stuff; save on a myriad of household items, tools, entertainment, fresh produce and a variety of services; and spend a day together as a family shopping, eating, and playing.

Let's get Cooking

Momento

PATENT/TRADEMARK

Silicon Valley U.S. Patent and Trademark
26 S 4th St.

Why I Choice this Craft

Silicon Valley is the epicenter of innovation. It all starts with an idea and the U.S. Patent and Trademark office is there to protect it. The original Nike Swoosh logo cost only $35 dollars to register and now a multibillion-dollar company. As the world's leading incubator of innovation, 1 in 8 patents issued to U.S. applicants are from this region. Fueling dreams, California is also the leading state with the most issued patents in high tech and biotechnology. I decided to trademark the phrase, 'Living the Map,' meaning to open your world and live without limits.

Toasting

Santana Row 6pm-8:30pm
377 Santana Row

SoCal culture takes shape at Santana Row, offering pretentious high-end shopping, fine dining, condos, and piazza. This district has become the premier social hangout, day or night for locals.

A Tasty Choice

There are eight arterial roads in the San Jose area that have many fewer intersections and driveways than typical arterial roads. All but one of these road names end with Expressway. While not a system in the physical sense, these roads, called Expressway System by local governments are administered and maintained by the County. These also have a related history, and were formed in the 1960s and early 1970s when the County added lanes and wide, paved shoulders onto existing roads. Lawrence Expressway, Montague Expressway, San Tomas Expressway, Almaden Expressway are the most used expressways.

HOT
NASHVILLE

Chef's Note

Nashville is evolving quicker than music, rewriting its song to blended genres and a new wave of transient culture. The city won't lose its central tune though, after all that's what attracts people to Music City in the first place, the artistry, showmanship, energy and pride. Nashville discovered its value to the rest of the world, and now has made a place on the stage for anyone to dance.

Cook Time: 22 hours

7am	Cumberland River Greenway
10am	Belle Meade
1pm	Music Row
2:30pm	Grand Ole Opry
6pm	Lower Broadway

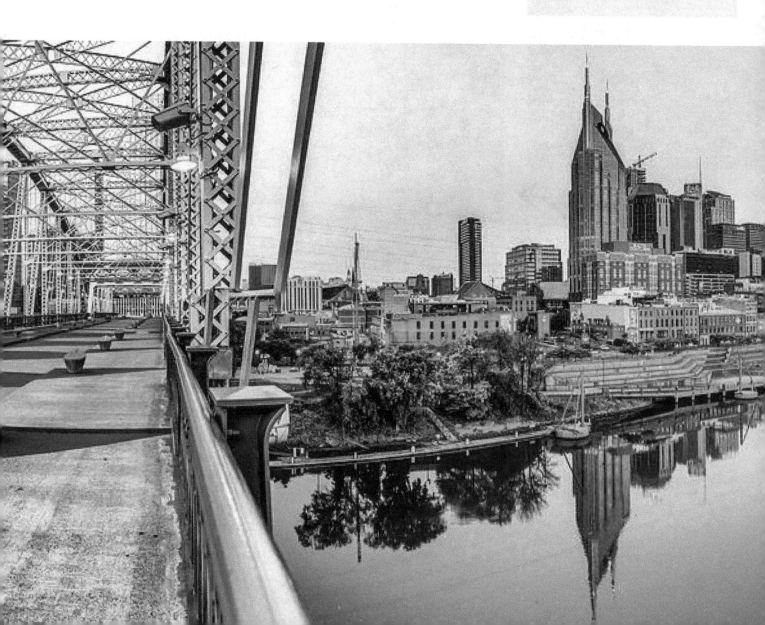

The Dutch Oven

The Gallatin
2510 Gallatin Ave.

A contactless and concierge-less hotel opened in May 2021, The Gallatin offers a flexible stay that gives back to the community. Originally home to the East side Church of Christ, this building has served the East Nashville community by providing refuge, safety, and belonging to people in need since 1925. The Gallatin Hotel honors this legacy by paying it forward and giving away the majority of its profits to local Nashville organizations that help the homeless and underserved community. Attached to the hotel is an event space and taproom from local brewery Fat Bottom Brewing.

Seasoning

Walk/Run Cumberland River Greenway
7am-9am

Enjoy the beautiful sunrise, starting at the Tennessee Titans stadium. Cross the Cumberland River on the John Seigenthaler Bridge into downtown. Stay on the Cumberland River Greenway on a pleasant, paved path for as long as you'd like and then turn around.

Local Inspiring Flavors

Breakfast
Frothy Monkey
1701 Fatherland St.

An all-day cafe, specialty coffee roaster, and wholesale bakery with cafes and production facilities in Nashville. Food and drinks are made from scratch using original recipes and thoughtfully-sourced ingredients from regional farmers and producers whenever possible.

They're invested in their communities, and a proud member of the neighborhoods they serve. You can count on Frothy to deliver quality, creativity, and approachability in everything they create. Their relationships with farmers and others who care about where ingredients come from is at the center of who they are.

Frothy Monkey has been a staple in the Nashville community since 2004.

Lunch
Edley's Bar-B-Que
2706 12th Ave. South

They treat everyone who walks through the door like an old family friend. They pride ourselves with not taking any shortcuts in the kitchen. Their meats are smoked low and slow using Southern white oak. The sides are made from scratch daily with the same amount of attention. Everything is done with intention, from the food to the service to the music. They strive to serve the best food they can make and prove ourselves a worthy host—one plate at a time.

Dinner
Wildhorse Saloon
120 2nd Ave. South

Eat and line dance at the Wildhorse Saloon. Located in the heart of historic downtown Nashville with the banks of the Cumberland River right outside our back door, before the age of interstate highways, floating barges had a brisk trade in cattle and crops. In an effort to revitalize the once robust Second Avenue area, Gaylord Entertainment turned a three-story historic warehouse into a country music entertainment and dining mecca with the beginnings of a TNN televised dance show. On June 3rd, 1994 a herd of cattle ran through the streets of Music City to the front doors of the Wildhorse Saloon and since that day, millions of music fans from around the world have stampeded through their doors for THE Nashville experience.

HOT
NASHVILLE

Tossing

Belle Meade Historic Site & Winery
10am-12pm

5025 Harding Pike

Dedicated to the preservation of Tennessee's history, architecture, hospitality, and equestrian legacy, guests can enjoy Historic Tours, Family Tours, Wine & Food Pairings, Bourbon Tastings, and Chef-Inspired Food & Wine Pairings.

The Mansion Tour tells the century-long history of Belle Meade through the stories and experiences of the Harding and Jackson families, as well as the women, men, and children who labored here. The Journey to Jubilee Tour invites discussion and explores the stories of the enslaved African-Americans who were brought to, and born at, Belle Meade from 1807 through the years following Emancipation.

Additionally, guests can explore the history and natural beauty of Belle Meade on a Guided Segway Tour of our arboretum and grounds.

Whisking

Music Row 1pm-2pm

This neighborhood is considered the heart of Nashville's entertainment industry. Nestled within homes and buildings are the recording studios from which your favorite songs came to be. Including everything from Elvis Presley's "How Great Thou Art" (recorded at Historic RCA Studio B) to Foo Fighters' "Congregation" (recorded at Southern Ground Nashville).

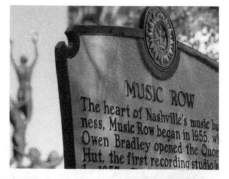

Dredging

Grand Ole Opry 2:30pm-4pm

2804 Opryland Dr.

The stage that showcases the past, present, and future of country music. We've been the home to the art form's growth and change, from the first broadcast in the National Life Building on WSM's Barn Dance in 1925 to the move into the new Opry House in 1974, and now to audiences across the globe on Circle TV and host to the Annual ACM Awards. The Opry remains the platform that connects artists and fans to the music they love.

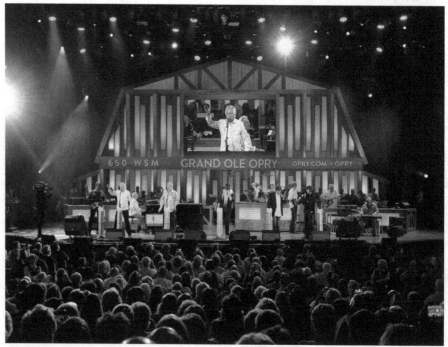

Frying

Lower Broadway, Downtown 6pm-10pm

A visit to Nashville is not complete until you wander Lower Broadway, known as Honky Tonk Hwy. People get wild! The music is playing in every doorway. The streets are bustling. Sure, it's an everyday thing in Nashville, but it's a special occasion for you, so dress up in your best country boots and hat.

Let's get Cooking

GUITAR PICK

Nashville Picks

Why I Choice this Craft

There are plenty of guitar manufacturers in Nashville, catering to those musicians that want handcrafted custom works. I wanted to make a guitar pick, since I don't play any instruments and couldn't carry a large guitar around with me. I found Nashville Picks, met the owner, Dustin Headrick at a local festival, Tomato Art Fest. I went behind his booth and started shaving a Tennessee quarter with different files and sandpaper. After an hour, I made one of his products.

Momento

A Tasty Choice

There is no shortage of festivals in Nashville. When they say Music City, they genuinely mean it. If you can't find a festival of music and art, it will find you. The locals are prideful about how appealing and hip Nashville is because there's no place they'd rather be than basking in the sun at one of their many neighborhood or world-stage festivals.

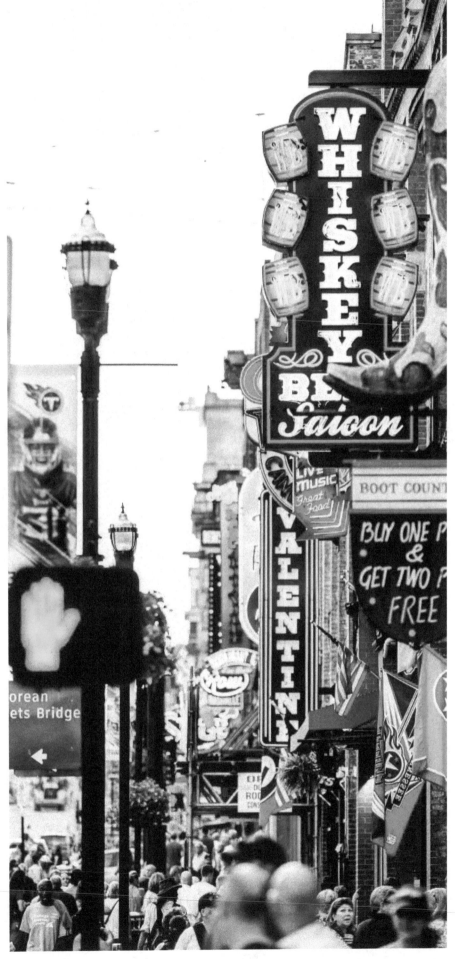

NEW ORLEANS
JAMBALAYA

Chef's Note

New Orleans is an escape from reality, like being on a Monopoly board of the classically recognized streets, such as St. Charles Ave., Magazine St., Bourbon St., Canal St., Royal St., and Audubon Place. The city is defined by not the everyday music you'd hear, food you'd try, architecture you'd see, or nature you'd encounter. New Orleans was ahead of its time, blending a cultural melting pot into its own authentic identity, finding its groove after centuries of molding.

Cook Time: 24 hours

8am	Audubon Park
10:30am	Magazine Street
2pm	Mardi Gras World
5pm	The French Quarter

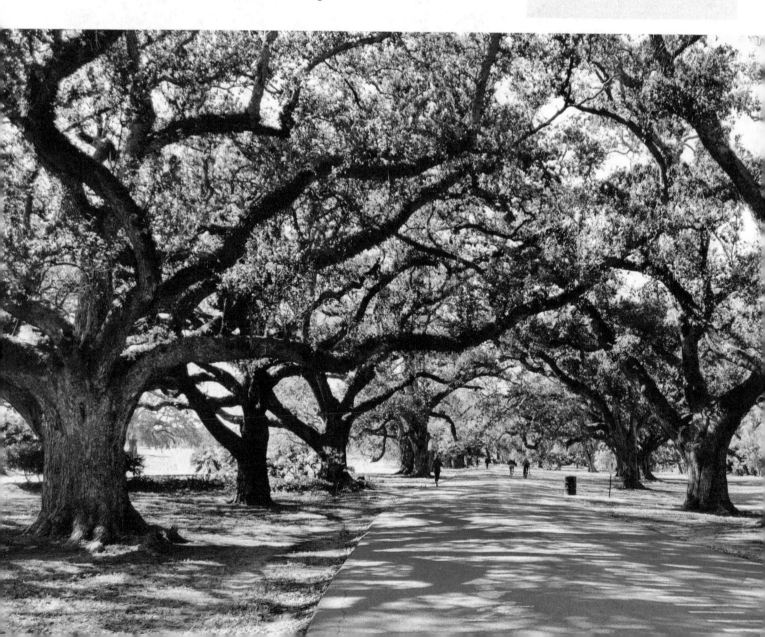

The Pot

The Troubadour

1111 Gravier St.

Nestled in New Orleans' burgeoning Central Business District, is a contemporary boutique hotel just blocks from the theater district and the charming French Quarter – the ideal locale to take it all in. The rooms are spacious with great lighting and downtown views.

Local Inspiring Flavors

Breakfast

Brennan's

417 Royal St.

For nearly seven decades, Brennan's has charmed the palates and hearts of patrons with its splendid ambiance, impeccable service, and authentic Creole cuisine. Masterful dishes like Bananas Foster and Eggs Hussarde are Brennan's originals, imitated across the globe. Brennan's today is a dazzling display of New Orleans's illustrious past persevering in the present. They invite you to come visit and experience classic Brennan's traditions like Breakfast at Brennan's, table-side dining, bananas foster, Happy Hour at the Roost Bar, and more.

Lunch

Mahony's

3454 Magazine St.

Born on historic Magazine Street, where food is life, the chef-inspired menu at Mahony's is loaded with fresh Louisiana seafood and local classics that deliver an authentic taste of New Orleans in every bite. Made only from the freshest ingredients, their mouthwatering po-boys and seafood will make you wish you had room for more. A great place to try the local po'boy sandwich.

Dinner

Tableau

616 Saint Peter St.

Located on Jackson Square attached to the historic Le Petit Theatre; Tableau is in the heart of the French Quarter. Tableau showcases regional ingredients and classic Creole dishes revisited. Their chef team celebrates the historical components of Creole cuisine and builds dishes based on their authentic roots.

With Creole cuisine blending flavors from many regions around the world including the Caribbean, France, Spain, Portugal, and the Ivory Coast, Tableau's dishes reflect a wide variety of flavors and influences combined with a modern approach. Tableau offers a variety of dining ambiances from the courtyard, to the main dining room, to the Drawing Room lounge to our balcony overlooking Jackson Square. From the balcony, listen to local street musicians from above. Classic New Orleans setting!

Seasoning

Audubon Park 8am-10am

6500 Magazine Street

Take the street car to check out the local wildlife and exotic vegetation! Audubon Park opened in 1898 and was the site of the World Cotton Centennial in 1884. People travel from near and far to marvel at and enjoy the ever-beautiful oak trees, lagoons, and expansive green space located within the park. For the millions who use the park for picnics, relaxing, walking, running, cycling and special events there is no better place in New Orleans for recreational fun and relaxation.

Named after artist and naturalist John James Audubon who lived in New Orleans starting in 1821, the park features a 1.8 mile paved loop for joggers, cyclists, and rollerbladers and several covered shelters ideal for a family reunion or a simple gathering with friends and family.

NEW ORLEANS
JAMBALAYA

Stirring

Stroll Magazine Street
10:30am-12:30pm

What could be better than shopping while strolling past beautiful homes and historic architecture? Magazine Street features six miles of some of the best shopping in New Orleans. The majority of their shops are locally-owned and carry everything you need: clothing, shoes, jewelry, home decor, gifts, antiques, fabrics, and more. Find your next great outfit, check out an art gallery, or pick up a New Orleans-themed gift for yourself or a friend. You'll love shopping on Magazine Street, and you'll have plenty of opportunities to stop for a bite to eat or even pamper yourself at a spa.

Sautéing

Mardi Gras World 2pm-4pm

1380 Port of New Orleans Place

Their tour allows you to see firsthand what it takes to bring Mardi Gras to life year after year. Walk through the hard work and extensive planning that goes into this grand event when you tour Blaine Kern Studios, an operating workshop that has created breathtaking floats for Mardi Gras and other parades around the world since 1947.

This all-access opportunity winds you through the massive studio, where artists and architects build Mardi Gras floats from the ground up. You'll learn about the history of this unique and festive tradition, going beyond its reputation to get a deeper understanding of the REAL Mardi Gras. The whole family will love touring the space where their artisans create show-stopping floats for more than 40 parades each year.

This New Orleans tour is an experience you'll want to document. There are hundreds of photo opportunities in front of floats and props.

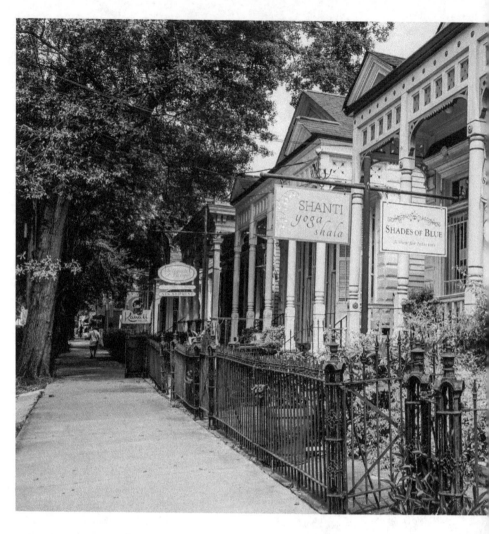

Simmering

The French Quarter 5pm-9pm

One-of-a-kind historic neighborhoods of America, often called the Crown Jewel of New Orleans, the French Quarter. But you'll find plenty of new mixed in with the old. There's a reimagined French Market, modern boutiques and artisan cocktails mix with beloved antique stores and old restaurants.

Like the Creole aristocrats lining the galleries of the Historic New Orleans Collection, the French Quarter is a timeless portrait – especially come dusk when swallows glide above the fortunetellers on Jackson Square and St. Louis Cathedral's butter-crème-colored walls reflect the fiery sunset. Ghost tours troop past mad Madame LaLaurie's mansion while neon signs stutter to life on Bourbon Street where syrupy red Hurricanes, slosh in famed 'go cups'– those plastic tumblers responsible for uncountable curbside parties. Night falls. Horse hooves clop, music throbs and gaslights flicker in a place full of long-told legends and those waiting to be born. Create one of your own.

A Tasty Choice

Throughout downtown and the French Quarter, don't be surprised by the wet pavement, even if it hasn't rained. Crews are busy power washing the sidewalks and streets every morning to clean the spills and thrills of the evening before. It's not the most pleasant-sounding operation, but it is refreshing to see the streets spotless.

Let's get Cooking

MARDI GRAS MASK

Mardi Gras Museum of Costumes and Culture

1010 Conti St.

Momento

Why I Choice this Craft

Masks have been worn by different societies for centuries. Some groups wear them for rituals, some for celebrations, and still others for the performing arts. Mardi Gras masks in particular originated in ritual celebrations. New Orleans has been celebrating Mardi Gras for hundreds of years, and is the largest masked party in North America.

In the beginning, masks worn during Mardi Gras allowed wearers to escape society and class constraints. When wearing a mask, carnival goers were free to be whomever they wanted to be, and mingle with whatever class they desired to mingle with. I made a mask with the traditions colors of New Orleans; purple, green, and gold.

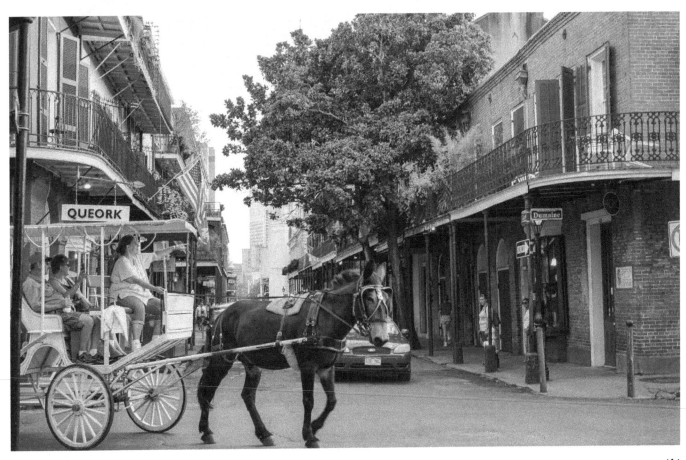

STILL HUNGRY?

PORTLAND LOBSTER

The Pot

Regency Hotel & Spa
20 Milk St, Portland, ME

Memento

NEW ENGLAND'S FIRST CRAFT BREWERY, GEARY BREWING CO.
38 Evergreen Dr.

Can't Miss: Poke through shops and galleries lining the cobble-stone streets of the Old Port. Only a block from the docks, this quaint romantic setting takes you back hundreds of years into a European-style cityscape.

WILMINGTON MACAROONS

The Mixer

Homewood Suites, Downtown Wilmington
820 Justison St.

Memento

MACAROONS AT HOTEL DU PONT
42 W. 11th St.

Can't Miss: Located along the beautiful Brandywine Creek, the Hagley Museum is the site of the largest producing black powder mills, and the first home to the du Pont family.

LITTLE ROCK
CHEESE DIP

The Sauce Pot

Hampton Inn & Suites Downtown Little Rock
320 River Market Ave.

Memento

PENDANT NECKLACE AT BELLA VITA JEWELRY
108 W 6th St Suite A

Can't Miss: The Arkansas River Trail is one of the most beautiful biking trails in the country, spanning a 20+ mile loop that features the longest pedestrian bridge in North America, downtown Little Rock skyline views, and steep river bluffs.

WICHITA BIEROCK

The Skillet

Aloft Hotels
3642 Oliver

Memento

RIB OF AN AIRPLANE WING AND RIVETING A WICHITA POSTCARD AT THE KANSAS AVIATION MUSEUM
3350 George Washington Blvd.

Can't Miss: The Keeper of the Plains Ring of Fire is a specular show that integrates the history and culture of Wichita. One of the most iconic images in Wichita, the Keeper of the Plains stands at the confluence of the Big and Little Arkansas rivers. This 44pm-foot, 5pm-ton weathered steel sculpture was donated to Wichita by Native American artist Blackbear Bosin in 1974. It sits atop a 30-foot pedestal overlooking the city.

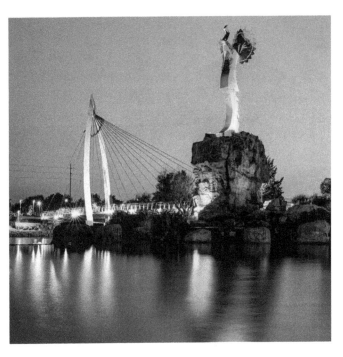

BOISE CHORIZO

The Frying Pan

Hotel 43
981 W. Grove St.

Memento

BASQUE CUISINE AT ANSOTS
560 W. Main St.

Can't Miss: Boise State University's trademark 'smurf turf' is the first-ever non-green football field in the nation. The view of blue is quite the site, watching one of college football's most dominate programs.

STILL HUNGRY?

FRIED GREEN BIRMINGHAM

The Deep Fryer

The Tutwiler
2021 Park Pl

Memento

**IRON KNIFE FROM A RAILROAD
SPIKE WITH KENNETH SPIVEY**

Can't Miss: The Birmingham Civil Rights Heritage Trail winds through downtown, marking significant locations along the 1963 Civil Rights march routes. Designed as a self-guided tour, the route directs visitors along this historic pathway by maps at each location. The trail speaks to the valor of both common people and to the spiritual leaders who spearheaded the fight against segregation and other forms of racism. Graphic photographs and dramatic cut-outs in the designs of the signs add to the rich experience. Beginning at Kelly Ingram Park, corner of 6th Avenue North and 16th Street.

SPOKANE
PEANUT BRITTLE

The Baking Sheet

The Historic Davenport
10 S Post St.

Memento

**WATERCOLOR PAINTING
WITH MEGAN PERKINS**

Can't Miss: When you are standing in the 100-acres of beauty that makes Riverfront Park an urban oasis, it's hard to imagine it was an old railyard. The area was not only cleaned up but turned into the site of the 1974 World's Fair. Now, Riverfront Park is the jewel of downtown Spokane and one of the most spectacular features of any city. The Spokane River winds through and cascades over basalt rock and two dams to create the largest urban waterfall in the country and you can take a gondola over them, making for a thrilling ride to view downtown.

DES MOINES
STEAK DE BURGO

The Skillet

Des Moines Marriot Downtown
700 Grand Ave.

Memento

**RAYGUN'S GREETING CARD,
THAT READS DES MOINES
FRENCH FOR DES MOINES.**
505 East Grand Ave.

Can't Miss: The Capitol Building of Des Moines overlooks the entire downtown and has impressive neoclassical and renaissance revival architecture. The domes make this one of the most stunning capitol buildings in the country.

RALEIGH CHEERWINE

The Soda Streamer

Origin Hotel Raleigh
603 W Morgan St.

Memento

**MICROSCOPE IN NORTH CAROLINA'S
RESEARCH TRIANGLE**

Can't Miss: Said to be the most advanced library in the world, the James B. Hunt Library was built to reflect North Carolina State University's status as a preeminent technological research university. Bold and iconic, the library's architectural design strikes a unique presence with its intriguing design of glass and zigzagging, solar fins. Inside, be dazzled by technological wonders like curved digital display screens, touchscreen kiosks and bookBot—a subterranean robot programmed to fetch books from the 1.5 million housed in an underground storage facility.

RENO BLOODY MARY

The Frying Pan

Grand Sierra Resort and Casino
2500 E 2nd St.

Memento

METAL PAIR OF DICE

Can't Miss: One of the city's standout symbols and sights, Reno Arch has been an important part of downtown for close to a century. Originally built in 1926 to commemorate the completion of the Nevada Transcontinental Highway, it now instead acts as a popular tourist attraction and permanent downtown gateway. Emblazoned under 'RENO' on the wonderfully retro neon sign is the city's slogan 'The Biggest Little City in the World'.

COLORADO SPRINGS BISON

The Grill

Garden of the Gods Resort & Club
3320 Mesa Rd.

Memento

**UNITED STATES OLYMPIC MEMBER BADGE AT THE
U.S. OLYMPIC AND PARALYMPIC MUSEUM**
200 S. Sierra Madre Street

Can't Miss: America's Mountain, Pikes Peak is a breathtaking adventure to climb 14,115 feet. Whether you choose to traverse the manicured path by foot or the cog railway, the summit understandably inspired the song, 'America, the Beautiful.'

STILL HUNGRY?

BLOOMINGTON, MN
VIKING COCKTAIL

The Shaker

Renaissance Minneapolis Bloomington
5500 American Blvd. W

Memento

LEGO STRUCTURE AT THE LEGO STORE
164 South Avenue

Can't Miss: Mall of America is the largest mall in the country, comprised of 550 stores and 5.6 million square feet. The indoor amusement park tops it off as the most entertaining mall.

PROVIDENCE
COFFEE MILK

The Pitcher

Omni Providence Hotel
1 W Exchange St.

Memento

GLASSBLOWING AN ORNAMENT AT GATHER GLASS
521 Atwells Ave.

Can't Miss: The Avenue Concepts takes you through the murals and sculptures of downtown Providence, the Creative Capital of World.

SACRAMENTO
CAVIAR

The Pot

The Sawyer
500 J Street

Memento

GOLD PAN

Can't Miss: Old Sacramento covers eight blocks (28 acres) of historic buildings along the city's waterfront, designated as a National Historic Landmark. Some of the Gold Rush-era structures are now part of the Old Sacramento State Historic Park, including the Eagle Theater built in 1849, the B. F. Hastings Building (circa 1853), and the Big Four Building dating to 1855. Old Sacramento includes more than 50 historic buildings, mostly from the 1850s, which represent the city's original commercial district, an area that once thrived thanks to the commerce propelled by the Pony Express and the transcontinental railroad.

TUCSON TAMALE

The Steamer
Sheridan Tucson Hotel & Suites
5151 E. Grant Rd.

Memento
**SALSA AND TAMALES AT
EL CHARRO CAFÉ**
311 N. Court Ave.

Can't Miss: Yearning to see towering, giant saguaros in their native environment? Saguaro National Park protects and preserves a giant saguaro cactus forest that stretches across the valley floor near Tucson. Unique to the Sonoran Desert, the park's giant saguaros sometimes reach as high as 50 and can live longer than 200 years. It's no wonder they've been described as the kings of the Sonoran Desert.

ANCHORAGE REINDEER SAUSAGE

The Stuffer
The Lakefront Anchorage
4800 Spenard Rd.

Memento
TOTEM POLE

Can't Miss: Flightseeing is one of the best ways to explore the mountains, soar over glaciers, and spot wildlife from above. Anchorage has more pilots and planes per capita than any place in the U.S., and the busiest floatplane base in the world.

SMOTHERED
OAKLAND

The Fire Pit
Claremont Club & Spa
41 Tunnel Rd, Berkeley

Memento
**MINIATURE SHIPPING CONTAINER
WITH HELLA SPRAYPAINTED ON
THE SIDE**

Can't Miss: Nestled in the 525-acre Knowland Park in the Oakland Hills, the zoo houses more than 700 native and exotic animals. The exhibits are organized geographically and reflect the ecosystems of the animals' native habitats. Visitors can enjoy rotating cultural exhibits in the education center, and kids will love the new butterfly garden and the rides area, with a roller coaster, an endangered species carousel, and a train. A gondola ride with unparalleled views of the Bay Area will take you up the hill The California Trail, including native species such as the Grizzly Bears, Grey Wolves, Bison and more!

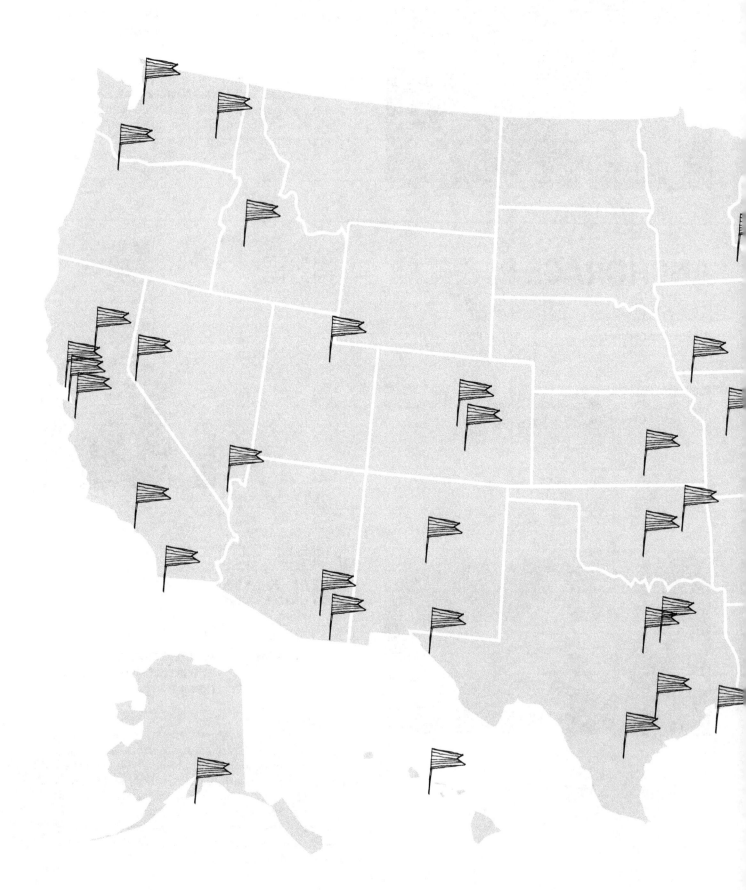

Where did we visit?

A Special Thank You:

www.AustinTexas.org

www.BirminghamAL.org

www.BloomingtonMN.org

www.Boise.org

www.BostonUSA.com

www.CatchDesMoines.com

www.CharlestonCVB.com

www.CharlottesGotAlot.com

www.ChooseChicago.com

www.CincinnatiExperience.com

www.Denver.org

www.DiscoverAtlanta.com

www.ExperienceColumbus.com

www.ExploreStLouis.com

www.FortWorth.com

www.goprovidence.com

www.GoToLouisville.com

www.LittleRock.com

www.MeetMinneapolis.org

www.MemphisTravel.com

www.NewOrleans.com

www.SFTravel.com

Shults Ford of Pittsburgh

Motorwerks MINI of Golden Valley

www.statenislandUSA.com

www.ThisIsCleveland.com

www.VisitAlbuquerque.org

www.VisitBaltimore.org

www.VisitBuffaloNiagara.com

www.VisitCOS.com

www.VisitDallas.com

www.VisitDetroit.com

www.VisitElPaso.com

www.VisitHoustonTexas.com

www.VisitIndy.com

www.VisitJacksonville.com

www.VisitKC.com

www.VisitLasVegas.com

www.VisitMilwaukee.org

www.VisitMusicCity.com

www.VisitNorfolk.com

www.VisitOakland.com

www.VisitOKC.com

www.VisitOmaha.com

www.VisitOrlando.com

www.VisitPhilly.com

www.VisitPittsburgh.com

www.VisitPortland.com

www.VisitRenoTahoe.com

www.VisitSaintPaul.com

www.VisitSaltLake.com

www.VisitSeattle.org

www.VisitSpokane.com

www.VisitTampaBay.com

www.VisitTulsa.com

www.VisitVirginiaBeach.com

www.VisitWichita.com

www.VisitWilmingtonDE.com

www.Washington.org

CPSIA information can be obtained
at www.ICGtesting.com
Printed in the USA
JSHW040241250522
26162JS00003B/8

9 781735 534640